Hendersonville
&
Flat Rock

Hendersonville
&
Flat Rock
An Intimate Tour

Terry Ruscin

Charleston London

History
PRESS

Published by The History Press
Charleston, SC 29403
www.historypress.net

Front cover image: The Episcopal Church of St. John in the Wilderness, Flat Rock.
Back cover images, clockwise from top left: *Wolfe's Angel*, Oakdale Cemetery, Hendersonville; apples ripening in the September sun, Edneyville; historic depot, Hendersonville; historic Henderson County courthouse, downtown Hendersonville; St. John in the Wilderness, Flat Rock; Italianate home at the Historic Johnson Farm, Rugby. Unless otherwise credited, photographs are by the author.

First published 2007

Manufactured in the United Kingdom

ISBN 978.1.59629.265.9

Library of Congress Cataloging-in-Publication Data

Ruscin, Terry, 1951-
 Hendersonville & Flat Rock : an intimate tour / Terry Ruscin; foreword by Louise H. Bailey.
 p. cm.
 Includes bibliographical references and index.
 ISBN 978-1-59629-265-9 (alk. paper)
1. Hendersonville (N.C.)--History. 2. Flat Rock (N.C.)--History. 3. Historic sites--North Carolina--Hendersonville. 4. Historic sites--North Carolina--Flat Rock. 5. Hendersonville (N.C.)--Biography. 6. Flat Rock (N.C.)--Biography. 7. Hendersonville (N.C.)--Social life and customs. 8. Flat Rock (N.C.)--Social life and customs. 9. Hendersonville Region (N.C.)--Guidebooks. 10. Flat Rock Region (N.C.)--Guidebooks.
I. Title.
II. Title: Hendersonville and Flat Rock.
 F264.H49R87 2007
 975.6'92--dc22
 2007009408

Notice: The information in this book is true and complete to the best of our knowledge. It is offered without guarantee on the part of the author or The History Press. The author and The History Press disclaim all liability in connection with the use of this book.

Dedicated to Louise H. Bailey
for caring and sharing,
and to Kitty Turner
for giving a newcomer a break.

CONTENTS

FOREWORD

*I*t took courage to close the door on a lucrative advertising business in San Diego, California, and head east to spend an early retirement in some unknown destination. But the desire for change was a catalyst. Advertiser turned artist and till-wee-hours-worker turned writer and photographer, Terry Ruscin crossed the Southern United States, coming at last to the Blue Ridge Mountains of Western North Carolina. The city of Asheville offered many opportunities to enrich his years of retirement, but San Diego had done that and he wanted a slower pace with a hometown atmosphere. He drove on, and when he came into smaller, quieter Hendersonville, he said, "This is it. I'll never leave." And from the start, he has seemed one of us.

To some people our town may seem a medley of brick and stone and concrete, a tasteful blend of reds, yellows and grays. An occasional church spire breaks the sameness of flat-roofed stores, and the one-hundred-year-old courthouse still stands for the sake of history.

Former Californian Terry Ruscin now calls Hendersonville home. *Photo by Barbara Hughes.*

Foreword

Few people notice, but the statue of Lady Justice on the courthouse dome is said to be one of only three in the entire United States missing an important item. Terry was quick to recognize that the blindfold the statue is supposed to be wearing is missing.

Terry deeply senses the pulse of a small Southern town that has drawn him into it. He beholds our community against a backdrop of crisp blue skies and brilliant sunsets, our gently curving Main Street bordered with trees and colorful plantings. He seeks and finds history among the progressive street-level businesses and beyond the homeyness of upstairs apartments. He goes regularly to a Main Street café for morning coffee, and he takes time to talk with friends and strangers along the way. "Hi, Terry!" echoes from all sides wherever he goes.

This book recounts Hendersonville's and Flat Rock's history based on painstaking research to make sure every fact is historically correct. Yet it is not pedantic. It's filled with human interest, offering readers an intimate and enchanting view of why other people, too, are saying, "This is it."

Louise Howe Bailey
Henderson County historian, author, columnist

PREFACE: AN INTIMATE TOUR

From downtown Hendersonville's stately Victorian-era storefronts to its neoclassic-styled courthouse and city hall, our town reminds us of gentler times. Times when horses and buggies, mule-drawn streetcars and Tin Lizzies traversed an unpaved Main Street—when livery stables counted among the diverse commercial buildings and farmers peddled produce curbside. Back then, nearly two hundred hotels, boardinghouses and sanitariums lodged tourists and health-seekers, and the Skyland Hotel hosted such celebrated guests as F. Scott and Zelda Fitzgerald.

The illustrious have also made their homes in these hills. Not far from town, we may visit Carl Sandburg's Connemara at Flat Rock and Thomas Wolfe's Old Kentucky Home at Asheville, and view the sculpture that inspired the title of Wolfe's *Look Homeward, Angel* hovering above the Johnson plot in Hendersonville's Oakdale Cemetery.

Around the turn of the twentieth century, Hendersonville earned the reputation as the "Dancingest Little Town in America." Main Street sported street dances, drawing clogging enthusiasts from near and far. The ballroom of the Skyland Hotel and a pavilion at nearby Laurel Park featured big-band names including Cab Calloway, Kay Kyser and the Garber-Davis Orchestra, led by the nationally known orchestra leader Jan Garber.

With open-air concerts and dances on a paved Main Street, downtown Hendersonville continues its musical traditions into the twenty-first century. And within easy reach of town, theatergoers and music lovers find cultural solace at the Flat Rock Playhouse and Brevard Music Center.

For hikers and nature buffs, nearby Pisgah National and DuPont State Forests, breathtaking Chimney Rock Park, Jump Off Rock and the Blue Ridge Parkway serve up nature in her array of seasonal moods. In this blissful corner of the Blue Ridge escarpment, we discover fields and ditches enlivened with wildflowers and woodlands abloom with clouds of dogwood and nosegays of mountain laurel. After a rain, forest pathways yield lush swaths of mosses and a surfeit of lichens and colorful fungi. Hikes and drives propose sweeping views of boundless meadows dotted with horses and cattle, and burnished skies reflected in glimmering lakes and streams and waterfalls.

Wilderness and farmland envelop Hendersonville and Flat Rock, cradling the city and village in verdancy. Green-and-white signs at the city limits enlighten the visitor that this is indeed a bird sanctuary, and birders travel from miles around to behold countless varieties of our winged friends.

For those of us perceptive enough to recognize it, there is energy here. The Catawba and Cherokee sensed it; so did the early pioneers and other European settlers like banker and part-

time resident Charles Baring, Judge Mitchell King and Christopher Gustavus Memminger, an attorney and first secretary of the Confederate treasury under President Jefferson Davis. Baring built the first summer home at Flat Rock and King built the second. Memminger built Rock Hill—later renamed Connemara—where Carl Sandburg lived and wrote.

Today, Hendersonville's historic downtown boasts one of America's best-preserved Main Streets, and the board of Historic Flat Rock, Inc., works diligently to sustain its cache of venerable buildings and wooded easements.

Along these ridges, music and art abound. The air is clear and sweet. Life is unhurried. Best of all, there is an intimacy here—a milieu allowing a respectful newcomer to fleetly ingratiate himself into the community, to learn about its rich history—including a few of its closely held secrets.

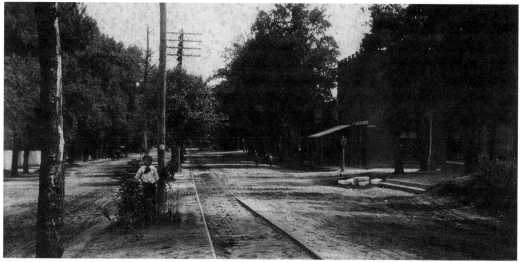

Downtown Hendersonville's broad Main Street, circa 1900. Note the trolley tracks in the middle of the street. *Courtesy of Henderson County Genealogical & Historical Society Inc. Photo by Arthur Farrington Baker.*

ACKNOWLEDGEMENTS

To My Sounding Boards:
Many thanks to my readers, listeners and consultants: Margarita FitzSimons Allston, Louise H. Bailey, Sandra DeVonish, Frank L. FitzSimons Jr., Hank FitzSimons, Charles Herrmann, Dr. George A. and Evelyn Jones, Jennie Jones Giles, Tom E. Orr, Kitty Turner and Libby Ward.

Introduction: The Birth of a Mountain County

*F*or thousands of years before European pioneers settled in the Appalachians, the Cherokee thrived, hunting in these forest-clad highlands and fishing in the vales crisscrossed with pristine waterways. In the late 1780s, William Mills, a Tory in the Revolutionary War, was one of the first non-native settlers in the region that would become Henderson County.

Local legend tells us William Mills—for whom Henderson County's Mills Gap was named—received the first land grants west of the Blue Ridge Mountains in North Carolina. Local news writer and historian Jennie Jones Giles explains that Mills River was named not for William Mills, as many people believe, but for an old mill that once operated on a bank of Mill Creek.

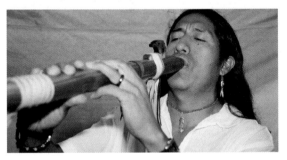

Cherokee flautist Alberto Cacuanbo performs during one of downtown Hendersonville's festivals.

Some historians, including Jones Giles, dispute that Mills was the first land grant holder in the county. As Jones Giles points out, the Stepp, Davis and Maybin families received land grants in the area the same year as Mills did. Jones Giles, who admits all the names of the county's first settlers are not known, writes:

In 1767 North Carolina's Royal Gov. William Tryon left New Bern to meet with the leaders of the Cherokee Nation to set a boundary line. The boundary began at the Reedy River near today's Travelers Rest, South Carolina, crossed the brow of the Saluda Range to Tryon Mountain in Polk County, the east side of the Blue Ridge, then north to the lead mines in Virginia.

It was not until July 20, 1777, that the large area open for settlement was officially ceded by the Cherokee in the Treaty of Long Island of Holston [including a region in present-day Henderson County known as Mountain Page].

The remainder of today's Henderson County did not open for settlement until after 1785, when the Treaty of Hopewell was signed with the Cherokee. It was not until 1787 that the state began issuing grants for land in present-day Henderson County.

In the early 1800s, lowlanders came from South Carolina seeking more healthful summertime environs. Mostly planters, these members of Charlestonian aristocracy founded a community of summer residences in a region the Cherokee called the "great flat rock." One could say this summer colony was the cradle of Hendersonville.

So, Who the Heck Was Henderson?

As the regional population blossomed, a county was formed from the southern section of Buncombe County and a portion of Rutherford County. In 1838, Henderson County was incorporated and named for North Carolina Supreme Court Chief Justice Leonard Henderson (1772–1833). Although Henderson never lived in or visited the county named for him, he was a North Carolinian, having been born in Granville County in the eastern part of the state. Henderson died at Williamsboro in Vance County, North Carolina. He is interred in his family's private cemetery.

Hendersonville, the county seat, was founded in 1841 and chartered in 1847 on a portion

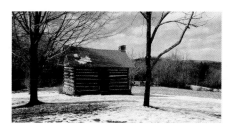

of Chinquapin Hill. Judge Mitchell King donated approximately fifty acres for the town site, with adjoining properties of twenty-nine acres given by Colonel James Brittain and John Johnson. The city, laid out by surveyor James Dyer Justice, was incorporated in 1847.

Over the years, portions of Polk and Transylvania Counties were carved out of parts of Henderson County.

An early pioneer's cabin, Henderson County.

Then and Now

Over the course of 160 years, the Hendersonville–Flat Rock community has grown from its rudimentary population of a few hundred to more than 14,000. Countywide, according to 2006 census reports, the population reached nearly 100,000.

In Henderson County, boys' and girls' summer camps abound (the largest concentration in the nation), and lowlanders still keep summer homes in Hendersonville and Flat Rock. Tourism, commerce, agriculture, light industry and retirement communities support the local economy of the county named for Chief Justice Henderson.

At 2,200 feet above sea level, Hendersonville tucks into a plateau of the Blue Ridge escarpment.

History in Stone and Wood

*W*hen they discovered its healthful, cooler clime in the early nineteenth century, South Carolinian lowlanders referred to the region now known as Henderson County as "the wilderness." The heavily forested region so named stretched from the Piedmont of western South Carolina through eastern Tennessee.

By the time Charlestonians began scouting here, the region was already home to hundreds of pioneer families with names including Clark, Clarke, Edney, Featherstone, Garren, Johnson, Jones, Justice, Justus, Lyda, Merrill, Mills, Orr, Pace, Shipman, Staton and Stepp.

The land boom began when English Charlestonian Charles Baring purchased land from pioneer settlers and built his grand summer home, Mountain Lodge, in the heart of the region known as Flat Rock, twenty years before Hendersonville was founded.

Mountain Lodge

Once the hub of Flat Rock's social scene, Mountain Lodge has stood abandoned since 1995—a lonely sentinel in the midst of unshorn lawns and overgrown bramble. With permission to access the fabled estate, one finds behind the wooden gates off Rutledge Drive a winding approach scarcely evident beneath its swath of car-window-deep grasses and wildflowers.

Upon reaching the antebellum home, one senses its former splendor. Embellished with Federal capitals, twenty columns soar to a steep roof clad with concrete shingles. Through the myriad of mullioned windows, residents certainly admired vistas of Bearwallow and Sugarloaf Mountains.

The builders and first inhabitants of "The Lodge," as they sometimes called it, were Charles and Susan Baring. One could say the Barings swayed the development of Flat Rock.

Trendsetters

Prominent Englishman Charles Baring of the Baring Brothers & Company of London banking firm was dispatched to Charleston, South Carolina, to arrange a marriage between his cousin, Lord Ashburton, and the wealthy widow Susan Cole Heyward, who was Welsh born and reared. When he first met Susan in 1797, Charles immediately fell in love, and they were soon wed. Some speculated that wealth captured his heart, for Susan—ten years Charles's senior—had inherited a lifetime interest in considerable landholdings, including rice plantations from her fifth husband, James Heyward.

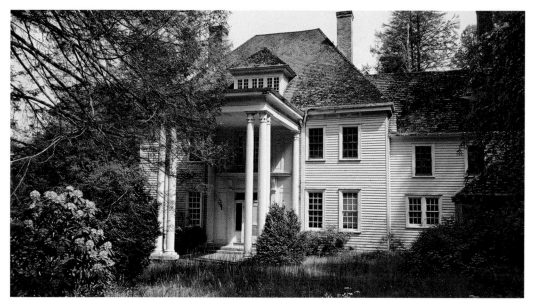

Mountain Lodge was the first summer home built at Flat Rock.

Oppressive heat, humidity and mosquito-infested rice paddies proved anything but idyllic for summertime residents of coastal South Carolina. A devoted husband eager to protect his new bride's frail health, Baring searched for a more desirable regional clime. Discovering the Western North Carolina site named the "Great Flat Rock" by early white traders, Baring purchased—in his wife's name—three hundred acres of the Phillips Creek property from Thomas Justice and Joab Hensley for $600. There, Baring began, in 1827—with the help of local pioneers—construction of a summer retreat, Mountain Lodge, the first Flat Rock residence built by members of the Charleston group that would soon follow.

The Finer Attributes of Flat Rock's First Summer Home

Baring developed his wife's Flat Rock estate along English lines. The baronial spread included the manor house known as Mountain Lodge, a porter's cottage, formal gardens, a deer park and a chapel with parsonage. Baring continued to acquire land until ultimately he owned three thousand acres.

In 1939, successive owners Dr. and Mrs. Edward Jones of Texas commissioned a makeover of Mountain Lodge by architect Erle G. Stillwell. The original five-bay structure is all but obscured by Stillwell's colonnaded porticos and a two-story porte-cochere—the former carriage entry. Notwithstanding, an air of intrigue surrounds the manor.

Today the 8,632-square-foot, three-level home sports among its forty rooms twelve bedchambers and six and a half custom-tiled baths. Additional features embody 12-foot-high ceilings, chandeliers, three fireplaces and satin-finished hardwood floors throughout. Crown-and-dental moldings punctuate the formal entertaining areas. A sunroom, a spacious kitchen with a 1920s vintage Aga stove, a butler's pantry, an octagonal billiards room and three other outbuildings round out the opulent atmosphere.

Gable and hip dormers break the uniformity of the home's sharply pitched roof. The grounds feature towering hemlocks and pines planted 175 years ago. Massive purple

rhododendrons embroider the gardens, as do the largest English boxwoods in America. Philadelphia botanist Mrs. Nicholas Roosevelt made the boxwood assessment for Newton Angier of Flat Rock, an erstwhile owner of Mountain Lodge.

The house retains sections of its original wallpaper hand painted with Oriental designs and scenes of the Crusades. One may also glimpse much of the home's inceptive Federal trim, including the mantels, staircase and front entrance; but gone is the neo-Gothic latticework porch.

The Barings and the "Little Charleston of the Mountains"

Charles and Susan Baring arrived each summer at Flat Rock (in what was then Buncombe County) with their extended family of foster children, assumed to be nephews and nieces. From their plantation south of Charleston, the family traveled in carriages followed by a caravan of wagons bearing luggage, groceries and servants.

In that genteel era, Flat Rock would soon host a summer colony populated by the crème of Lowcountry society. Charles Baring sold portions of his land acquisitions to fellow Charlestonians, including wealthy planters and statesmen such as Judge Mitchell King. Other notable buyers of Baring's landholdings at Flat Rock were Christopher Gustavus Memminger (first secretary of the treasury of the Confederate States of America) and Count Marie Joseph Gabriel St. Xavier de Choiseul (French consul to Charleston and occasionally to Savannah, 1831–56).

Sadie Patton wrote in her book *The Story of Henderson County*, "During the 15 years she was chatelaine of Mountain Lodge, Susan Baring was one of the community's social rulers…She was at her best when as guest of honor, and she presided over the fête given annually in celebration of her birthday."

It has been written also that Susan Baring was very handsome, bright and amusing, and she hosted grand dinner parties, cotillions and dramatic presentations at Mountain Lodge. Others describe Susan as "driven by social ambition" and with "a temper sometimes violent as a September gale." Alexander Baring, Charles's son from a second marriage, wrote of Susan, "It seemed she ruled her husband entirely." And Deidre LeBoutillier wrote, "She was known on more than one occasion, when he made a comment that did not fall in with her views, to remark, 'Charles, my love, you are a fool.'"

Susan died in 1845, her wealth—a lifetime inheritance—reverting to the Heyward heirs. Her widower Charles lost Mountain Lodge.

Charles subsequently married Constance Radcliffe Dent of Georgia and built their home, Solitude, near Mill Shoal, which is now the Highland Lake Inn property. Charles and Constance had one child, Alexander Baring.

St. John in the Wilderness

On Sunday mornings, Susan Baring, dressed all in white, rode with her husband in their bright yellow carriage with its coat-of-arms—a carriage drawn by perfectly groomed horses harnessed with silver buckles and rings. The other members of their party followed. Upon arriving at the carriage entrance [of St. John in the Wilderness], a footman waited for Susan to lay her prayer book and Bible on a velvet pillow he held at the ready, then he opened Susan's door. Another attendant was sent to notify the rector that Susan was at the church

door. Susan and her party then entered, followed by a maid in a white turban and bearing the velvet cushion holding the prayer book and Bible. The maid also carried a large turkey-tail fan, which she used to cool her mistress during the service. Only when the Barings were seated, could the service begin.
—*Carolyn Sakowski,* Touring the Western North Carolina Backroads

Loyal to the Church of England and finding no Anglican churches proximate to Flat Rock, the Barings built the first Episcopal church in Western North Carolina. The inaugural log chapel, burned in a woods fire, was soon rebuilt of brick near its original site, where St. John in the Wilderness stands today. The Barings hired the Reverend T.W.S. Mott, an ordained Episcopal minister, to serve as rector and tutor their foster children. In 1836, the Barings deeded the church to Reverend Levi Silliman Ives, Episcopal bishop of North Carolina.

From 1852 to 1853, South Carolinian architect Edward C. Jones designed and oversaw the enlargement of the gabled-roof brick church, including an Italianate tower and an extension of the nave. Charles and Susan Barings' bodies are interred on the south side of the church, under the three pews they had reserved for their household.

Revival

For decades, Newton Duke Angier and his wife, Jane Sherrill, breathed new life into the old Baring property. When the Angiers bought Mountain Lodge from the Joneses in 1957, they upgraded the heating (an oil furnace replaced the coal-burning system) and added weather-stripping and fresh paint.

"Mountain Lodge was a summer home," Newt Angier explains. "It would have been frightfully cold in wintertime without the improvements we made."

Of the Duke tobacco-and-lumber family, Angier was born in New Jersey. He spent most of his early life in Durham, where he was raised by his grandparents, Lida Duke and Jonathon C. Angier (son of Melvin Angier, first mayor of Durham). A Princeton graduate, Newt Angier chuckles about not having attended Duke University.

"I majored in English and history," he says. "But I wound up as a field manager for my family's business."

The Angiers, their three children and foster son lived and kept horses at Mountain Lodge. For fifteen years, the family took enormous pleasure in the fine home and its luxurious gardens and rambling countryside acres. Angier recalls,

We threw some great parties. The house could accommodate twenty-six overnight guests, and this happened. As in the days of the Barings, our parties sometimes went on for days. The entire time we lived there, we did not have a security system, and we did not lock the doors. In fact, I never carried a key! I reasoned that if someone ventured up that long driveway, they weren't about to mess with anything.

Asked about ghosts, Angier describes a personal encounter. "I was changing a light bulb up in the ranch—that's what we called the third floor—when I heard walking where there was no place to walk. My hair went straight up, I got the light fixed as fast as I could and I left."

Angier goes on to say his children many times claimed to have seen the specter of Susan Baring. "When the living room doors would slam shut for no apparent reason, we'd say, 'There goes Mrs. Baring again.'" Smiling, he adds, "She's still there, but she's a friendly ghost."

Bright Prospects

Currently, the home is owned by William Maxwell Gregg of Columbia, South Carolina, and stands on 23.71 acres. Gregg—namesake of his uncle, who owned Hendersonville's Gregg Hardware on Main Street—has employed teams of subcontractors to restore the grandeur of Flat Rock's patriarchal summer home. Recently, landscape architects have begun trimming back decades of brush, horticulturists have treated the hemlocks for woolly adelgid and—with an eye to historical integrity—painters, craftsmen and carpenters are refurbishing the venerable estate known as Mountain Lodge.

Two Centuries of Lineage: Ownership of Mountain Lodge

Susan Baring (who, with her husband, Charles, christened the estate Mountain Lodge): 1827–45

Indenture between trustees Judge Mitchell King, Daniel Blake and Richard Roper, with Charles Baring conveying his lands and tenements to his trustees for the purpose of selling them to pay off an agreed-upon debt owed to Baring Brothers & Company of London: 1849

Edward L. Trenholm paid $12,000 to Baring Brothers & Company and purchased the Mountain Lodge tract (359 acres "more or less") from the trustees (Charles M. Cheves purchased an additional 80 acres of the estate and the balance of 2,296 acres was returned to Charles Baring in 1858): 1853–96

Alicia M. Trenholm (96.5 acres): 1896–1911 (14 acres were sold to Louise Rutledge in 1898)

George J. Baldwin (82.5 acres): 1911–35

Dr. Edward H. and Margaret Stuart Jones (197 acres. Changed named of home to Heaventrees): 1935–58

M.O. and Grace Galloway (197.125 acres): 1958–59

Newton Duke and Jane Sherrill Angier (25.02 acres. Changed name of home back to Mountain Lodge): 1959–72

Albert M. Sr. and Sarah Lee Little Moreno (25.02 acres): 1972–95

William Maxwell Gregg (23.71 acres): 1995–present

Argyle

Between sips of iced tea, Louise Bailey and I discussed the biennial Flat Rock Tour of Homes. Louise excused herself to her library, then returned with a small book, which she opened to a spread on Argyle. Reviewing the photographs, a nostalgic notion swept over me. Impulsively I asked when we would visit the estate. "It will break your heart," Louise warned.

Notwithstanding, I drove Louise to her great-great-grandfather's summer retreat off the Greenville Highway (U.S. 225) in Flat Rock. On that warm summer day, we rolled

slowly up an unpaved track and parked near a barrier marked with a No Trespassing sign. We then hiked perhaps an eighth of a mile beneath the shade of venerable hemlocks and pines.

As Louise had predicted, I felt a twinge in my chest when I spotted through the trees the two-story domicile Judge Mitchell King called home during summers of yesteryear. Argyle (built 1830–31), the oldest estate in Flat Rock to be continuously owned by the same family, had sadly fallen into a state of ruin.

The fine antebellum home's white paint blistered and flaked in the sun and its few remaining hunter green shutters hung precariously from their hinges while others rotted on the ground. Wooden Doric columns and veranda railings lay randomly on the porch; others leaned against the siding. The north end of the second-story veranda had collapsed, though a thoughtful soul had attempted to shore up the deterioration with two-by-fours. Lawns and landscaping stood long neglected; boards and other debris littered the site.

We could not enter the home by virtue of its decayed state. "Furthermore," Louise informed me, "I believe there is an alarm system." We settled for a tour of the grounds.

Typical of antebellum homes, neoclassic touches adorn the doorways and windows of Argyle. On the main level windows and the remaining shutters stretch to the floor. Two wings were appended to Judge King's summer retreat in 1847, and we guessed the total interior space to be seven thousand square feet. Additional features include a granite foundation and steps, three attic dormer windows and a weathered tin roof.

During Judge Mitchell King's time, a network of lattice sheathed the porches, and seating stretched along the interior perimeters. Pointed arch openings through the latticework gave the impression of the Alhambra at Granada, Spain. Judge King's grandson, Alexander Campbell King Sr., later had the latticework removed and columns added.

As Louise and I stood on the grounds of Argyle, listening to the trilling of titmice and a draft purring through the hemlocks, I lost myself in nature's music—and more. Was I hearing the ghosts of yesteryear?

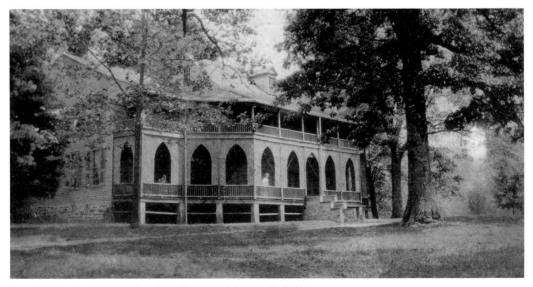

Argyle as it looked in its heyday. *Courtesy of Louise H. Bailey.*

Louise mentioned the overnight guests who had passed through the now-sagging structure before us. The Kings' colleagues and guest lists read like a who's who of Charleston society. There were the prominent Charles and Susan Baring, the Count Marie Joseph Gabriel St. Xavier de Choiseul, his countess Sarah and son Lieutenant Colonel Charles de Choiseul. Other notable guests included John Drayton, Frederick Rutledge and Andrew Johnstone. There was also C.G. Memminger, author of the Declaration of Immediate Causes, chairman of the committee that drafted the Constitution of Confederate States and secretary of the Confederate treasury. Not to mention Edward Trenholm, partner with his brother George and others in Fraser, Trenholm & Company, whose ships ran successful blockades for the Union attempting to penetrate Southern ports during the War Between the States. Charles Cotesworth Pinckney, American soldier and statesman, member of the First Provincial Congress of South Carolina and later a member of the United States Constitutional Convention, was also a guest.

Near the south wing of the once-stately home, a rotted rope dangled from the limb of an ancient oak. A child's swing in gentler times, we imagined. I asked Louise about the activities at nineteenth-century Argyle. "Besides the judge's business ventures and farming," she told me, "there would have been tennis teas, charades, balls, intellectual discussions and readings of the classics."

Judge Mitchell King's diary from Saturday, October 8, 1853, reveals more: "We discussed music, Milton, Shakespeare, Pindar…Tennyson, Brown Massey, Leigh Hunt…Judge Caldwell dined with us. Mr. Dana, Fanny Mar and two boys spent the evening at Argyle. Mr. Dana sang 'The Old Armchair.' I am sitting on the stile, Mary [his granddaughter] on another."

Louise and I moved on to the back of the property, finding it littered with ancient appliances and a moldering automobile. From our view plane, it was easy to discern the additions to the house. We turned our attention to the fire-gutted, vine-covered library, or "book room," as the judge called it.

When household festivities disturbed Judge King, he stole away to his book room, a small cottage behind the house. This library was stacked from floor to ceiling on two walls with shelves. King, an avid reader, was known to say that ladies chattering in the main house drove him to his book room for solitude. In this cottage, King's granddaughter, Margaret Campbell, taught Sunday school, and general lessons on Fridays. Still later, Mary Lee Adams (King's granddaughter and Margaret Campbell's sister) used the room as a studio where she painted portraits, setting a precedent for Harriet King (Judge King's great-granddaughter), who also painted there.

Within the walls of Argyle, currently owned by Alexander Campbell King Jr., former resident Susan Petigrew King wrote *Gerald Gray's Wife and Lily: A Novel*—the forerunner of Margaret Mitchell's *Gone with the Wind*.

If not for fear of setting off an alarm system, I would have risked danger and ventured inside the decaying structures, but settled later for viewing photographs made in 1978. In them, I saw comfortable elegance: oak floors, paneled wainscoting, fireplaces in nearly every room and mullioned windows. Louise shared with me that the furnishings were mostly of walnut and an extensive collection of portraits and shelves of tomes adorned the walls.

Though determined to find it, Louise was unable during our visit to locate the Kings' rock spring, where, in Argyle's heyday, ladies sat perched upon the periphery, cooling themselves and picnicking.

Mitchell King. *Courtesy of Louise H. Bailey.*

Strolling back toward the homestead, we paused to admire sprays of snowy white flowers—wild clematis—popular in wedding bouquets in the era of Judge Mitchell King. We spotted in the distance two dilapidated barns, sheds and what looked like a conservatory.

Back when, the Kings planted tracts of their land with crops of corn, oats, wheat and turnips. Livestock included oxen, cattle, horses, mules, sheep, turkeys, chickens and guinea fowl.

The distant barking of the groundkeeper's dogs interrupted our reverie. With our backs to Argyle, Louise and I walked to my car. "Mitchell King was quite a fellow," Louise said. "I would like to have known him."

King's Argyle, a landmark of local history, stands today a sighing structure. Three days of nonstop rain in early September 2004, followed the same year by the winds churned northward by Hurricane Ivan, wreaked further damage to the manse. How fortuitous it would be for an interested party to restore this historically significant jewel for the sake of posterity. It would be unthinkable for a tangible slice of Southern history to go the way of bulldozers and tract development.

Judge Mitchell King

Mitchell King was born June 8, 1783, to James and Ann Kirkwood Kingo in Crail, Scotland. Mitchell left Crail at age nineteen and traveled to Prussia. After several months, he returned home dissatisfied. He next set sail from London to the East Indies to find acceptable employment. The voyage was delayed; thus Kingo remained in London and attended school. He then sailed to Malta and Sicily on the *Castle of Hull*, which was captured by a Spanish privateer and diverted to Málaga. He escaped to America on the *Sally* bound for Charleston, South Carolina, and arrived penniless in November 1805.

In America Kingo dropped the "o" from his surname and involved himself in educational and social circles of Charleston. King was a brilliant scholar, having studied Latin, French, Spanish, astronomy, mathematics and science. For a time, he held a teaching position at the College of Charleston.

Mitchell King studied law and was admitted to the bar in 1810. He later became a prominent attorney, probate judge and then president of the trustees of both the College of Charleston and the Medical College of South Carolina. In 1857, the College of Charleston conferred upon King the honorary degree of LLD (doctor of law). He also was an export merchant in Charleston and was instrumental in effecting a railroad built from the Atlantic Coast to the Mississippi Valley.

King made his first trip to North Carolina in 1829, into the French Broad River Valley and Asheville, as a member of a survey team evaluating possible railroad routes. The following is from his diary.

In the fall of 1829, I made my first visit into the mountains of Western North Carolina. The health of a very dear member of my family was so much benefited by the excursion that I purchased a body of land and erected a summer retreat in the most picturesque and healthy region in the world. My annual visits to North Carolina have endeared it more and more to me and I have rejoiced to see its progress and prosperity. Flat Rock is a tableland of the South and when thoroughly known cannot fail to become a favorite resort of citizens.

His summer retreat, built 1830–31 in the pioneer settlement of Flat Rock, King named Argyle after the ancestral shire of his wife, Susanna Campbell, and her sister Margaret, whom he married after Susanna's death. Susanna and Margaret were descended from Lord Campbell, Scotland's Duke of Argyle.

The Dawning of Hendersonville

From John Cagle, Mitchell King purchased 290 acres in 1830. For the Argyle property, on October 2, 1830, King paid John Davis (a veteran of the War of 1812 under Colonel John Coffee) two dollars per acre for a tract consisting of 540 acres, including a sawmill.

Some local historians speculate that King's home Argyle incorporated a pioneer's log cabin from earlier times, and Lenoir Ray suggested, in his book *Postmarks*, that an early settler named Lincoln Fullman lived in an "improved house" on the property. King's writings disclose the mention of a "weather-boarded log cabin" on the estate, but his 1854 sketch of the Argyle plat plan shows this building at some distance from the main house. Furthermore, my future visits to Argyle included a tour of the interior, where its formal lines in no way implied the incorporation of a log cabin. The "improved house" was, perhaps, what the Kings put to use for lodging their servants—a building that, by all appearances, predates the main house.

King chose the location of Flat Rock for its idyllic weather and more healthful climate for his ailing Susanna. The Kings continued purchasing land in the Mud Creek area and beyond, adding to their vast holdings. From William Justice, King bought an additional 500 acres on September 21, 1831. A mill on present-day Blue Ridge Road he acquired in partnership with Andrew Johnstone. All told, the Kings owned more than 1,100 acres in Flat Rock and present-day Hendersonville.

When Henderson County's boundaries were drawn in 1838, Mitchell King was the largest landowner within them. As there was neither town nor county seat, he donated acreage in 1841 to be used for the location of a town site, and thus Hendersonville began. King's slaves laid the town's main street.

Susan Owenby, daughter of Argyle caretaker Kirk Jones, wrote, "Judge King gave the land for Hendersonville providing Main Street would always be 100 feet wide. He probably had the forethought how badly a wide street would be needed. He gave the land for Rosa Edwards School providing there would always be a school there."

Summers at Flat Rock

Together with Flat Rock's first summer dwelling—Mountain Lodge—Argyle marked the beginning of the summer colony where residents of Charleston took refuge from malaria

and stifling summers. Thereafter, Flat Rock became known as the "Little Charleston of the Mountains."

Susanna bore Judge King two children, and Margaret bore nine more. Had all of their children lived (several were stillborn or lost to miscarriage), there would have been eighteen.

In summers, the Kings traveled by train from Charleston. Until 1879 the train came only as far as Greenville, where the northbound family boarded a carriage or stagecoach, continuing the trip to their refuge at Flat Rock, many times pausing for refreshment at a tavern or overnighting at an inn at Travelers Rest. About this, Judge King once wrote, "We left Charleston by train on Thursday morning…spent the night in Columbia…boarded a train for Greenville…left Greenville at 6:00 a.m., Saturday. At 8:00 p.m., we dined at a wayside boardinghouse. We arrived at Flat Rock at 10:00 p.m., Saturday after traveling 40 miles in 14 hours."

The judge was a romantic, leaving as a part of his legacy "The Wanderer," among other poems. Though he "passed wretched nights" and suffered "fearful headaches…and indigestion," he enjoyed such treats as tumblers of "peached iced custard" and the wonders of nature.

In King's diary from Tuesday, September 27, 1853, he wrote, "Beautiful aurora borealis extending fully 90°—¼ of a circle along the northern horizon about the middle of the western half—pink colored streamers rising towards the zenith."

A month before his death (November 12, 1862), King penned the last entry in his diary:

> *This is the first entry, which I believe I have made in this book since Tuesday 22 August.*
> *It may be the last.*
> *I have for about an hour been looking among my papers. I am exhausted beyond expression.*
> *O God, guide, sustain me and make me in all things obedient to Thy will.*

Mitchell King is entombed beneath the Scots Presbyterian Church in Charleston, South Carolina.

The following is from King's poem "The Wanderer":

> *Ye rich, ye great, whom fortunes favoring smiles*
> *Have almost placed above the reach of fate.*
> *Beware! Ah cling not to the luring wiles*
> *She forms to bind you to your fickle state.*

Brookland

Lying within the city limits of Hendersonville since the neighborhood's annexation in 1994, Brookland—one of Flat Rock's earliest summer retreats—retains ten private acres of what was once a two-thousand-acre estate. Owners C.E. ("Gene") and Debby Staton have devoted thirty years not only to restoring Brookland but also to collecting and conserving memorabilia pertaining to the historic property, including the original deeds. It's only fitting

that the Statons live in the venerable home, given their passion for local history, ensuring the estate's preservation and upkeep. What's more, Gene's mother lived at Brookland for eleven years in the 1920s and '30s when his maternal grandfather, John F. McGraw, was caretaker of the property.

A Summer Home

In their drawing room, the Statons display portraits of Brookland's antecedent summer residents. The first, Frederick Rutledge of South Carolina's Hampton Plantation, was one of the original settlers of the Flat Rock summer colony. Rutledge built a small frame house—believed to be the present guesthouse—on the property in 1829. He sold to Charlestonians Charles and Mary Edmondston, who built the large house in 1836. British Consul of Savannah Edmund Molyneux and his wife, Eliza Herriott Johnston, were the third owners; the fourth were Major Theodore G. Barker and his wife, Louisa King, of Mulberry Plantation near Charleston. Next were banker Henry H. Ficken and his wife, Julia Ball, of Meeting Street in Charleston. To date, the Fickens' tenure at Brookland is the longest.

Frederick Rutledge (1800–1884)

Flat Rock's Rutledge Drive was named for Frederick Rutledge, grandson of "Dictator" John Rutledge, South Carolina's chief justice and first governor. Frederick Rutledge studied medicine at the University of Dublin and later married his cousin, Henrietta Middleton Rutledge.

The Rutledges were rice planters and owners of Hampton Plantation (named for Hampton Court Palace in England) on the South Santee River between Georgetown and Charleston, South Carolina. The couple graced Charleston's most fashionable circles.

Seeking a summer retreat, Rutledge explored Saratoga Springs, New York, and then, with his brother-in-law Daniel Blake, traveled to the wilderness of Western North Carolina with the idea of promoting Flat Rock as a summer resort for South Carolina's aristocracy. Charles Baring, Judge Mitchell King and Frederick Rutledge were the first Charlestonians to purchase property in Flat Rock.

In 1829, Rutledge acquired the acreage that became Brookland in what was then Flat Rock. The Rutledges had six children. The family occasionally summered at Flat Rock while they maintained Hampton Plantation as their winter home and countryseat.

When his young wife died in 1842, Frederick Rutledge was so distraught that he spent successive summers with relatives at a homestead known as The Meadows in what is now Fletcher. He never remarried. His son, Henry Middleton Rutledge (1839–1921), became the youngest colonel in the Confederacy. Henry fathered Archibald Rutledge, poet laureate of South Carolina.

Frederick, Henrietta and Henry Rutledge are buried in the churchyard of Flat Rock's St. John in the Wilderness, where they were members.

Meet the Statons

Married for thirty-nine years, Gene and Debby Staton have three grown children and two grandchildren. Gene, a sixth-generation descendant of North Carolina pioneers, traces

his ancestry to three of the region's founding fathers: Benjamin Staton (who came to Western North Carolina from Virginia in the late 1700s), William Mills and the Reverend Samuel Edney.

A graduate of Hendersonville High School and the University of Georgia and former senior vice-president of First Federal Savings & Loan (currently First Citizens Bank), Gene Staton finds time in his retirement to put Brookland back in shape. Debby, formerly of Rochester, New York, and a graduate of UNC Asheville, teaches at Etowah Elementary School.

Over the years, the Statons have involved themselves ardently with their parish, St. John in the Wilderness, where Gene was a senior warden and Debby was a president of ECW (Episcopal Church Women). Both are past vestry members, and Debby sings in the choir.

Debby collaborates in her husband's regard for local history and his love of Brookland. The couple shares in its restoration, as well as conducting ongoing genealogical research concerning the home's previous owners.

A Sense of Place

Pulling off the Greenville Highway and turning into the Brookland Manor neighborhood, one would never suspect that the enclave sequesters a historic gem. The drive along Balsam Road and its side streets discloses a community of 1950s and '60s vintage homes. The manor's situation, deep within a heavily wooded, ten-acre oasis, preserves its nineteenth-century setting. To access the estate, one travels upon a crushed-rock driveway that winds between rhododendron, fir and pine, further enhancing the hoary milieu. Once inside the wooded cloister, the surrounding neighborhood disappears.

Revival

The first year-round residents of Brookland, Dr. J. Marion Ross and the novelist Ann Ross, purchased the home and ten acres in 1968. Nine years later, the Statons bought the property from the Rosses.

"The Rosses converted a summer home to a year-round residence," says Gene Staton, adding, "In the process, they 'Williamsburged' the house."

While the décor was in good taste, Staton explained, the furnishings, draperies, paint and carpeting reflected the ambience of Colonial Williamsburg, not the feeling of a Flat Rock summer home.

The Statons resolved to restore the historic manse to its original mien. They removed carpeting, waxed the original wooden floors, sandblasted black paint from the Henderson County granite fireplace surrounds and exposed a covered fireplace. They painted over the Williamsburg hues with Greek Revival and "Charleston" colors of the period—colors such as the dining room's walls of "Iron Ore" with "Pink Mix" trim and "Tomato Cream Sauce" ceiling. The parlor's walls are "Rosy Peach" with "Harbor Brown" trim and "Peach Kiss" ceiling.

As with most restoration projects, there was more than met the eye. When removing paneling unrelated to the original house, the Statons discovered charred underpinnings. Local lore, recalling a kitchen fire during the Ficken occupancy, relates tales of the family having extinguished the blaze themselves.

Further exploration revealed 1800s methods of building, including peg-and-dowel construction, square-headed nails and horsehair as an ingredient in the plaster. "And vestiges of a cistern," says Gene. "The Barkers replaced the shallow Greek Revival roof with a steeper pitch, which accommodated the installation of a water tank for indoor plumbing."

"Edmund Molyneux revised the home as well," Gene says, pointing to a nearly inconspicuous joint in the dining room floor. "To provide additional seating space for their many guests, Molyneux had the dining room's east wall extended."

By virtue of the Statons' loving care and attention to historical details, Brookland sports its original doors and hardware (James Carpenter brand locks, Thomas Clark hinges), stained pine floors, ten fireplaces, handmade brick chimneys and walnut trim. Ground-floor ceilings soar to twelve feet and the second-floor ceilings to eleven feet. Each floor features five fireplaces, including one in an en suite bathroom. But for its kitchen, bathrooms and central heating, little of Brookland has been modified since the mid-nineteenth century.

Before Hendersonville

Brookland, Gene Staton maintains, is the only building that has overlooked Hendersonville since its beginning. Today, one may still catch glimpses of the historic Henderson County courthouse dome and the spire of the First Baptist Church through a naturally occurring topiary at the back of the grounds.

For the 2006 Tour of Homes in Flat Rock, which included Brookland, the Statons assembled at their home a retinue of antecedents of former owners. Gathered on the back piazza were Margarita FitzSimons Allston, Louise H. Bailey and Alexander Campbell King Jr., descendants of Louisa King Barker; and Ficken family descendants John and Elizabeth Ball and Beirne Chisholm. The group enjoyed the peek-a-boo views of downtown Hendersonville, reminiscing about childhood memories at Brookland—times when they played on the broad expanse of lawn and carved their initials in the tree trunks.

The History Lives On

Scottish Charlestonian architect Charles Edmondston (1782–1861) designed Greek Revival–style Brookland. The lumber of virgin timber was cut at Oleta Falls sawmill in East Henderson County and hauled by oxcart, with one load (330-board feet) taking an entire day's journey. The two-inch-thick siding was incised vertically and the paint mixed with sand, lending a faux stone simulation to the home's exterior—a technique used at George Washington's Mount Vernon. Over the years, owners of Brookland altered the look of the manor, at one time adding a coating of pebbledashed stucco to the main house and outbuildings. The Statons removed the coating from the main house and guesthouse and left the pebbledash on one of the outbuildings, thus preserving that element as a part of the estate's history.

Today, one finds no televisions, washing machines or computer stations in the main house. Rather, many of the furnishings hail from nineteenth-century Charleston. Among the treasures are two vases that were the property of C.G. Memminger, a banquet-sized double-pedestal dining table, a sideboard, a circa 1860 piano from Charleston's Henry Siegling Co. and a vintage mirror and hand-carved mantel. One of the fireplaces girdles an English fire-back from 1776. And the Statons' library houses C.G. Memminger's secretary and tomes from the collections of Memminger and Judge Mitchell King.

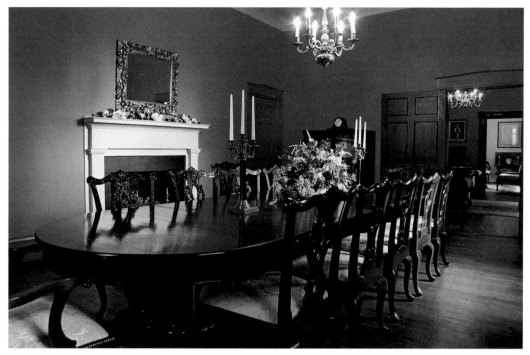

Former Brookland owner Edmund Molyneux extended the dining room's east wall to make room for more guests.

One of the Statons' sitting rooms features fine examples of Flat Rock furniture crafted of walnut and designed by Squire Farmer, and a chestnut-framed sofa and two chairs by J&J Hildebrand of Asheville that predate the Flat Rock pieces (1853). The Statons also collect timepieces, including mantel and banjo clocks, an 1805 Simon Willard and a circa 1915 mahogany Frank Herschede Co. grandfather clock.

The Statons have created—besides a grand home and showplace—what some may call a museum. "Nonetheless, we feel comfortable here," Gene Staton says of his beloved Brookland. "And we love the memorabilia; it's stuff we live with. Debby and I really enjoy the old place."

Two Centuries of Lineage: Ownership of Brookland

Frederick Rutledge of Charleston purchased 277 acres on October 29, 1829, and built a small frame house on the property.

Charles Edmondston bought the property from Rutledge, November 28, 1835, and built the current house in 1836.

Edmund Molyneux purchased the real estate January 9, 1841.

With the onset of the Civil War, Molyneux returned to Europe, where he died in 1864. Brookland was abandoned.

Major Theodore G. Barker bought the property June 2, 1882, and acquired additional adjoining acreage through acquisition and inheritance.

Henry Ficken purchased 161.9 acres November 1, 1918, and added additional adjoining acreage.

The Fickens subdivided the Brookland estate into the Brookland Manor neighborhood in the late 1950s.

J. Marion Ross, MD, of Hendersonville (ten acres) bought the property August 8, 1968.

C.E. Staton of Hendersonville (ten acres) purchased the property June 9, 1977.

Originally a part of Flat Rock (which had no boundaries until it was incorporated as a city in 1995), Brookland and the surrounding Brookland Manor neighborhood were in "no man's land" before the City of Hendersonville annexed the subdivision in 1994.

Chanteloup

For more than ten years, Linda and Leonard Oliphant devoted nearly every waking moment to the refurbishment of Chanteloup. "The house owns us," Linda says.

Though intrigued with the overall appearance of the 1836 estate, the Oliphants acknowledged the challenges when they purchased the historic Flat Rock property in 1995. "When first we stepped inside, our hearts sank," recalls Linda. "Wallpaper hung from the walls in great curls, floorboards were buckled and the kitchen floor had caved in."

In spite of its crumbling glory, the house called to the Oliphants for succor—with peeling wallpaper and warped floors but minor steps on an onerous journey toward restoration.

As pet owners, and finding no homes available for rent while restoration moved forward, the Oliphants camped at Chanteloup, living in one room, using a tub in one of the bathrooms and a sink in another.

"Through the years we have employed up to eight full-time subcontractors at a time," Linda says. "Do you know what it's like to have eight people lined up, each waiting to ask you a question?"

Those questions included, "Are you sure you want plaster, rather than drywall?" and "What should we do about the snakes?" When the Oliphants moved in, thirty-five black snakes shared their home. While the new owners with their domestic pets lodged in the parlor, a construction crew raised a wing of the house and poured a new foundation under the kitchen. Roofers labored overhead. "Before the work began, you could see the sky through one of the bedroom's roof groins," Leonard says, "and another ceiling had fallen."

Next, work crews repaired from the attic down. Flashing around each fireplace had rotted, causing walls to leak. "The plaster had turned to sand," Linda recalls. "Though three times as expensive as drywall, we insisted on plaster throughout to ensure the historical integrity of the home. Drywall would have minimized the effect of the wonderful moldings."

Masons dismantled then rebuilt each chimney. The face of the house and garden walls—all hewn from locally quarried granite—required resetting of the pointing. Leaks abetted wood rot. Dirt and mildew were ubiquitous. Asbestos was removed from the heating system. A new well was drilled to improve water pressure, and all plumbing was upgraded.

"We brought everything up to code, a very tedious process," Leonard says. "All windows were disassembled, repaired and re-glazed."

Restoration costs grossly exceeded the half-million dollars the Oliphants originally estimated. "We felt obligated," Linda explains. "This is Leonard's dream house. He could not stand to see it fall apart, and we did not want another owner to fix it the wrong way."

To ensure historical accuracy, the Oliphants enlisted the services of Asheville preservationist Robert Griffin, AIA. Griffin was instrumental in the restoration of Biltmore Village Historic District. "Robert really cared," Linda says. "He told us exactly what we could and could not do."

Therefore, do-it-yourselfer Linda Oliphant oversaw the massive project of restoring Count de Choiseul's "castle."

A French Nobleman's Château at Flat Rock

Cousin of Louis-Philippe, king of France, the Count Marie Joseph Gabriel St. Xavier de Choiseul was the French consul to Charleston and occasionally to Savannah from 1831 to 1856. The count was active in court circles in France and Austria. His uncle arranged the marriage of Marie Antoinette to Louis XVI. The de Choiseuls—as did many other Charlestonians—found Flat Rock's summer climate to be more healthful than Charleston's. No doubt, the count and countess also enjoyed the natural wonders and social sphere of nineteenth-century Flat Rock.

In 1831, Count de Choiseul and his countess Sarah visited prominent Flat Rock residents and friends Charles and Susan Baring and purchased from them 205 acres on Mud Creek for the sum of $410. Upon this acreage they built Saluda Cottages—presently the Campbell Boyd Estate—and lived there from 1831 while their castle (now known as Chanteloup, or "Song of the Wolf") was built on land also acquired from the Barings. Completed in 1841, The Castle was the year-round home of the de Choiseuls for more than twenty years.

Following the countess's death, the count returned to France to demand an increase in salary. At the time, rumors flew about his supporting a mistress, and history records the count having left his daughters destitute at Flat Rock. In his homeland of France, de Choiseul remarried, died and was buried. His first wife (the Countess Sarah), daughters Beatrix and Eliza and son Charles are interred in the cemetery of Flat Rock's St. John in the Wilderness.

Impeccable Revival

Linda Oliphant's credentials as interior designer and color consultant are evident throughout the reemerging Chanteloup. "Changes are made with historical integrity in mind," she says.

As restoration nears completion, the Oliphants stand back to admire interiors befitting a castle. Exceptional features of this nearly ten-thousand-square-foot aerie include fifteen-foot ceilings, a floating staircase adjacent to the entry hall, views to exquisite grounds and, behind pocket doors, a grand salon and library.

In the mid-nineteenth century, the de Choiseuls' larder and ovens were housed in a separate building. Chanteloup's kitchen today is contiguous, flowing in design from the rest of the home, and with all the modern conveniences. Custom cabinetry mimics the design of the dining room's built-in hutches. An arch frames a comely breakfast nook with views to a veranda and formal landscaping. Linda added the arch in keeping with the style and proportions of the home's original window frames.

Other changes included the addition of an elevator and the subtle widening of closets to adapt to today's wardrobes. The unfinished attic was floored with boards hewn from a huge

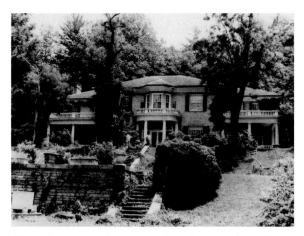

Chanteloup was home to French consulate Count Marie Joseph Gabriel St. Xavier de Choiseul. *Courtesy of Henderson County Genealogical & Historical Society Inc.*

pine on the property. A wooden door panel was replaced with glass, opening a view from the entry hall to the formal gardens. Canister lighting was added throughout and the number of electrical outlets was increased. Eleven of the thirteen original fireplaces remain—a closet conceals one; the other, formerly in the kitchen, was removed.

"We took a nineteenth-century house and made it comfortable for contemporary living," says Leonard.

Upstairs, one finds elegant bedrooms, among them the palatial master suite with lavish bath. One of the six bedchambers sequesters Leonard's collection of Scottish antiques, the Oliphant tartans and weaponry.

Encompassed by thirty-one of its original acres, Chanteloup retains the image of a grand estate. Landscape architect Frederick Law Olmsted designed the gardens for the Biltmore Estate, 1889–90. Former Chanteloup owners Lucie and Martha Norton of Louisville, Kentucky, commissioned Olmsted in the early 1900s. The grounds include boxwood hedges, a pair of Carrara marble lions said to be from Monticello and a breadth of granite stairs to the original pool.

From the gardens, one's gaze is drawn up the granite staircase to the back of a grand colonnaded home—the former front of the de Choiseul castle. "Each of the thirteen columns had rotted and needed to be replaced," says Linda. "There were no columns when the Norton sisters purchased this home. In the Old South, the number of columns symbolized the social status of an owner, so when the Nortons appended the wings, they had columns installed."

In the Shadows

Do ghosts dwell at Chanteloup? At least one does, according to Linda Oliphant. "I sense her," she says. "Our granddaughter has seen her." The child described the voice of the ghost as "foreign, mature and female with elegant speech patterns" when it warned her against the perils of the staircase after dark. Likewise, a spirit—perhaps the same as the granddaughter's spectral counselor—does not want a particular bedroom door closed. "When the de Choiseuls lived here, this second-story bedroom was a parlor with no door," Linda explains. "When the door is closed, the house feels overwhelmingly uncomfortable, so I leave it open—always."

Auspicious

"We did this for ourselves, not for a profit," says Linda. "We had an affinity for the house."

The story of Chanteloup's revival is a love story. With the painstaking efforts of Leonard and Linda Oliphant, Chanteloup has been redeemed.

Two Centuries of Lineage: Ownership of Chanteloup

Count Marie Joseph Gabriel St. Xavier de Choiseul (christened the estate The Castle): 1836–58

Colonel Robert David Urquhart: 1858–98

Lucie W. and Martha A. Norton (renamed the estate Woodnorton): 1898–1917

Mary Whitehead Parsons (renamed the estate Parsons Fields): 1917–24

William D. and Nina McAdoo: 1924–33

John M. and Margaret Camden Hundley (named the estate Chanteloup): 1933–41

William Nicholas Fortescue Jr. and Lottie Hundley Fortescue: 1941–93

During the latter years of the Fortescue ownership, the property was held up in bankruptcy court, seized by the Life Insurance Company of Virginia, occupied by various tenants including the Gunnings and the Vottis and was then abandoned.

Historic Flat Rock, Inc.: 1993–95

Leonard V. and Linda M. Oliphant: 1995–present

Connemara

For four months in 1897 when he was twenty, Carl ("Charlie") Sandburg rode the rails, sneaking rides in empty railroad cars, working odd jobs and camping in hobo jungles. This experience influenced Sandburg's writing and political views and, as a hobo, he learned a number of folk songs. Later in life, after he gained recognition as a writer, Sandburg toured the country performing these songs.

Known as a "man of the people," versatile and enormously talented Sandburg was a folk singer, historian-biographer, editor, newspaper columnist, nationally renowned poet and author, recipient of twelve honorary doctoral degrees and winner of two Pulitzer Prizes.

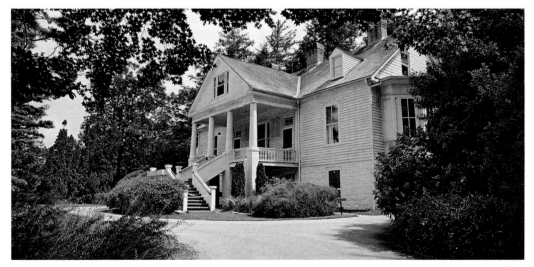

Connemara (then called Rock Hill) was home to Christopher Gustavus Memminger and later to Carl Sandburg and his family.

Sandburg lived with his wife Lilian ("Paula") Steichen Sandburg at Connemara for twenty-two years, a period during which he wrote over one-third of his published works. Because he never believed he was an author for one place alone, he termed himself "the eternal hobo."

Historic Real Estate

In the early 1990s, I first visited Carl Sandburg Home National Historic Site with my parents, never dreaming one day I would live just a few miles up the road. On that first visit, I missed the details about owners preceding the Sandburgs.

The significance of the site known as Connemara precedes the Sandburgs by more than one hundred years. In the early nineteenth century, Charlestonian C.G. Memminger purchased the property we have come to know as Connemara. Around 1838, Charles F. Reichardt designed the Greek Revival–style home that Memminger called Rock Hill.

After Memminger's death in 1888, Rock Hill was purchased in trust as a summer retreat for Mary Fleming Gregg, wife of William Gregg Jr. of Graniteville, Georgia. The Greggs owned the property for about ten years. In 1925, Charleston textile tycoon Captain Ellison Adger Smyth bought Rock Hill, renamed it Connemara to honor his Irish ancestry and lived there for seventeen years. Smyth replaced an 1839 barn erected during the Memminger years with the structure we see today.

With a goatherd and more than fourteen thousand books, the Sandburgs and their three daughters moved from Michigan in 1945 and called Connemara home until Carl's death in 1967.

Connemara Farms

Sandburg's wife Paula—sister of the renowned photographer Edward Steichen—developed a prizewinning herd of goats in Michigan. The Sandburgs moved to Flat Rock for its milder climate and to provide adequate pasturage for their growing herd.

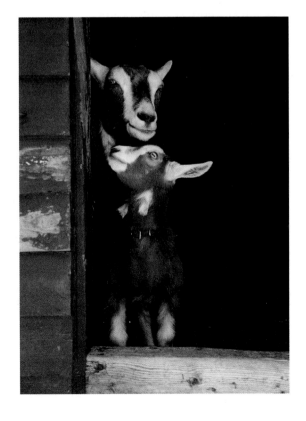

Sensitive to cow milk, Mrs. Sandburg began breeding goats for her own use. She knew that goat milk was easier to digest than cow milk (twenty minutes versus two hours). Her endeavor led to a passion and at one time her Chikaming herd counted more than three hundred head.

A Toggenburg nanny and kid—descendants of Paula Sandburg's prizewinning Chikaming herd.

Today's goats of Connemara are descended from Mrs. Sandburg's original herd, which included her champion, Puritan Jon's Jennifer II (a Toggenburg). Jennifer broke the milk production record in 1960, having produced 5,750 pounds of milk in 305 days.

The Sandburgs bred three types of goats: Toggenburg, Nubian and Saanen. Milk from all goats was sold locally, and Mrs. Sandburg made yogurt, ice cream, fudge and cheese from the milk. She ripened her cheeses in the Memminger springhouse, a cool environment much like that of the cheese-curing caves of France.

A National Park

In 1968, the Department of the Interior purchased Connemara from Paula Sandburg and the Sandburg family donated the contents of the home to the National Park Service to be preserved as the Carl Sandburg Home National Historic Site. The property is the only Flat Rock estate of its era not to be subdivided. Today, the National Park Service manages the site, preserving the Memminger and Sandburg legacies for future generations.

A Wealth of Culture, Sights and Activities

A national historic site since 1988, the 264-acre park embraces a plenitude of attractions and activities enjoyed by more than 100,000 annual visitors. At Connemara, the Sandburg pilgrim or even the casual tourist may enjoy the serenity of rural life set amidst rolling meadows and graceful woodlands. Guided house tours confer glimpses of the Sandburgs' day-to-day lives. The 1920s vintage barn and its adjacent milking parlor (added by the Sandburgs in 1947) preserve Paula Sandburg's passion for tending goats. Park rangers demonstrate artisanal methods of goat-cheese making. Visitors take pleasure in observing the herd, notably in springtime when new litters of kids entertain visitors with their precocious antics.

Nature lovers appreciate the five miles of hiking trails on moderate-to-steep terrain, with trailside wildflower surprises and awe-inspiring views of the Blue Ridge Mountains— reputedly among the oldest mountains in the world. Two lakes, several ponds, flower and vegetable gardens and an apple orchard lend additional splendor to this living museum known as Connemara.

Carl Sandburg Home hosts a variety of annual events and activities, including performances of Sandburg's *Rootabaga Stories*; excerpts from the Broadway play *The World of Carl Sandburg*; the Sandburg Solo Guitar Recital; Poets of Tomorrow; Sandburg Folk Music Festival; A Visit with Lincoln; and Home for the Holidays.

Each spring (April through May), baby goats are born at Connemara. During the summer, rangers demonstrate the art of goat-cheese making, with tastings. Goat barn and milking parlor tours are available.

More Historic Structures at Flat Rock

Beaumont

Every two years, owners of select Flat Rock residences open their homes, offering to the public glimpses of our rich mountain and lowland heritage. The residences included in

Historic Flat Rock's Tour of Homes resonate historical character, for many of them were once the summer lodgings of renowned South Carolinian and Georgian dignitaries.

One such Lowcountry resident was Andrew Johnstone, a prosperous rice planter who moved his family to Flat Rock when Union troops occupied his hometown of Annandale (near Georgetown, South Carolina) during the Civil War. Slave labor built Johnstone's stately home, Beaumont, in 1839, in what was then a part of Flat Rock. Bushwhackers— after supping at Beaumont—slaughtered Johnstone in his dining room.

Pleasant Hill

On the far reaches of the Beaumont estate, Johnstone's son William built Pleasant Hill in 1839, also with slave labor. Beaumont and Pleasant Hill were linked via Dark Valley Road through Mud Creek swamp before Little River Road was opened. Andrew Johnstone and Confederate potentate and railroad man C.G. Memminger worked together to open the road.

A massive bell, dated 1920, hangs near the house at Pleasant Hill. Local lore maintains that this bell was a signaling device to forewarn Johnstone property residents of approaching danger. If only the bell's date were 1820, the information would jibe with the history. Likewise, local lore includes rumors of a tunnel running between the two Johnstone homes—a story never proven.

Pleasant Hill retains twenty-two of its original eight hundred acres shared with Beaumont. A cottage likely predating the home presently serves as a guesthouse, and another, the caretaker's quarters.

An early twentieth-century pony barn stands in a field along one side of the long driveway and on the other side, the Dahlia Barn with its eighteenth-century post, peg and beam–style architecture designed in 1996 by local architect Ken Gaylord. In it, the Pleasant Hill owners Gene and Linda Kopf display an extensive collection of North Carolina folk art, including works by Leonard Jones and Richard Burnside. Counting among the more unusual artifacts is Fats Domino's bright red piano and his tin-panel painting from a barroom where he performed.

Although in the early 1900s the owners of Pleasant Hill altered the exterior appearance— imparting a "chalet" look—the interior retains a feeling of the Old South. Sleeping porches, high ceilings, moldings, floorboards, mantels, double-hung French doors and windows count among the original and unaltered appointments, as does a free-flying staircase.

The home's gas-burning chandeliers, now wired for electricity, maintain their stately provenance, and wallpaper styles are of the period during which early lowlanders summered at Flat Rock. More of the Kopfs' folk art accouters the space, as does a collection of Staffordshire dogs, an Irish wake table and what has been described as the largest singular collection of North Carolina pottery.

While much of the home feels like a step back in time, the kitchen no longer occupies an adjacent building. Set within the heart of the home, it is a gourmet's delight with stainless steel appliances, stunning cherry-wood cabinetry, granite countertops and glazed Mexican-tile floor.

The grounds of Pleasant Hill sport prize dahlias, a passion of the Kopfs'. Beds of hollyhocks, sunflowers and gladioli also grace the property, as does a pool—previously a spring-fed pond.

Tranquility

Edward Read Memminger, a Charleston attorney, botanist and son of C.G. Memminger, built Tranquility in 1890 as a gift to his new wife, Ella Drayton. The three-story Queen Anne–style home features all rooms on the first two floors so arranged that each opens onto a porch. The present owners, Dr. Malcolm and Gerry McDonald, have lovingly restored the ornate Victorian.

Tranquility boasts its original plaster walls, windows, heart-pine floors, baseboards, interior paneled doors, mantels and wood trim. A craftsman from Charleston fashioned the home's plaster crown moldings and chandelier medallions on site. A Victorian rocking chair of oak with embossed leatherwork is one of the Memminger pieces that remain in the home.

The McDonalds' restoration included retouching the three chandelier medallions, replicating the original colors of the home's exterior, re-pointing the foundation and rebuilding the South Carolina red brick chimneys. The couple also designed a two-story wing to match the existing architecture, as well as a carriage house apartment that, with its dormers and scrolled balconies, mimics the character of the main house.

A nineteenth-century staircase from Savannah provides access between the floors of the new wing, and a contemporary kitchen was built around an antique, oaken French sectional hutch. Daylight streaming through stained-glass windows in the central tower drenches another staircase in prismatic glow.

Views from Tranquility sweep from Glassy Mountain to Mount Pisgah. Edward Memminger likely planted some of the property's more ancient trees. Upon Memminger's death, the University of North Carolina acquired nearly one thousand of his rare specimens.

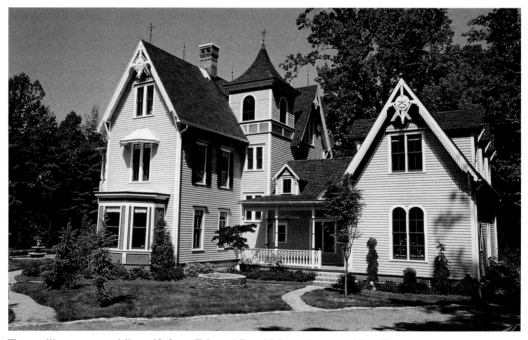

Tranquility was a wedding gift from Edward Read Memminger to his wife.

Rhododendron

Nestled at the foot of Glassy Mountain, Rhododendron (circa 1890) stands on part of a larger tract settled in 1847 by William Maxwell. As would be the case with many historic homes, ownership has passed through numerous hands. Maxwell purchased the original 115 acres, of which he sold 100 to William Cuthbert of Beaufort, South Carolina, in 1859. Cuthbert lived there until after the War Between the States.

Successive owners included a Mr. Glover of Orangeburg, South Carolina; Glover's mother-in-law, Matilda Fowles, also of Orangeburg; and the Rudolph Seiglings of Charleston (owners of Saluda Cottages), who purchased the property in 1890.

The combined landholdings of Rhododendron and Saluda Cottages were known at the time as San Souci. The Seiglings soon turned their house over to friends, the Lewis Simons Jerveys of James Island, South Carolina. Robert Tucker took over the deed in 1911, and in 1919 he sold the home and 29.4 acres to the Jenkins Robertsons of Charleston, who in turn sold to the Robert Clevelands of Spartanburg in 1925.

The real estate was auctioned in 1950. Mrs. George M. Rhodes of Columbia was the winning bidder for the home and 9.5 acres of the property. Rhodes's descendants continue to use Rhododendron as a vacation retreat.

At the terminus of a rhododendron-flanked drive, the home rests atop a knoll shaded by ancient arbors gracing the park-like grounds. The two-story house with wraparound porch is typical of a late nineteenth-century Flat Rock summer residence. Furnishings of note include maps of the Savannah River and Wilmington Island, where the Rhodes's Revolutionary War ancestor, Captain John Screven, owned rice plantations. Examples of Chinese export-ware accouter the home, as does a timeworn Aubusson carpet; a portrait of James Habersham, the last colonial governor of Georgia; and a mahogany jeweler's desk made in 1814 for a Charleston watchmaker.

Additional Flat Rock Properties

Ellen Allston Cottage
Richard Altmann Home
J.C. Barrett Home
Boxwood
W.S. Carrier Home
Dam House
Dethero Cottage
Dunroy
Elliott Place
Embrook
Emmy's House
Enchantment
Five Oaks (currently the Flat Rock Inn)
Greenwoods
Heidelberg House at Bonclarken
Highland Fling

Hilgay
Hilgay by the Lake
Hunter's Moon
Cyrus Hylander Home
Oke Johnson Home
Kenmure (formerly Glenroy)
J.G. Kessaris Home
Laurelhurst
Little Hill
Longwood
Looking South
Lowndes Place (at one time known as The Rock and the Rockworth boardinghouse, the structure currently houses offices of Flat Rock Playhouse)
Many Pines

McCullough Cottage
R.W. Moss Home
Oak Knoll
Old Parsonage
Pace Place
Piedmont
Pinebrook
Quiltbuilt
D.C. Reeves Home
Road's End
Rutledge Cottage

R.C. Sauer Home
Shenandoah
Sherwood
Stone Ender
Stradley and Jones House (the former home of postmasters and currently the Flat Rock Village Hall)
Tall Trees
Teneriffe
Wigwam
Wright Cottage

Further structures of historical note in Flat Rock include the Woodfield Inn (formerly the Farmer Hotel, circa 1853) and Peace's Store, circa 1890 (currently the Wrinkled Egg). The Old Post Office (currently housing the Book Exchange and the offices of Historic Flat Rock, Inc.) dates from 1847. The Old Mill (currently the Mill House Lodge), circa 1830, on West Blue Ridge Road, was a sawmill and a flourmill.

Beyond Flat Rock

Agriculture has long been a vital force in the economy of Henderson County. North Carolina is the nation's seventh-largest apple-producing state and Henderson County the largest apple-producing county in the state. The county is also the largest producer of vegetable crops in the western part of the state and ranks second among North Carolina's one hundred counties in production of ornamental and floricultural crops.

Henderson County farmers also produce livestock, dairy products and row crops. Regional produce includes estimable harvests of corn, peaches, grapes, cherries and strawberries.

In observance of its agricultural heritage, Henderson County celebrates two annual events: the Apple Festival and Farm City Day. The latter is a daylong commemoration featuring urban and rural displays.

In many cases, farms have given way to real estate development. Nevertheless, rural landscape dotted with cattle and barns remains undefiled through much of the county.

Besides barns—those venerable sentinels of early Americana—Henderson County hosts turn-of-the-century buildings featuring lofty downtown living, a vintage courthouse and depot and a restored and preserved farm museum.

Historic Johnson Farm

What fun, stepping back in time, catching glimpses of the way farmers lived and worked in days of yore, browsing the implements they used and immersing oneself in local heritage. It's never too early to discover the source of eggs or meet a donkey. Children of all ages may experience all of these wonders and more at the Historic Johnson Farm.

Among the facets of farming, Johnson Farm's Executive Director Ingrid McNair explains the "pecking order" of poultry. "Notice the hens," she'll say. "All of their combs

The Old Post Office at Flat Rock.

are different sizes. The smaller the comb, the lower the bird in the pecking order." As if to illustrate the lesson, a larger-combed hen sometimes pecks a lowlier member of the flock.

Historic Johnson Farm keeps Araucanas (chickens that lay pastel blue eggs), barred rock, Hamburg and leghorn chickens. Rabbits and miniature ponies once counted among the livestock, but coyotes took them as prey. The farm added donkeys to fend off predators and the foundation plans to add more animals.

This Old House

In 1874, Oliver Moss of Spartanburg, South Carolina, purchased from D.L. Boyd five hundred acres in a Henderson County region known as Rugby with the intent to grow tobacco. Moss hired local builder and master craftsman Riley Barnett to build an Italianate home of parged brick made of clay from the French Broad River basin. All of the pinkish-red bricks were fashioned onsite from a mixture of clay, brick dust and lime, then fired at a low temperature, which accounts for their unique texture. The exquisitely proportioned edifice, begun in 1876, was completed in 1880. The home is believed to be Henderson County's first brick house.

Besides tobacco, Moss grew corn, oats, rye, wheat, sugar, yams and Irish potatoes. In the late 1880s, North Carolina's tobacco crops exceeded demand and the market price for the crop plummeted. After eight years of farming and suffering economic hardship, Moss threw in the towel and sold 310 acres of his Rugby property to Robert and Mary Leverett for $4,000. The purchase price included the brick home and outbuildings.

The Leveretts' daughter, Sallie (1866–1925), widow of Leander Brownlow Johnson, took over the farm around 1912. Sallie, widowed when her husband died from complications of gangrene following an accident while cutting wood, was left to care for her young sons, Vernon and Leander Jr., who remained bachelors because—according to local lore—Sallie required their help on the farm. The site's former executive director, Lisa Whitfield, reports that Leander Jr. worked a brief stint as a chemist in Virginia, where he met a prospective wife. When word reached Sallie, she traveled to Virginia and fleetly retrieved her son.

On the Johnson property, Leander and Vernon erected a two-story white clapboard building in 1920. The eleven-bedroom, two-bath structure served as a summer boardinghouse for thirty-five years. At the peak of the 1920s tourism boom, boarders at the Johnson Farm could have a room for a week with three home-cooked squares a day, all for five dollars.

The Historic Johnson Farm provides hands-on experiences for children like J.D. LaMond, pictured here with a leghorn rooster.

"Aunt Sallie"—as locals and summer boarders knew her—was renowned for her gracious hosting and cooking and she served many a grateful gourmand around a nine-foot-long table crafted by Vernon and Leander's grandfather. Fried chicken, country ham, baked chicken with biscuits and farm-fresh vegetables counted among the delicious fare. According to Whitfield, dessert menus included three-layer coconut cake, pound cakes and pies. And there was always homemade butter. The long table remains in the dining room, as do the appliances, furniture and cooking utensils in Sallie's cozy kitchen.

Vernon and Leander constructed a barn of oak in 1923. Painted white, the stalwart building sports a gambrel roof overlaid with aluminum. In 1933, Vernon—disgruntled at having to give up his room to guests—built a cottage for his own use. Other buildings of interest on the remaining fifteen acres include the well, granary, chicken house, pig barn, blacksmith shop, corncrib and potting shed. A two-hundred-year-old poplar shades Vernon's Cottage.

Preserving the Past to Enrich the Future

In 1987, in their later years, the Johnson brothers willed their farmstead to the schoolchildren of the area. The brothers had already begun a museum of farming implements in their barn's loft, having wished to share the region's heritage through their bequest.

Today, the restored Historic Johnson Farm operates as a heritage learning center for schoolchildren and the community. Annually, thousands of people visit the site, tour the

historic buildings, hike the nature trails and observe the animals. Through the Folk Arts Program, children make corn shuck dolls, dip candles, participate in hayrides and identify wildflowers along the trails. Annual events include a spring festival and a Christmas open house.

A public-private project, the site is listed with the National Register of Historic Places. The nonprofit Education Foundation manages the site in cooperation with the Henderson County Board of Public Education, owner of the property. Nationwide, only three public school systems own a historic farm.

Touring the Farmstead

Besides chickens and donkeys, the Historic Johnson Farm offers something for those of all ages. For architects—and even budding architects—there is the magnificently crafted Johnson home. Docents say that sometimes people arrive on the property with measuring tapes and sketchbooks, hoping to replicate the structure's pleasing proportions for their dream homes.

Historians appreciate the attention to detail in the use of furnishings and colors. The wide wooden plank flooring, three-story quarter-turn staircase, seven fireplaces, the parlor's bay window with lace curtains, oil lamps and period kitchenware add up to a step back in time to the turn of the twentieth century.

Vernon's cottage embraces a woodworking shop on the basement level and the barn's loft houses farming implements and other turn-of-the-century artifacts. On the barn's ground level, one may view animal stalls and storage rooms.

The Interpretive Education Center offers folk-arts classes and is available for public programs, educational exhibits, concerts, demonstrations, teacher workshops, fundraising dinners, reunions, meetings and various community events. A small gift shop purveys old-timey toys, candy and souvenirs.

With the Historic Johnson Farm in their midst, local and visiting youngsters needn't wonder about times when folks raised and cultivated their own provisions—when farmers spent limited free time in a bay-windowed parlor playing cards and looking at stereopticon cards, or gathering around a long refectory table to enjoy folksy fare. Hendersonville's children and their parents have forward-looking Vernon and Leander Johnson to thank for this living history center right in their backyard.

Tobacco Barns—A Vanishing History

When fall color peaks and tropical storms retreat, tendering a smattering of clouds against crisp cerulean skies, some local photographers seize the opportunity to capture these glorious backdrops, setting out with their cameras to hunt for barns.

"Barning" is the term for this hobby in barn-strewn Wisconsin, though, unlike the Dairy State's chiefly red structures, we find in North Carolina mostly graying tobacco barns. And here in the Tar Heel State, "barning" means something to the contrary.

Considered vernacular architecture, barns reflect customs, ethnicity and traditions. Though dilapidated, tobacco barns are intrinsic to our history and agricultural heritage. Decades ago, nearly 500,000 tobacco barns dotted North Carolina's landscape; today, there are fewer than 50,000.

Four Seasons of Toil

Handing and looping were, perhaps, the simpler chores of cultivating tobacco. "Handers" lifted the leaves to the "loopers"—the workers responsible for attaching the leaves to poles for drying. For what might seem a crop easily grown, the many steps require immense dedication and backbreaking physical labor.

Work begins in winter, when farmers prepare small plant beds where the seedlings will be started. Preparation includes burning to sterilize the soil, sowing seeds and then covering the beds with twigs or heavy black plastic or cheesecloth as a measure of protection from frosts. Before spring, fields are cleared and soil fertilized. In May, tobacco growers plow their fields and next use a peg-tooth harrow to loosen the soil. Seedlings are then transplanted from the beds to the fields using a tool called a dibble to drive holes in the ground.

Throughout the growing season, farmers top and sucker tobacco plants to encourage branching and force nutrients into the established growth. Pesticides quell the tobacco hornworm (*Manduca sexta*), but these ravenous caterpillars are but one plight of the tobacco farmer. Early on, storms can usher in freezes. Blue mold takes its toll if not controlled. Worse still, hurricanes and excessive rainfall further damage tobacco crops.

During harvest time, from late August to early September, tobacco plants reach a height of four to six feet. Croppers (pickers) identify ripe leaves by a speckled ("sugar-spotted") appearance and a curly leaf tip. Pulling the ripened lower leaves a few at a time is called "priming."

Pickers of olden times loaded the prime leaves into mule-drawn wagons or sleighs, then hauled them to a barn. A crew unloaded and handed the cargo to loopers, who gathered the leaves, looped them with twine and strung them to poles (slender pine saplings) hung across looping horses—a sawhorse-style apparatus. Today, mostly tractors, harvesters and

Tobacco leaves looped and hung for drying.

automated stringers are used, though farmers still hand the laden poles to crews in the drying barns; a process called "barning" the tobacco.

The next step is curing the tobacco in the two-story barn. Farmers use one of two methods, air-drying or flue-curing. The former method incorporates ventilator panels in the barn; the latter, a sealed building with a flue and brick furnace that must remain stoked for four to six days at carefully controlled and progressively increasing temperatures. Once cured, the barn is left open to encourage moisture back into the leaves. The cured tobacco is then delivered to the pack house (warehouse) for grading. Now, after months of toil, the tobacco is at last ready for auction.

The Economy of Tobacco

North Carolina is tobacco dependent, the crop having played a fundamental role in the state's economy and social history for three centuries. As late as 1997, James A. Graham, North Carolina commissioner of agriculture, referred to tobacco as the bedrock of North Carolina agriculture.

More than two-thirds of the Tar Heel State is divided into tobacco belts: Burley (dark-leaf tobacco) to the west and northwest, New Bright in the east, Old Bright in the mid-north, the Middle Belt and the Border Belt to the south. ("Bright" is a lighter tobacco, picked as it ripens—the bottom leaves first—and flue-cured.) Henderson County's proximate belt, the Burley, is found in Buncombe, Yancey, Haywood and Madison Counties, among other counties in the northwest.

They Don't Do It Like They Used To

Since the late twentieth century, mechanized methods of cultivating tobacco have replaced many of the hands-on methods—the mule with tractor, the sleigh with harvester. Even the architecture of the drying barns has changed. Though some old-time tobacco barns have succumbed to the scrap heap, others are still in use. Some stand abandoned—precariously poised, framed with seasonal splendor—for the photographer-enthusiast. Certain others remain serviceable as garages and tool sheds for other crops, or as studios. As Nancy L. Mohr wrote in *The Barn: Classic Barns of North America*, "The durable men and women who tied their fortunes to the land don't give up easily. Nor do their barns."

The oldest of tobacco barns, found predominantly in the northern Middle Belt, were constructed of hewn logs chinked with clay and roofed with hand-hewn shingles. A taller, frame-constructed barn was built in the late 1800s, together with "floating sheds" supported by low-angle brackets rather than posts—a method of construction yielding more space for tobacco and barning crews.

As our iconic barns decay or become obsolete due to a bottom-line-driven economy, larger utilitarian sheds of galvanized metal take their place. Today, most of North Carolina's tobacco crop is bulk cured in such structures.

Notwithstanding, old tobacco barns are to be found by the thousands in North Carolina. Next time you drive a country road—no matter the season—when you spot one of these shrines of self-sufficiency, pause and admire. It could be gone tomorrow.

Where to Look for Them

In the western part of the state, one of the best places to scout tobacco barns is up State Road 19/23. Pull out at Stockton and drive through the back roads, then return to the highway, follow the signs and proceed toward Barnardsville. Don't expect to see all of the barns from the highway. Back road excursions are imperative.

Madison County hosts several tobacco barns still in use. And if you have the time for more than an afternoon's outing, head toward the Great Smokies in eastern Tennessee. Beyond the towns of Gatlinburg and Pigeon Forge, the Cades Cove region is rife with dazzling scenery, including old barns—some of log construction and others cantilevered. They say some of these structures predate the Civil War.

Historic Henderson County Courthouse— "The People's House"

In speaking of the Henderson County courthouse, retired State Supreme Court Justice Bob Orr remarked, "It is a monument to each of the men and women who have been a part of its history and the history of Henderson County and our state and nation."

Even when it stood tattered and abandoned, Henderson County's historic courthouse elicited the attention of townspeople, tourists and photographers who admire its neoclassic revival lines, its antiquity and the colorful and solemn events that oftentimes enliven its environs. Veterans of wars and other patriots pause in silence to gaze upon the various monuments gracing its lawn. The sentiment of those with a lifetime invested in this community feel even more deeply about this important landmark.

Kermit Edney referred to the courthouse as a symbol of justice. Dr. George A. Jones says, "It's beautiful and has been for 100 years a center of Henderson County. Over the years, many of my relatives have served in that courthouse." Louise Bailey considers the structure a handsome building, representing the history of our county, adding, "We need to preserve it for its historic significance." And Tom E. Orr frequently and passionately refers to the century-old courthouse as "the People's House."

Chronology

Before Hendersonville was chartered as a town in 1847, county court proceedings were held in locales such as the Hugh Johnson home in Mills River. Another location was the eighteenth-century Mills River Academy. According to Louise Bailey, the Johnson home may well be considered the place where Henderson County was born.

Between 1842 and 1844, for $336.70, John M. Kinsey built a courthouse with a flat roof and two-story arched portico on Main Street and First Avenue. Its source of heating came from wood stoves and there was neither electricity nor indoor plumbing. Of Henderson County's first official courthouse, Lila Ripley Barnwell wrote in the December 6, 1923 issue of the *Hendersonville News*:

> *A handsome, dignified structure of brick and stucco. The lower floor comprised a large hall and offices for the clerk of the court, tax collector and others. The upper story was reached from the piazza by two flights of stairs of cut-stone steps. During court sessions, a crier stood in the piazza to call the names of those wanted. The auditorium was a large room with*

wooden benches, except in a part partitioned off by a railing for the judges' stand, the lawyers and those having direct business in the cases. Split bottom chairs accommodated those who sat there. The floor was covered by a thick layer of tan bark [to deaden the noise] *sodden with tobacco juice and was the abiding place of a host of fleas.*

By the turn of the twentieth century, Henderson County's courthouse was deemed unsafe. On the same site—but set back from the sidewalk—the domed yellow brick structure begun in 1904 was completed in 1905 for $33,437 and furnished for less than $5,000. The original structure encompassed 21,208 square feet. County commissioners P.T. Ward, J.J. Baldwin and S.W. Hamilton were appointed as a building committee, and English architect Richard Sharp Smith of Asheville designed the building. Smith also was supervising architect of Biltmore House. William F. Edwards was chosen as building contractor.

Physical Attributes

As planned and budgeted for, the 1905 courthouse was constructed of yellow brick with Corinthian columns, cut-stone front steps and a domed three-stage cupola. Interior appointments included five-foot-high burled tiger oak wainscoting, marble tile on the main floor and cherry-wood appointments in the second-floor courtroom and council chambers. Beyond the decorative amenities, the new courthouse featured indoor plumbing, steam heat, electrical wiring and a trough on the street level for watering horses.

The galvanized tin dome, originally sheathed in copper paint, was a lofty platform for a buxom statue of Themis, the Greek goddess of divine justice and law and the mother of the fates.

The walkway to the piazza featured a circle with a cast-iron fountain, and the side of the council chambers facing Church Street was fitted with three large arched windows. Those windows were boarded up—according to some accounts—to prevent the prisoners in the adjoining jailhouse from taunting the jurors.

Reminiscences

The history of Henderson County's courthouse is steeped in memories of the town that grew up around it—and of its occasionally colorful citizens.

Louise Bailey remembers seeing country folks coming into town to watch the trials, a form of entertainment in the early 1900s. In the mirror of her mind, Louise sees the mountain men chewing tobacco as they stood on the piazza.

Some of the old-timers of Henderson County recall Vincent "Rosebud" Nelson, a man who enjoyed more than an occasional nip and was known to brag that he did time in a penitentiary before he was eighteen, having been charged with stealing chickens. During one of Nelson's sentences, the judge said he was going to give Nelson thirty days or thirty dollars. "Give me the thirty dollars," Nelson quipped.

One fine day in the 1920s, Nelson—at that time in his twenties—scaled the front of the courthouse using nothing but his hands and feet. This caused quite an uproar. Native Roy Bush Laughter recalls that many of the spectators, unwilling to witness a catastrophe, turned their backs on the acrobatics. Before Nelson reached the top, the authorities brought the pandemonium to a halt.

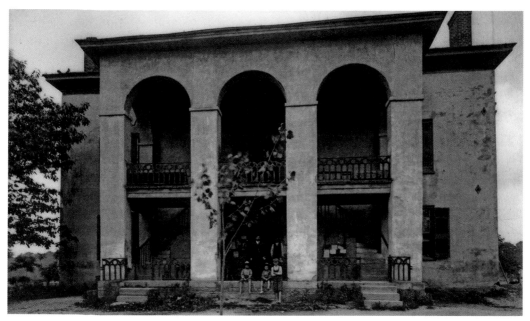

Many also recall when the Confederate monument that now stands at the northeast Henderson County's first official courthouse, completed 1844. *Courtesy of Henderson County Curb Market. Baker-Barber Collection.*

corner of the courthouse lawn stood in the center of Main Street near First Avenue. The marble obelisk was moved from the street to make room for the passing of automobiles.

Over the Years

A fire scarred Henderson County's hall of justice in 1915. In 1925—the same year in which the obelisk was moved—a jailhouse was appended to the Church Street side of the building. In the late 1920s, the congregation of the First United Methodist Church worshipped at the courthouse while awaiting the completion of their new church.

Structural repairs were made to the dome in 1943, only to require additional and massive repairs to the tune of $200,000 in 1990. Local folks had already recognized the importance of the courthouse, as it had been nominated to the National Register of Historic Places in 1979. What's more, the iconic landmark emblazons the Henderson County seal, the Hendersonville *Times-News* masthead and a highway sign promoting historic downtown Hendersonville.

On September 5, 1992, President George H.W. Bush spoke in front of the courthouse, causing less commotion than did Rosebud Nelson.

Occupied from 1905 to 1995—by courts, the county commissioner and administrator, sheriff's department, board of elections, school board, register of deeds and tax collector—the old hall of justice was abandoned with the completion of the new courthouse on Grove Street in April 1995.

A less buxom Themis stands upon the dome of the historic courthouse, made from a modified casting of the original, which now resides in the new courthouse. According to historian Louise Bailey, our Lady of Justice (both versions) is one of only three in the country not wearing the traditional blindfold.

A Confederate monument graces the lawn of Henderson County's 1905 courthouse.

The year 2005 marked the one-hundredth anniversary of Henderson Country's historic courthouse. Special events included Tom E. Orr's stage production of *Evidence of Yesterday*, the theme of the centennial.

Trial Trivia

Clerk of Superior Court and former Judge of Probate Tommy Thompson evokes some engaging cases tried in the 1905 courthouse, including one of bastardy. A woman with a less-than-sterling reputation had accused a man of fathering her illegitimate child. Defense attorney Arthur Redden Sr. asked a number of men in the courtroom to stand. Redden then asked the woman if she knew any of the men. She knew them all. "Then, are you not like a rabbit runnin' through a briar patch?" Redden asked the woman. "You got stuck and don't know which briar done it." The case was dismissed.

One of Thompson's reminiscences involved a gun in the courthouse. "A long time back, before metal detectors were used," Thompson says, "Congressman and attorney Monroe Redden tried a case in Hendersonville. While standing in the judge's chamber, the disgruntled defendant stepped in with a revolver and pointed it at Monroe. Bailiff Albert Jackson—who later became sheriff of Henderson County—grabbed hold of the gun and when the trigger was pulled, it caught the webbing between the defendant's thumb and index finger. The gun wouldn't fire. Instead, the hammer tore a good chunk of flesh from the defendant's hand—and Monroe's life was spared."

Another case recalled by Thompson involves a teenager named Willie who, together with several brothers, was constantly in and out of court. During one session, Willie bolted out of the courtroom, leapt from the top step of the second-floor landing to the main floor and ran into the street. District Attorney David Fox (later a judge) chased after the boy.

A Bright Future

In his annual address to the Georgia Historical Society in Savannah in 1917, Alexander Campbell King Sr. (1856–1926) said, "The influence on a people of the history of its ancestors finds expression in the thought that a people which is not proud of the history of its ancestors will not have a history of which its descendants can be proud."

Although plaster eroded between the protective chicken wire netting and the columns' red brick and paint buckled from its wooden trim, Henderson County's historic courthouse was structurally sound—and worthy of restoration. Fortuitously, the Henderson County Historic Courthouse Corporation (HCHCC), formed in 2003, oversaw the steps necessary to put the landmark building back in shape.

In 2003, Dr. George A. Jones—director of the Henderson County Genealogical & Historical Society Inc.—pleaded with the Henderson County Board of Commissioners to refurbish the historic courthouse. Jones lobbied politicians for federal renovation grants and bargained with local leaders for a design he thought would best honor the architectural integrity of the building.

Tom E. Orr credits Henderson County Commissioner Chairman Bill Moyer for aggressively pursuing the courthouse rehabilitation after so many years of inaction. Dr. Jones adds that the County Board of Commissioners followed Moyer's lead, voting unanimously to move forward on the restoration. Federal and private grants were anticipated by the HCHCC.

On April 19, 2004, Jones was elected chair to the board of the HCHCC and Judy Abrell, vice-chair; Tom E. Orr, secretary; and Virginia Gambill, treasurer. Former county manager David Nicholson was project coordinator. Other members included Theron Maybin and Stuart Stepp. On April 19, 2006, the corporation signed a lease agreement for fifty years with the Board of Commissioners for the operation of an educational museum within the Henderson County courthouse structure.

The vision of the HCHCC embraces a living history museum, encompassing 2,045 square feet of rooms and hall space for the purpose of promoting the region's past through exhibits, computer-assisted audio-visual displays and cultural events. Videotapes of productions such as Tom E. Orr's *Evidence of Yesterday*, the Thomas Wolfe–inspired *A River of Unending Images* and others will rotate for viewers' edification and enjoyment. Programs for all ages and interests will vary every six months.

Tom E. Orr, retired teacher and drama coach at Hendersonville High School and trustee of the Blue Ridge Community College, says, "Our goals include educating area students, residents and visitors about the past in order to ensure an informed and inspired future."

Restoration began in July 2006. Auxiliary improvements included a three-story, 12,000-square-foot structure at the back of the courthouse, an annex encompassing handicap access, an elevator, restrooms and a second-floor community room.

In addition to museum space, the courtroom was re-purposed for county commission meetings and other public functions, with seating for more than 140 people. The record rooms became the new offices for the county finance and personnel departments.

In the interim, workers stripped up to twelve layers of paint from the original wood doors, moldings and wainscoting. Craftsmen smoothed out the unattractive texturing on ceilings in the main entrance, returned walls to their original coverings and replaced damaged sections of marble flooring. The finished building includes a fire-protection sprinkler system and air conditioning.

Refurbished, Henderson County's historic courthouse is again a backdrop of high drama, tragedy and comedy—a microcosm of an American life we hope to recapture. Welcome, once again, to "the People's House."

The Historic Depot—Hendersonville's Southern Railway Passenger Station

Back when mass transit meant Pullman cars drawn by steam locomotives, the small mountain town of Hendersonville was a way station between Jacksonville, Charleston,

Spartanburg, Saluda and Asheville and depots beyond. On July 4, 1879—to the delight of Hendersonvillians—an iron horse hauling a narrow-gauge string of cars made its first appearance at a new station on the end of Depot Street (now Seventh Avenue). This modern mode of transportation helped to make Flat Rock and Hendersonville important recreation centers—when as many as fourteen trains arrived each day.

Trains #27 and #28—part of a luxury line known as the Carolina Special between Charleston and Cincinnati—ran daily beginning in 1912. The Special paused at Melrose Junction, hitched up to a Santa Fe–type Helper engine to assist in the climb up the perilous Saluda Grade (six hundred feet in less than three miles between Melrose and Saluda), stopped at Saluda to unhitch the Helper and then continued to Hendersonville and points north. Citizens gathered at each whistle stop just to see who was coming to town, thrilling to the sights and sounds of huge conveyances announcing their arrival with the clangor of a bell and a piercing whistle, belching smoke and steam as they rolled into town.

In 1968, Hendersonville's era of passenger trains ended, though until 2002 as many as seven freight trains per day traveled through the Hendersonville station. Today, the Norfolk Southern Rail Line runs but a few freight cars along the depot's adjacent tracks every week.

Norfolk Southern Railroad—current owners of the real estate under Hendersonville's station (the City of Hendersonville owns the building)—elected to reroute most trains south by selecting different circuits, thus bypassing Hendersonville. With the exception of occasional deliveries to area industries, the tracks alongside Hendersonville's depot are dormant reminders of our town's once bustling railroad era.

In 2000, the depot was registered by the North Carolina Historical Society as a historical landmark, thus commemorating its long and useful history in serving the public.

In the early twentieth century, the Hendersonville depot sported a passenger shed. *Courtesy of Apple Valley Model Railroad Club. Baker-Barber Collection.*

The Evolution of a Depot

In 1879, Hendersonville's depot was little more than a boxcar-sized shelter with a packed earthen floor. By the early 1900s, the station was about the size and conformation of the Saluda depot, and updated with a concrete floor together with expanded space, segregated waiting rooms, cargo holds and restrooms. A Queen Anne–style cupola above the ticket window added a touch of Victorian elegance to the classic Craftsman structure. By 1902, the depot reached 87 feet long, for a total construction cost of $2,613. To provide a women's waiting room and additional baggage handling space, 15-foot sections were added to each end in 1906. The present structure is 140 feet long.

During its heyday, the Hendersonville depot sported a 22,000-gallon water tank across the tracks with stand pipes and underground lines to Tracks #1 and #2—just far enough apart to allow two Mikado-type steam locomotives to be serviced at the same time. In peak years, six passenger trains stopped daily in Hendersonville. In that "steam age," the locomotives pulled mail, baggage, coach, diner and Pullman cars. The Carolina Special sometimes included an observation car emblazoned with the words CAROLINA SPECIAL. In those days, Jennie Bailey ran the Cedars as a boardinghouse, and her husband, Captain Joseph W. Bailey—until his death in 1942—was the Hendersonville depot agent for thirty years. Captain Bailey spent more than half a century with the Southern Railway and was one of the first conductors on the train from Hendersonville to Lake Toxaway.

Today, the visitor to Hendersonville's depot no longer finds a small cylindrical building that once served as headquarters for the signalman. Nor does one see the semaphore that replaced the cylindrical building. Gone too is the passenger shed and the dormers that once punctuated the roofline along the depot's broad sides. The roofline has changed over the years, but the exterior appears—for the most part—as it did in the early twentieth century.

Railroad Enthusiasts

Hendersonville's Apple Valley Model Railroad Club has occupied the depot since 1991, when club members helped restore the historic building. The forty-three-member club also constructed an HO-gauge model railroad representing Hendersonville and other parts of Western North Carolina. With over 800 feet of track and more than 125 track switches, the 420-square-foot display is replete with village scenes from Saluda to points north and west of Hendersonville, with plans for expanded tracks and scenes representing additional whistle stops in Western North Carolina. All told, the models will represent stations between Asheville and Salisbury, including Black Mountain, Hickory, Morganton, Old Fort, Marion and even Spartanburg. The landscaping features waterfalls, tunnels, lakes and mountain passes.

Labors of Love

Between June and September 2005, the Apple Valley Model Railroad Club's restoration project improved the interior space of the entire depot complex. Members raised funds—combining the monies with a $75,000 federal grant (previously captured by the Historic Seventh Avenue District, Inc., in association with the City of Hendersonville)—consulted with architect and historic preservationist John Horton and pitched in to restore the depot.

Wainscoting was stripped from the walls, dry rotted wood was removed and replaced and dilapidated brick chimneys were reconditioned and re-flashed—a process including demolition and reassembling the exterior portions of the chimneys. Where salvageable, sections of original bead-board wainscoting were returned to the walls and replica-work replaced the balance of the trim. Club members took care of the demolition phase, trimming $2,500 from the budget. Much material and labor was donated by the City of Hendersonville, which also helped with roofing repairs, the fire alarm system and trash removal.

Most windows were re-glazed; all doors were removed, repaired or rebuilt and re-paned, stripped, painted and re-hung. All hardware but the locks was retained. Original material was labeled and put back in place.

Heating and restrooms were upgraded. (In the old days, coal stoves had heated the facility.) All walls were insulated, and the electrical system was amped up to two hundred. And for the first time in its 103-year history, the depot sported air conditioning and hot water.

Of the elaborate electrical work and equipment, club president Dan Lang said, "That's where most of the money went." He added, "We now have a fire detection system and exterior emergency lighting. Then there was the refuse. Club members took care of all that, saving $650—the cost of dumpsters."

Unclear as to the original palette of the depot interior, club members chose period hues of yellow with brown trim. The restoration included new ceilings, exhaust fans, lighting fixtures with chain-suspended schoolhouse globes in the style of the originals and fluorescent fixtures for the model display areas. Original schoolhouse lights were refurbished and re-hung.

"We brought it all up to code, and including those unforeseen problems common to any construction project, we came in under our $108,000 budget," Lang proudly reported.

Visitors to the restored depot can view the club's enchanting models in comfort and safety and look forward to expanded displays in what was once a waiting room and stationmaster's office. The ticket office with its original marble counter will be the staging area for the new displays.

This achievement illustrates what can be done—and for a reasonable cost—when dealing with passion and elbow grease versus committees, corporate boards and bureaucratic red tape.

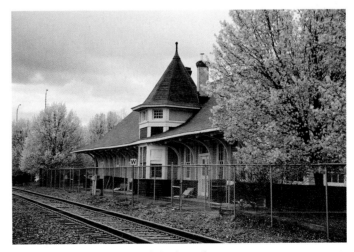

Hendersonville's depot as it looks today.

The Grey Hosiery Mill

In 1915, at the request of residents to bring industrial development to town, Captain James P. Grey of Johnson City, Tennessee, built a one-story red brick hosiery mill in Hendersonville. The original portion of the Grey Hosiery Mill with its lofty clerestory windows served as the knitting room. Additions were made in 1919 and 1947. Located two blocks east of historic Main Street, the mill occupies one-half of the western side of the block bound by Fourth Avenue East, Grove Street, Fifth Avenue East and Pine Street. The mill produced knee-length ribbed stockings and seamless hosiery.

Holt Hosiery of Burlington, North Carolina, purchased the mill in 1965 and halted production in 1967. Subsequently, the old mill has served a number of purposes, including a craft store, temporary home for the library, a Buck Stove fabrication operation and a fundraising and flea market arena. The City of Hendersonville acquired the property in 1994. In 2000, the Grey Hosiery Mill was listed with the National Register of Historic Places as the only historic industrial building remaining in the Hendersonville city limits. Its historic status protects the original portion of the building against demolition. The City abandoned the property in 2003, moving its offices one block east.

Hendersonville *Times-News* columnist Stephen M. Black wrote on January 6, 2007, "This building represents an industry that employed many county residents. The mill paycheck kept body and soul together in hard times for a lot of our families. The building itself should be saved as a monument to the workers who spent their lives supporting their families."

The Grey Hosiery Mill, listed with the National Register of Historic Places, is the last standing industrial building so designated within the city limits of Hendersonville.

Aloft on Main Street—An Urban Environment

A microcosm flourishes above the Victorian-era storefronts on Hendersonville's North Main Street. Since the late 1800s, merchants, doctors and pharmacists have made homes of the step-ups, and others resided in single-family homes that formerly dotted each side of South Main Street. In the 1920s and '30s, the Clarkes of Clarke Hardware Company lived in the second-story space above their mercantile in the 500 block of North Main Street. Dr. William Dedin Kirk—an art enthusiast—lived above a shoe store on Fifth Avenue and North Main Street. Kirk, who contracted tuberculosis, moved to Hendersonville for its clean, sweet air and established a sanitarium here.

After the Depression years and World War II, downtown Hendersonville declined somewhat until the 1970s, when the one-hundred-foot-wide circuit underwent improvements including angled parking and brick planter boxes. More businesses moved in and visionaries attracted to urban living rented, subleased and purchased living quarters on Main Street.

The Farrars

Contemporary residents Joe H. Farrar, DMD, and his wife Gayle live part time on the second level of the People's National Bank and the adjoining building to the north in the 200 block of Hendersonville's historic Main Street.

"This was an empty shell when we first saw it," Gayle says of her second-story urban residence. "Beyond a padlocked plywood door you could see fire and smoke damage, but I knew from the depths of my soul that we had to have this place."

A view down Main Street, downtown Hendersonville, from atop the Skyland Hotel, 2006.

To transform the space within into an architectural treasure, the Farrars enlisted the services of interior designer Harry Deaton of Tennessee and Paul Taylor Construction Company of Hendersonville for structural concerns.

"Paul Taylor has a great eye for detail," Gayle says. "And we appreciate Harry's skill for blending old, new and personal items."

The People's National Bank Building, completed in 1910, has also housed the People's National-Northwestern Bank merger, First Union Bank and Trust Company, a laundry, the *Hendersonville Times*, the *Times-News* and, presently, law offices on the street level. The imposing neoclassic-style building designed by Richard Sharp Smith in 1899 incorporates two Ionic columns, a dentate cornice and stepped rectangular pediment. Smith was the supervising architect for Asheville's Biltmore Estate and St. Lawrence Basilica. PEOPLE'S NATIONAL BANK brands the granite entablature of the pale yellow brick structure. Local firm Jackson Welding & Supply designed and produced the iron entrance gates.

From Main Street, one enters the Farrars' 4,500-square-foot aerie by way of stairs to behold an open environment of kitchen, formal dining space, family room and living room against time-burnished and faux textures. A palette of reds, greens, cocoa and bone complements exposed brick, original adze-hewn beams and five-inch-wide Brazilian cherry-plank flooring. Designer Deaton's blend of antique and contemporary objects punctuates the light-flooded space; the result is history with style.

"The buildings had windows only on the front and the back," Gayle explains. "To maximize light, we added more windows on the north and south sides, and opened skylights."

Gayle further explained the challenges of bringing two buildings together—a process that lasted eighteen months. During eight of those months, laborers installed Craftsman-style balconies, which are above code with their I-beam anchorage. Further challenges necessitated a crane to move in construction materials and eventually the Farrars' furnishings.

"The construction workers blasted through adjoining walls," Gayle says of blending the structures as one. "We saved material and incorporated it, for instance, in that fireplace over there—which had been a shower stall. We had the mantel made to match the existing beams in the living room."

Concrete walls, masterfully textured and painted, cue colors to the historic brick and wood. Gayle so appreciated the patina of the fire-and-smoke-damaged brick that she had it sealed. "It worked color-wise," she says, "and is part of the building's history."

The kitchen, her husband's domain, glints in salsa red with a verde fire-polished granite island and glazed bone tile countertops. Dr. Farrar is a serious cook. A commercial-grade Dacor range counts among his appliances.

A 1937 Chickering concert grande vies for attention in the Farrars' living room. Gayle earned a BME with a principal in piano at Troy College in Alabama; the piano was an anniversary gift from her husband. Gayle enjoys playing the classics, serving on local boards, volunteering and being a stay-at-home mom for her children, Morgan and Grayson.

Ceilings soar from twelve feet in the back to twenty-two feet at the front. Four skylights brighten the corridors and open spaces, lending grace to original wooden cornices and lintels. Veined and elephant-hide nap and overlays of textured papers camouflage concrete walls that formerly separated the two buildings.

"There was a six-inch difference in the level of the floors," Gayle explains. "That was another challenge for the construction crew!" Moreover, one building's floors were of concrete, the other's of wood.

A corridor off the great room segues to three bedrooms, four baths, a powder room and a guest suite with full kitchen and dining cove, laundry and private bath. "My mother's quarters, when she visits," Gayle says of the suite.

Accessible by elevator, the rear entry hall features a salsa red patent leather ceiling. An additional balcony graces the back of the home, where the Farrars watch the sun set behind Laurel Park and distant mountains. "And glorious sunrises from the front balconies," Gayle adds.

The Rashes

Up Main Street at #508, Jim and Bonnie Rash have made a home above their Silver Fox Gallery. The Rashes bought the building after moving to Hendersonville from Tryon in May 2004.

"I have always wanted to live in a loft," Bonnie says, "and Jim is open to alternatives. We've gone the suburban executive home route in major cities. It was time to live downtown."

Jim, a traveling manager for King B Brands of Belgium, refers to his Hendersonville loft as a sanctuary. "When at home," he adds, "I can lounge around upstairs and enjoy the history of our home, or I can go downstairs to greet and meet people in the gallery." Bonnie adds, "This is not a boring condo."

The gallery was once a restaurant called Home Food Shop, for fifty years the largest standing family-owned restaurant in North Carolina. The nine-thousand-square-foot building dating from 1888, like the Farrars' residence, was once damaged by fire. In the late nineteenth and early twentieth centuries, the structure, abutting an identical footprint, overlooked a livery stable on the other side.

The Rashes' airy loft environment was formerly crimped with walls when it was an advertising agency about twenty years ago. "First thing we did," says Bonnie, who designed the interior, "was to remove walls. The space was all chopped up, and lofts are all about being open."

Encompassing three thousand square feet, the living space above the gallery glows with natural and artificial light. Glass panels and transom lenses, sconces and track lighting throughout the residence, together with edgy chandeliers fashioned by some of the Rashes' represented artists, lend a play of light to each nook and cove.

Exposed brick—original to the building—sets the tone for alternating six- and four-inch heart-of-pine flooring, glazed Mexican tile and a sisal-look commercial-grade Milliken carpet tile system. Moldings of whitewashed ash with semi-gloss varnish frame the interior doorways. Earth tones of soft greens, purples and terra cotta marry the theme, and touches of contemporary art grace walls and art niches.

Additional features include a guestroom with king-sized bunks for grandchildren and a workout room with sauna.

The home segues smoothly from the downstairs gallery of upscale contemporary art. The Rashes consider the building a "combo space, an incredible bonus, the living space of our dreams." Studio furniture, art glass, sculpture and paintings furnish their loft. A

The second story of the 1910 People's National Bank and an adjoining building are home to Dr. Joe and Gayle Farrar, downtown Hendersonville.

Benjamin Moore palette of Carrington beige, Providence olive and Pittsfield buff accent the natural brick walls and wood tones.

The flow and connectivity of business and residence are conducive to art soirées, which the Rashes stage upstairs to kick off new shows.

"One day we would like to add a green roof," Jim says of his vision for a roof terrace with a wrought-iron spiral staircase to access the garden. He adds, "This structure is square, plumb and solid. The building had a wonderful core when we bought it. We feel the presence of the owners before us. Presently, we are just stewards; one day, this will pass to future visionaries."

In Sync with the Pulse of Main Street

"We have always loved downtown Hendersonville. Over the years, we watched Main Street change a lot," says Gayle Farrar. "We enjoy shopping and eating here—and living in the midst of everything."

Gayle sneaks out at 7:00 each morning and buys breakfast at McFarlan Bake Shop. Around 11:00, she returns to Main Street to buy lunch. The family eats dinner out most every night, and always walks Main after dark.

The Rashes, too, enjoy strolls along Main Street. When Jim is in town, he and Bonnie hit the street early. "We have it practically to ourselves," Bonnie says. "This is like living in a little neighborhood in a major city, but you wander a few blocks beyond and there is no major city."

"This is a city that honors its history," says Jim, "an inviting place with such diversity. There is a real charm of living here."

The Farrars concur. As their quarters on Main Street evolved, friends and colleagues asked—and still ask—why they would want to live downtown. The Farrars answer, "We have no regrets. We just love it here."

JUST FOLKS

\mathcal{T}hey say people make the place. The people of Henderson County—some of them seventh- and eighth-generation descendants of English and Scots-Irish settlers—exemplify the concept of Southern hospitality.* In due course, it did not take long for this newcomer to ingratiate himself into the local culture and social scene. Now, I cannot imagine living anywhere else.

The Appalachians have long been associated with notions of stills and hillbillies. On the contrary, software designers and Olympic gold medalists count among our citizenry, as do best-selling authors, vascular surgeons and serious thespians. Some of these people have lived here for only a few years or are just settling in. Among my favorites are the creative types and the natives, including one of the longest-lived of them.

Louise Howe Bailey

Known fondly in Henderson County as a "local treasure," Louise Howe Bailey's heterogeneous life spans more than nine decades. Blessed with extraordinary intellect, charm and wit, Louise captures the hearts of people from all walks of life. More importantly, she steadfastly chronicles the more interesting facets of the county of her birth, recording oral histories that otherwise might have been lost to the passage of time.

Henderson County history comes naturally to Louise Bailey, a great-great-granddaughter of Judge Mitchell King and great-niece of Dr. Mitchell Campbell King—Judge Mitchell King's son—who built Glenroy (circa 1850, currently the Kenmure Country Club) at Flat Rock.

A graduate of Columbia University in New York with a master's degree in library science, Louise might have pursued a medical career had things been different when she was younger. "If I were a man, I would have been a doctor," she says. "I thought I'd be a lab technician, but was sidetracked into library science."

Born to William Bell White Howe III, a country doctor, Louise married Joseph P. Bailey, also a country doctor. Not surprisingly, one of the Baileys' three sons, Robert, is a physician, while son Joseph Jr. teaches anatomy, general science and physiology at East Henderson High School and Blue Ridge Community College. The Baileys' late son, William, was a camp director.

*According to Henderson County historian Jennie Jones Giles, Scots who settled in the Carolinas, frequently referred to as Scots-Irish, were chiefly of Scottish blood. Before immigrating to America, they passed through Ireland, sometimes delaying there before continuing on to America—and hence the "Scots-Irish" handle.

As a young woman, Louise taught at Edgefield High School in South Carolina and later worked as a supervisor of library science majors at her undergraduate alma mater, Winthrop University (at that time Winthrop College, where she majored in biology) at Rock Hill.

In her thirties, Louise met Carl Sandburg while riding horseback across his property in Flat Rock. "Can you type with as many as two fingers?" Sandburg asked her. "And if so, would you be available in the afternoons to help me get *Remembrance Rock* to the publisher on time?"

"Well, two fingers grossly exaggerated my experience on the typewriter," Louise confesses. "We weren't required to use typewriters when I was in school." Nevertheless, Louise accepted the job. She sorted and transcribed a flurry of notes jotted on scraps of paper and typed them for Sandburg's publisher. During the course of her association with the celebrated author and poet laureate, Louise enjoyed private concerts as Sandburg strummed his guitar and sang selections from his *The American Songbag*.

Henderson County historian Louise H. Bailey rides atop the Hendersonville *Times-News* float in the 2006 North Carolina Apple Festival Parade. In the background are the McClintock Chime Clock and the State Trust Co. Building.

Once, while dining at the Bailey home, Sandburg helped himself to a side dish of green beans until there were none left. He then asked the family never to speak of what he was about to do, whereupon he lifted the vessel to his mouth and drank the pot liquor. "I never told anyone about it while Carl was living," Louise says.

Louise's introduction to the world of published writing rapidly evolved beyond the role of typist. The year 2007 marked the fortieth year of her column "Along the Ridges" with the Hendersonville *Times-News*. Her musings include poignant historical nuggets and childhood memories in a more rustic Henderson County, all delivered prosaically, many times with a pinch of her special brand of humor.

Author of nine books on local history, Louise has spoken to countless audiences on historical subjects. The Louise Bailey Archives at Blue Ridge Community College house documents and memorabilia pertinent to her literary and cultural contributions. She has starred in a documentary film about Henderson County, and a play has been written about her life. In her nineties, she still conducts tours of her beloved St. John in the Wilderness Church. Amazingly, she is also a cancer survivor.

In short, one would be privileged to know such an icon as Louise Bailey. I had no idea Western North Carolina held in store for me this special kinship.

Serendipity

Transition can be tough, especially when a change of address spans nearly three thousand miles. In spite of that, when Southern California outgrew its charm and Western North Carolina beckoned me, friends and colleagues ridiculed my whim, insisting I would never leave the Golden State. Then, when the Bekins truck pulled up, I too wondered about my decision— about adapting to an unfamiliar culture, about fitting in and making new friends.

Scarcely settled into my new digs in rural Hendersonville, I strolled across my property one mild winter day when a female voice called out. I turned to find an attractive woman who introduced herself as Libby Ward. She handed me a banana pudding still warm from the oven and crowned with picture-perfect meringue. "I'm your next-door neighbor," she said. "Welcome to the neighborhood."

Carl Sandburg at Connemara, 1948. *Courtesy of Henderson County Genealogical & Historical Society Inc. Photo by Lucile Stepp Ray.*

For forty-five minutes, we spoke on the street, passing the heavy confection back and forth. When Libby seemed satisfied with her interrogation—having learned the major details of her new neighbor's life—she suggested I meet Louise Bailey.

Smiling at my sense of puzzlement, Libby enlightened me. "A local columnist, historian, author and a very interesting lady. Your kind of person."

"How does one get to know such a celebrity?" I asked.

"She's down to earth. Give her a call; ask her to lunch."

I did, and Mrs. Bailey agreed to meet me at Sinbad Restaurant in downtown Hendersonville.

The Hot Seat

With eyes twinkling as though we were long-lost friends or relatives, the tall, white-haired woman in Sinbad's foyer said, "You must be Terry."

As we were ushered to our table, the sprightly nonagenarian strode confidently with the poise young girls once learned as they balanced books on their heads.

Before we ordered our luncheon selections, Louise caught me off guard when she asked where I went to church. I had never been asked such a question in California—a state where some rebuke people of faith. I wondered if my answer would jeopardize a possible friendship with Henderson County's venerable savant. Nevertheless, I blurted out the name of the church.

"How do you like it?"

"It's so big, impersonal…"

"Then you should come to St. John in the Wilderness. We call it the 'huggy-kissy' church."

I had already visited her church, admiring its antiquity and physical attributes—and if the congregation were friendly, all the better.

Fearing our dialogue would next turn to politics, I was relieved when the topic segued to history, the glories of nature and the reasons I had moved to the region. In the course of our repast, I was impressed not only by Louise's knowledge, but also by her sense of humor. I wondered what she thought of me.

"You're just as common as the rest of us," she said as we concluded our meal, then added, "I am paying you a compliment, young man. That's what Carl Sandburg would have said to someone he liked."

On our way out, I offered Louise my elbow. When she took it, I picked up my pace in order to keep up with her as she impelled me toward the parking lot.

See You in Church?

When I stepped through the narthex of St. John in the Wilderness, my eyes scanned the pews. When I spotted Louise, she was already following me with her eyes and her blithe constitution invited me to join her. That was a few years ago. Since then, Louise and I sustain a little joke that began the first Sunday I missed a service at St. John in the Wilderness.

The *Times-News* had printed a small ad for Etowah Baptist Church, announcing a special guest: Donna Douglas, who played Elly May Clampett on television's *The Beverly Hillbillies* (1962–71, CBS). Miss Douglas—by then an evangelist—would deliver the homily. Having been a fan of the sitcom and the enchanting Elly May, I couldn't resist a foray to Etowah. When I returned home, my telephone blinked with a message from Louise: "This is your conscience calling. There was a very empty spot in our pew today."

Weeks later, as an engagement would occupy my customary hour to attend, I went to the earlier service at St. John. Wanting not to risk a guilty conscience, I pressed a Post-it note to the pew-back facing Louise's usual space in "our pew." On the note, I scribbled that I had already been there that day. Since then, Louise and I tease each other about our consciences, should either one of us miss an 11:00 a.m. service.

Parlor Games

Louise Bailey lives in the house her father built in 1926—a stalwart building of granite standing in the midst of fifty wooded acres known as Laurelhurst in the heart of Flat Rock. Our friendship continued to blossom in that home as we sipped tea, nibbled sweets and discussed subjects from A to Z.

One of our heated debates involved cicadas and katydids. I'd always believed the latter buzzed diurnally in the sweltering summer heat. As a newcomer, I was yet to learn that katydids, instead, strum their leg hairs against each other after dusk, filling the woods with a strident concerto. Louise insisted that cicadas make a buzzing sound during daytime hours, while katydids provide the nocturnal symphonies. Stubbornly, I disagreed, until a probing of zoological texts proved me wrong.

Through Louise's library windows, we watch many a bird. From purple finches and rose-breasted grosbeaks to goldfinches, cardinals and towhees, Louise's feeders are never in want of a feathered spectrum.

The Bailey acreage, rife with wildflowers, fulfills another mutual hobby. I can always count on Louise phoning me when something unusual springs up on her property. "Come see my Indian pipes," she'll say; or "My sweet shrubs are abloom. Have you ever seen their brownish-burgundy flowers?"

One year, on the occasion of my birthday, Louise invited me for tea. During our visit, we spoke of our church and one of its founders, Susan Baring. Louise then showed me a photograph of what appeared to be an apparition wafting through the churchyard. "Susan Baring's ghost," Louise said with conviction. As I scrutinized the image, she chuckled and admitted, "The photographer was smoking a cigarette."

Before I took leave, Louise invited me into her kitchen. "This is for you," she said, pointing at a three-layer, ten-inch-tall German chocolate cake. "I baked it myself." It was delicious, every moist crumb of it.

A practical and frugal woman, Louise has tutored me in stress-free living. "If you want to live as long as I have," she explains, "you won't worry about such things as all those leaves on your lawn. The wind will take care of them." On a similar note, when her car requires washing, she backs it out of the carport on rainy days.

A favorite reminiscence of our visits entails my acquaintance with Gullah or "Sea Island Creole"—the nearly lost language of Angolan slaves who labored for South Carolina coastal planters. One afternoon, Louise played for me a 33rpm album of Gullah readings. Then, sensing my incomprehension, she dashed to her library, returning with a book, flipping through the pages as she strode. She placed the open book in front of me, pointing to the words resounding from the phonograph. Reading the words helped me follow along with the narrator and appreciate a dialect combining Old English and Angolan.

Beyond the Parlor

With Louise, I have haunted historic homes in Flat Rock, including her ancestral Argyle. Always the trooper, Louise is a willing companion, whether for a hike in the woods or up narrow flights of stairs to explore the second or third story of a creaking manse.

During the devastating ice storm of 2005, the power returned to many Henderson County neighborhoods before it was restored in Flat Rock. When the lights and heat came back on in my neighborhood, I invited Louise to stay at my home. When she declined, I drove to her home, dodging fallen trees, limbs and electrical cables. I found her bundled in woolens and as cold as a stone. "Pack your overnight things," I insisted. "You're coming with me."

What a joy it was, during her two-day stay, to hear more accounts of Henderson County's past delivered in her soothing, alto voice. Less enjoyable, perhaps, were our Scrabble

games—after which, when I told others she had beaten me, she retorted, "Beat him? I cleaned the floor with him!"

Y'all Come

Since the mid-1930s, Louise has attended the annual homecoming at Cedar Springs Baptist Church in the Green River section of Henderson County. "I feel a loyalty to the people there," she says. Louise inherited seventy-five acres in the area, a camping and hunting sanctuary owned previously by her father.

Since I have known Louise, I have tagged along to the Cedar Springs homecoming, always enjoying the Reverends Tinsley or Chandler's fiery sermons, the congeniality of the congregation and the tasty home-cooked fare served afterward at the fellowship hall. Congregants treat Louise like a queen, and to accompany her to the festivities is like being in the entourage of royalty.

Meeting the Local Gentry

About local culture and Southern customs, I have learned much from Louise Bailey. What's more, she has introduced me to the crème de Flat Rock. Amazing, my earlier concern about making acquaintances and friends in my new hometown. Thanks to Louise, it did not take long to feel as though I belonged.

I have never known Louise to turn down an invitation, and she is invited to practically every social function in the region. In her company, I have attended all from barbecues and private dinner parties to musicales, symphony concerts, stage plays and fancy fundraisers—forever learning and harvesting new friends along the way. Always an inspiration, a friend, a mentor and mother-confessor, Louise Bailey is indeed a remarkable woman.

The Reverend Dr. George Alexander Jones

Champions of perennial lifestyles emphasize the benefits of remaining active, both physically and mentally. One could say Henderson County's Dr. George A. Jones and Louise H. Bailey exemplify this formula for longevity, for there is never a static moment in either of their lives. Bailey's and Jones's calendars fill as though they were sedulous executives, but the two perform tasks more vital than swinging business deals. Bailey gathers and reports on oral histories of the region, thus helping to preserve our cultural heritage. Jones rescues buildings—including an entire neighborhood of them.

Deeply Rooted

The inveterate George A. Jones is a sixth-generation descendant of Henderson County pioneers. His ancestry includes the Justus and Pace families, which remain as prominent names in the county. Judge Columbus Mills Pace (1845–1925) was Jones's great-uncle. Judge Pace's home (Locust Lodge) may be seen at 813 Fifth Avenue West in Hendersonville.

Captain Robert Jones (1794–1890)—one of Henderson County's first justices of the Court of Pleas and Quarter Sessions—was George A. Jones's great-great-great-grandfather.

The Reverend Dr. George Alexander Jones.

The sixth of eight children, George was born in Saluda in 1920 to Uel G. Jones (a rural mail carrier) and Martha Constant Jones (a substitute teacher). Jones knew early on what he wanted. "An education," he says emphatically.

The Shaping of a Great Man

Upon entering college, Jones had not chosen a major focus of study, but he recalls always yearning to learn history. "History is the story of the human race," he says.

During his college years, a spiritual conviction led Jones to the ministry. He earned his undergraduate degrees in history, general science and education from Lenoir-Rhyne College at Hickory, and his master's in theology and his doctorate in history from Southern Baptist Theological Seminary in Louisville, Kentucky. In a church near Louisville, Jones met Evelyn Masden, a piano player and teacher. A year later, the two were married.

Jones served as an army chaplain during World War II and the Joneses moved to Beaufort, South Carolina, in 1955.

Stepping Up to the Plate

During his fifteen-year tenure as a minister in Beaufort, Jones became concerned with the town's deteriorating neighborhood of mansions dating from the early 1700s. "Summer homes of plantation owners," Jones explains, "affording them the benefit of ocean breezes."

The historic mansions stood in disrepair, divided and used largely as low-rent apartments for navy men and marines stationed temporarily at Beaufort.

"I put myself in a position to do something about this," Jones says. "If you want to get something done, you go to the core. And to effect change, you work from within the politics."

After studying the situation, Jones found an angle for cutting through the political red tape and ultimately restoring the neighborhood. South Carolina's Governor Robert McNair, a good friend of Jones's, had appointed a city commission and asked Jones to chair it. When the governor met all of Jones's conditions, Jones agreed to be chairman. He then asked McNair, "What is the highest historical level we can zone the district?"

Governor McNair allowed "Zone 1" status, requiring the property owners to restore the neighborhood with an eye to historical integrity. Jones went on to chair the planning and zoning commission for Beaufort County.

There were no laws on the books forcing the planning and zoning commission to report to a city or county council. "Because of that loophole," Jones says, "I was able to get the planning and zoning approved—to save and properly restore the historic neighborhood."

Had Jones not stepped up to the plate, "greed would have destroyed the neighborhood," he says. "It would have become a commercial jungle, as we see in other areas." Impressive, considering Beaufort's size: geographically three times larger and with two times the population of Henderson County.

Having preserved a part of Beaufort only whet Jones's appetite for more of the same. "Each time I traveled abroad and saw the old buildings still standing, they spoke to me about the integrity of a culture," he says.

Jones also helped start the United Way in Beaufort, spearheaded desegregation, formed the Human Relations Council and prompted Beaufort's mayor and council members to raise the pay of city workers to minimum wage. "They were earning only one dollar an hour," he says.

"Beaufort is the only city of any size in South Carolina that never experienced a riot or even a protest demonstration," Jones proudly reports. He further explains his push for peace and his involvement with city affairs after the assassination of Reverend Dr. Martin Luther King Jr.

"Black leaders had asked for school closings on the day of King's funeral," Jones says. "With some difficulty, we accomplished that. We organized a memorial service on Beaufort's Freedom Mall the Sunday following King's funeral."

During his years of work for desegregation, Jones was threatened many times by the Ku Klux Klan. But he kept pushing. "It's the Christian and American democratic thing to do; the right thing to do," he says.

Further Callings

In 1970, the Joneses moved to Cincinnati, where George served as the executive director of the Northern Kentucky Baptist Association. During that stint, he delivered the invocations for four visiting presidents: Nixon, Ford, Reagan and George H.W. Bush.

Jones thought he had retired in 1985; instead, he and Evelyn were called to Germany, where he served as pastor for an English-speaking congregation at a Baptist church in West Berlin. While in Germany, the Joneses made mission trips to England, Wales and Scotland.

Jones's retirement years found him working also on an advance team for Billy Graham's first crusade in Russia. When asked for his thoughts on Graham, Jones says, "A remarkable man." He adds, "Throughout history, giants have arisen during different periods, and Billy Graham is certainly a giant of our times."

The Joneses have also traveled with Christian delegations to Asia and the Middle East.

Home Again

In 2003, Jones was instrumental in forming the Henderson County Historic Courthouse Corporation to ensure the restoration and survival of Hendersonville's landmark 1905 courthouse. Jones also actively pursues funding and grants for the multi-million-dollar project.

At every opportunity, Jones speaks out about preservation, including the hopeful salvation of Hendersonville's Grey Hosiery Mill. He does not approve of a local organization's plans to raze the historic mill and build a performing arts center on the property. "The old mill would make a fine museum space," Jones says, "for vintage automobiles, for instance. They can build the arts center somewhere else."

Jones feels strongly about saving Western North Carolina's farmland and orchards from residential development. "If this continues," he says, "we will lose our historic character altogether."

Multi-faceted

Saving tangible history is only one of Jones's passions. Foremost, he is a Baptist preacher. He teaches a Bible class for men at Hendersonville's First Baptist Church. His board positions include—besides the Henderson County Historic Courthouse Corporation—the Henderson County Apple Festival and Farm City Day (the annual celebration of the county's agricultural enterprises). Jones also served nine years—the maximum term—on the board of Hendersonville's Pardee Hospital.

Jones is perhaps best known around Hendersonville as the president of the Henderson County Genealogical & Historical Society Inc., which he helped found in 1983. In coat and tie, he arrives by 9:00 a.m. sharp each Monday through Friday at the society's headquarters on Main Street and Fourth Avenue, where he oversees the records and answers the queries of fellow historians and other interested parties.

In his spare time, Jones fulfills a personal goal of "reading one large book per week." He and Evelyn have three daughters, one son, five grandchildren and three great-grandchildren. "They all give me books," he says. Jones has written two books and is collaborating with one of his daughters on another manuscript.

Asked about mentors, Jones thoughtfully gazes heavenward. Following a protracted silence, he speaks. "I don't know that I have any. There are so many that I haven't bothered to select just one—or more." Another silence; then,

> *William Barclay [1907–1978], a theologian and professor of Divinity and Biblical Criticism at Scotland's Glasgow University. Barclay wrote and sold more books than anyone I have known. Having met him and attended his lectures, I am in awe of him.*
> *And John Sherman Cooper, a Kentucky senator…We are definitely a part of all we have met.*

Over the years, the inspirational George A. Jones has become a mentor for others. We in Henderson County are blessed to have him as part of our rich heritage.

Scott Treadway

At Flat Rock Playhouse performances, Scott Treadway's portrayals from Arnold Crouch in *Not Now, Darling* to Bob Schroeder in *Beau Jest* have his audiences in stitches, even rolling in the aisles. His skill to amuse comes naturally.

From early childhood in Johnson City, Tennessee, Treadway tapped his inherent propensity for evoking laughter, entertaining his sister with hand puppets and marionettes. "She's the first person I made laugh," he says of his late sister, who was afflicted with cerebral palsy.

Audience acclaim was irrepressible. "So, I started building stages and sound systems, designing the lighting and special effects for my puppet shows," Treadway recounts with

a twinkle in his doe-like eyes. "And when my performances really caught on, I charged the neighborhood kids admission."

As a youngster, Treadway enjoyed watching *The Carol Burnett Show*. "Not only for the excellent comedy," he says. "But I admired the teamwork."

Treadway earned his BA in theatre performance at the University of Tennessee and played his first leading roles at Miami's Ruth Foreman Theatre, Boca Raton's Caldwell Theatre and Knoxville's Clarence Brown Theatre.

Treadway arrived at Flat Rock as a college freshman in 1984. In 1985, he starred as Eugene in *Look Homeward, Angel*—his first leading role at the playhouse. At that point, the young comic questioned his career decision, but soon discovered he was learning more at the playhouse than he was at school. He paid his tuition with

Scott Treadway takes a breather between rehearsals at Flat Rock Playhouse.

money earned from acting in union shows, and by the time he was a sophomore, Treadway was a professional actor with an equity card. Of mentors, he avows W.C. "Mutt" Burton (1907–1995), a thirty-year veteran of Flat Rock Playhouse.

At forty-one, the rubber-faced Treadway embarked on his twenty-fourth season with the playhouse. His talents transcend his comedic style, as he has also spearheaded playhouse fundraising. As associate artistic director, he guides some of the performances and photographs stage productions for promoting the playhouse in ads and playbills. Treadway thrives on teamwork and finds its epitome at Flat Rock Playhouse. "What I love most is the process of helping select and cast the shows," he adds.

Broadway Bound?

Hollywood moguls and Broadway producers have endeavored, unsuccessfully, to woo Scott away from his beloved Flat Rock.

"Broadway is the pinnacle," he says. "And I love New York, but…"

At the top of his "buts" list: "Here in Flat Rock, I am able to lead a normal, functional life and have a top-notch theatrical career as well," he says.

Scott mentions that doing a show for more than a few months—the natural order of things on Broadway—would bore him. Though Scott maintains a national stage presence, having performed in North Carolina, Florida and Tennessee, he prefers living year-round in Flat Rock—especially since the curtains opened on a new scene in 2004 with the birth of his daughter, Ava Marie, who plays the starring role in his life.

The State Theatre of North Carolina

The history of Flat Rock Playhouse dates back to a vision of the British actor-director Robroy Farquhar (1911–1983). Known as the Vagabond Players, Farquhar's troupe read

and acted in the mid-1930s in New York; Bedford Springs, Pennsylvania; and Miami before landing in Flat Rock.

Farquhar's dream of a summer theatre came true in 1940, when the Vagabonds opened their new venue in an antiquated gristmill in Flat Rock on the edge of Highland Lake Camp. It became known as the Old Mill Playhouse. The war years took Farquhar overseas after he was drafted in 1941. By 1946, when he reorganized his Vagabonds, the mill property had been sold. A vacant schoolhouse on Lake Summit became available and success soon followed, leaving the Vagabonds with other dilemmas: a stage too small for certain productions and limited seating capacity.

By 1952, Farquhar was staging productions in a circus tent on the site of the great flat rock adjacent to the Rockworth boardinghouse (also called The Rock and Lowndes Place, circa 1884). The same year, Farquhar organized the Vagabond School of the Drama. He had a flair for socializing and fundraising, and in 1956 the players eschewed the big top when their "Raise-the-Roof" campaign provided the necessary funding to build a shed-theatre adjoining the stage house. Farquhar's "Be a Brick—Buy a Brick" campaign garnered the funds necessary to fulfill his ultimate vision: the Flat Rock Playhouse venue of today, which was built in 1959.

In 1961, an act of the North Carolina Assembly officially designated Flat Rock Playhouse as the State Theatre of North Carolina. Over the years, more than four million theatergoers have attended first-rate performances at Flat Rock Playhouse.

Steady growth of Farquhar's Vagabond School of the Drama includes its increasingly popular Apprentice Company, which has enabled hundreds of college students to train with the professional company, and the YouTheatre program, which provides theatrical training for youngsters in grades kindergarten through twelve.

Since 1980, Robroy's son, Robin R. Farquhar, has held the position of executive and artistic director for the playhouse, which has hosted such greats as Carl Sandburg, Burt Reynolds, June Havoc, Dom DeLuise, Elizabeth Ashley and Charles Nelson Reilly—and Scott Treadway.

Tom Reeves

The gods, likening themselves to all kinds of strangers,
go in various disguises from city to city,
observing the wrongdoing and the righteousness of men.
—*Homer,* Odyssey *XV, l.72*

Not long ago, a raven soared across a crimson field branding a brick wall at the corner of Hendersonville's Fourth Avenue and an alleyway known as Wall Street. Artist Tom Reeves fancied the ambiguity of the raven for his former studio-gallery. "The raven is a beautiful bird," says Reeves, "a powerful symbol in various cultures, representing evil or wisdom."

In 2006, Tom Reeves closed ravenstudio, a working gallery where he painted and wrote. Much of his paintings are in oils, though he occasionally composes with acrylics, works with pen and ink and draws in all media.

"I paint humanity," Reeves says—a tour de force evidenced in a series of symbolic portraits such as *odyssey five*, a developing frieze of faces forming a Homeric site in shapes, texture and movement. Under Reeves's skillful brush, ethereal faces—including Penelope's—emerge from skeins of color. "I enjoy the aspect of discovery in painting...rather than having a plan," Reeves adds.

Unexpected strokes and patches of canvas show through, exposing reality, indulging the beholder with latitude for speculation as drama flows between the pieces. Reeves's interpretations of Homer's verse

Local artist Tom Reeves.

accompany each of the images. "I'm driven through the process," says Reeves, "an interesting dynamic that keeps me moving toward an unknown goal."

Meditative, never overpowering, reemerging artist Tom Reeves's portraits pulsate with metaphor. Whereas some of the canvases may appear unfinished, the keen onlooker completes the work contemplatively. Reeves's studies are valid art forms, and the symbolism is impossible to avoid.

> *Sink into being, into the water,*
> *Fill your lungs, remove yourself, and continue,*
> *The body remains,*
> *Sink into the trough with the heaviness of the body,*
> *Let the body remain,*
> *Then understand peace because of the journey,*
> *Movement in her.*
> *—Tom Reeves, "penelope"*

Born in Charleston, South Carolina, Reeves moved on to Charlottesville, Virginia, and Philadelphia before settling in Hendersonville. He studied at Pennsylvania Academy of Fine Art and earned an MFA from the University of Pennsylvania, where he trained under Neil Welliver.

Reeves's works count among private collections in Paris, Washington and Philadelphia, where he painted a mural for the University of Pennsylvania Museum. Reeves taught life drawing at the University of Pennsylvania and was involved in several Philadelphia art shows—a prelude to attention in New York, where he believed his approach to art was not appreciated. He soon escaped what he calls "the New York–dominated art world," because,

"as Robert Hughes wrote in *Nothing if Not Critical*, 'The center has shattered and artists have scattered across the country, disgusted with the corrupt nature of big-time art.'"

Reeves says, "Art is a means of revealing balance in the universe. This can be accomplished through chaos or tranquility in the image. The receptive eye opens to the fact that we are the universe, that balance can be achieved."

Painting for many years as he wished to paint, Reeves also worked on a shrimp boat, was a taxi driver, bartender, karate instructor (he earned a black belt in tae kwon do), cartoonist, librarian and a caretaker on an estate. Of these phases of his life, Reeves says, "I created like a madman, painting hundreds of canvases, and one winter I wrote 230 poems."

Tom Reeves accepts commissions and contributes a portion of all his profits to benefit the cause of Shashamane ("Promised Land"), property given by Haile Selassie as a Rastafarian community in Ethiopia. The thirty-five-year-old community is forming Motherland International Relations, with plans to open a hospital.

Angela Hayes

Local audiences perceive seraphic qualities in her evensong and vespers performances. Jazz buffs tap their feet as she belts out tunes accompanied by jazz guitarist Marc Yaxley at Saluda's Purple Onion. And theatergoers enjoy her stage presence as she sings such roles as Maria in *The Sound of Music* at Greenville's Peace Center, as Martha Jefferson in the Flat Rock Playhouse production of *1776* and as Cathy in *The Last Five Years* with the Stoneleaf Theatre Festival in Asheville. The voice belongs to Angela Hayes, a Western North Carolina soprano and stage actress destined for fame.

Vance Reese, PhD, adjunct professor of music at Brevard College, says of Angela, "After hearing Angela Hayes sing Liszt art songs and some opera arias, I coached her for the role of Cathy in *The Last Five Years*, a role involving several different, contrasting vocal styles. Her versatility is amazing, her work ethic strong and her spirituality deep. I would pay good money to see her on the stage."

An Angel in Our Midst
Blessed with the visage of a goddess and the timbre of an angel, twenty-something Angela Hayes is as unassuming as Hestia—the Greek deity of hearth and home. Moreover, this consummate ingenue who earned a master's degree in vocal performance and speaks four languages was born right here in Hendersonville.

One of three daughters born to Thomas and Cynthia Hayes of Saluda, North Carolina, Angela attended Faith Academy, currently known as Hendersonville Christian School, in grades one through five and ten through twelve. Between, she was home-schooled.

Before her college years, Hayes interned with Flat Rock Playhouse's YouTheatre. As an undergraduate, she was a chorus member at the playhouse and played Angel #3 in *The Littlest Angel*.

Flat Rock Playhouse actor and associate artistic director Scott Treadway says that Hayes is "a perfect example of talent, beauty and incredible discipline, she has taken a God-given talent and honed it into an incredibly lovely voice. Angela is a joy to work with, bringing

a great asset to our community and certainly to the playhouse."

At Brevard College, Hayes earned her BA in music with an emphasis in sacred music. Dr. Vance Reese, one of her professors and coaches, says, "Angela Hayes is one of those bright, optimistic, loving and talented persons that happens on the local scene once in a while. I first knew her as a student at Brevard College when I was teaching there. Though she had talent then, her forte has grown considerably in her graduate and post-graduate work."

Hayes moved to Kansas in 2001 and graduated from Wichita State University (WSU) in 2004 with her

Soprano Angela Hayes sings evensong at Hendersonville's St. James Church.

master's degree. She chose WSU for its excellent masters program, where grad students have the advantage of being cast in major roles, unlike other schools offering doctoral degrees—where doctoral candidates would likely win the best roles. Sherry Freund coached and accompanied Hayes at WSU.

"One of my favorite people," Freund says of Hayes. "She proved herself a talented, hard-working, conscientious performer, and, maybe even more importantly, a generous and congenial colleague to her fellow students on and off stage."

Born to Sing

"I remember always singing," says Hayes. "My mom sang me to sleep. She has said I hummed along—before I could talk."

"Nana," her Scots-Irish paternal grandmother Ruby, always sang to Hayes. "Celtic tunes and Appalachian lullabies," Hayes recounts with a reflective smile.

Family-oriented Hayes, who believes her musical talents were absorbed by osmosis—from her Nana and parents—embarked upon a musical career in grade-school plays and talent shows. In a church choir since she was five, Hayes also sang in community choirs, at weddings and receptions. "And I played harmonica when I was seven," she adds. Not until high school did she begin receiving remuneration for her performances.

Roles

Hayes was cast in the lead role of Lauretta in *Music Master*, a chamber opera performed at Opera Kansas in 2004. The same year, at WSU's Miller Concert Hall, she played a lead role as the lily in *Secret Garden* and ensemble roles as Erste Dama in *Die Zauberflöte* ("The Magic Flute") and Casilda in Gilbert and Sullivan's *The Gondoliers*.

While attending WSU, Hayes also starred in the world premiere of *The Nightingale and the Rose*, a romantic chamber opera based on the Oscar Wilde short story. The National Opera

Association premiered the production as part of their 2004 convention in Kansas City. Philip Hagemann, who wrote the opera, worked behind the scenes of the premiere, offering Hayes—at that time a grad student—and fellow performers an opportunity to experience the creative process of a writer.

"I adore Oscar Wilde," Hayes says, "So that was an amazing experience, even though my role was a minor one."

Cast amidst the Lizard, Daisy, Rose Bushes, Nightingale and the Prince, Hayes's name will one day be listed in the opera annals as first to sing the role of composer Hagemann's Butterfly.

Her Inspiration

Emmylou Harris and operatic sopranos Renée Fleming and Dawn Upshaw count among Hayes's artistic models. "My voice-type is more like Upshaw's," she says, "rather than a huge voice. So, I focus on lighter roles. In other words, instead of the countess in *The Marriage of Figaro*, I would be the maid Susannah."

Hayes—who grew up singing folk and bluegrass—explains, "I can belt" (what she defines as "controlled screaming"), but prefers the roles of light-lyric soprano. For her listening pleasure, she enjoys an eclectic range of musical styles from motets, opera and classical to folk, reggae, Asian pop, the Irish rock of U2 and the melancholic quality of Joni Mitchell.

Too Busy for Romance

Self-confident and career-focused, Hayes's head is not easily turned. No dating and no plans for marriage, "unless Superman were to land beside me," the five-foot-ten-inch diva quips. "Well, if he did, I would think about it," she quickly adds.

Asked about the "ideal man," Hayes gazes heavenward with her saucer-sized eyes. She answers softly, "Creative, in a different capacity than mine. Preferably tall…" Largely, Hayes is too busy for romance. "I am not ready to settle down," she adds.

Hayes adores animals and is the companion of two felines, one Siamese and the other an American shorthair. "They are more like dogs than cats," she says.

Between gigs, Hayes works as a nanny for three families. "Nothing will get you over yourself more quickly," she explains, "than working with children." Hayes admires the brutal honesty of children. "Kids aren't conditioned to censor their personal traits, emotions or creative expression."

A Bright Future

Angela Hayes has learned that further rehearsals and training leads to the challenge of getting the roles. "I feel constantly pressured to market myself—especially in this little corner of the world—to be involved in the larger artistic community."

One of Hayes's goals is to perform with Cirque du Soleil. Her aspirations also include singing onstage at Milan's La Scala and London's Covent Garden. Aside from that, she has enjoyed teaching at Flat Rock Playhouse's YouTheatre since September 2005. Hayes has also taught private voice lessons and a group vocal master class of summer apprentices at YouTheatre. "I love helping people find their voices, and will probably always want to teach," she says.

Asked if she would ever consider leaving Western North Carolina, Hayes fleetly replies, "Absolutely. I am open to possibilities—whatever the universe offers."

Betsy Bisson, YouTheatre director at the Flat Rock Playhouse, says of Hayes, "Angela is an incredible talent—her voice is flawless and she makes it all sound so effortless. Add to that her personal stage charisma and work ethic and I can hardly imagine she won't be a star—in the best sense of the word—in the not too distant future."

The universe offered our hometown songstress an opportunity abroad. In September 2006, Hayes embarked for Italy to further her Italian studies and to work with opera coach and accompanist Roberta Ferrari of Teatro la Fenice in Treviso, one of Italy's oldest opera houses.

Bonnie Fox

Bonnie Fox fashions custom garments from scraps with a past. Since childhood, Fox has collected classic and latest styled clothing, together with yards and bolts of forgotten-but-seductive pieces. Into these vintage fabrics, she breathes new life; the result, a capricious collection called Déjà Vie ("already lived").

Bonnie Beckwith was born in Hendersonville in 1984. In 2002, she married local artist Travis Fox. Talent runs in Bonnie's family; her sister, Jennie Vargas, is a skillful jeweler.

Sartorial Prodigy

"I began sewing by hand when I was eight years old," Fox says, "and first used a sewing machine at sixteen. When I was three, I decided I didn't want my mother to dress me, so I either made my own clothes or had a lot of input into what was made for me."

Fox took sewing classes with her mother, "only to learn the rules, so I could break them," she says with a gleam. She broke the rules on her Barbie, restyling the doll's wardrobe. "I even cut her hair," Fox says.

Fox's line of signature restyled dresses, skirts and tops is available at Hendersonville's Two Chicks Boutique.

Two Chicks and a Fox

Longtime friends Bev Satterfield and Connie Williams co-own Two Chicks Boutique on the corner of Church Street and Third Avenue, purveying gently and scarcely used designer attire for women. Satterfield and Williams met while working in the insurance business, and for eight years dreamed of owning a boutique for women. Their vision became a reality in 2005 when they opened Two Chicks in Hendersonville.

Bonnie Beckwith Fox with one of her creations.

Satterfield, a Hendersonville native, and Williams, formerly of Jacksonville, Florida, offer ready-to-wear outfits by Ralph Lauren, Calvin Klein, Banana Republic, The Limited and local designers. The high-end designer collection includes fashions by Bonnie Fox and jewelry by Jennie Vargas.

"One of Bonnie's designs," says Satterfield, "was snatched up by a customer the first day we had it in the shop. We hadn't even displayed it!" The hot ticket item was a slinky dress Fox called "Orange Dreamsicle."

Déjà Vie—Reincarnated Raiment

Fox speaks of her own collection:

> *Each garment is a collage of scraps from both vintage and recent clothing; scraps that have already lived as parts of other garments. Each has a past and with each one, I imagine what the original may have looked like, when it was made, who wore it, to which places.*
>
> *I admire vintage fabrics and enjoy imagining the people who were associated with them. Seeking to honor these remnants of the past, I give them a future in my designs.*
>
> *The spirit of Déjà Vie is time and timelessness—exemplifying the concept that every scrap of time is a valuable part of the human experience. Each finished garment is a balance of retro and futuristic style, neither limited to nor defined by any period.*

What Goes Around Comes Around

Fox is bright, resourceful and creative. "Most styles out there are so boring," she says, "because everyone is wearing them." Therefore, she designs togs for those who share a kindred sense of fashion. Her target customer is not limited to an age bracket, but rather to women with a sense of whimsy and free-spiritedness. "A woman with a strong sense of self, who knows how to express herself confidently," Fox adds.

Asked to describe the style of her line of clothing, Fox replies, "I design pieces that I would feel comfortable wearing. For the most part, that's a retro mélange of the past with a 'modern-alien-2050 look.'" She adds, "Or 'post-apocalyptic-survivor'—what some would call the 'Lexington Avenue' or 'Asheville'—look."

"Color-wise," Fox says, "I use twilight hues: a medley of lavenders, mint green, blues; and rainy-day colors: grays, silvers and black. I occasionally use a few splashes of neon, but I prefer to keep the palette neutral and subdued."

Fox's Déjà Vie originals incorporate fabrics custom dyed by local artist Elissa Merrill, whose dying techniques include batik and *shibori*. The latter method involves dipping and then knotting fabric around lengths of bamboo.

Fox incorporates functionality into her line. "I design clothes that are easy to get into and out of. Some designer dresses can be fabulous and at the same time, difficult to don and take off."

Thought, effort and love are key elements in the evolution of Déjà Vie wearable art. Fox, like many artists, has a strong connectivity with her art. "I sometimes wish I could screen potential customers," she says, laughingly. "Because I feel close to my designs, I would like to know that they find good homes."

Bonnie Fox is making her mark in the local couture scene. Her fresh designs assuredly make a statement, and anyone wearing a Fox original should be prepared to be stopped on the street.

Mountain Traditions

When was the last time you saw a gumdrop tree, a jar of moonshine jelly or a deer or rabbit fashioned from a hornet's nest? Have you ever eaten country ham and biscuits with sausage gravy prepared on a wood-burning cookstove? Munched an apple fresh from the tree? Heard idioms like "gwuhpair" (go up there) and "ugly as a mud dobber" (dauber)? Words such as "Chuesday" for Tuesday and "mought" for might? Much of this and more is customary at the Henderson County Curb Market, where one finds plants and flowers, old-timey crafts and comestibles—and the plumb nicest people around.

Concerts and dancing in the streets span the generations in Hendersonville, and although "Bearfootin'" has entertained spectators for only five years, this installation of bears on Main Street is an integral part of the local arts and crafts scene.

Joseph Bailey with the Montreat Scottish Pipes and Drums.

In celebration of the season and honoring the county's agricultural heritage, thousands of tulips greet spectators on Hendersonville's Main Street each spring. Come autumn, leaf peepers flock to these mountains to ogle some of the fieriest color in the East.

As in other parts of the New World, Appalachia's early pioneers sought freedom to worship as they chose. By the early 1920s, Americans distinguished this region and parts beyond as "the Bible Belt," in view of its preponderance of Baptist churches. What began as simple log structures have ultimately run the gamut of worshipful places from clapboard-sheathed to brick and stone, crowned with soaring spires and towers—and representing the spectrum of creeds.

The Hendersonville–Flat Rock community embodies a multifaceted heritage dating back hundreds of years. What a delight it is to discover peerless cultural aspects in a world inclined toward homogenization.

Henderson County Curb Market

I enjoy watching things grow, but what I like best about farming is that I am able to put food on people's tables.
—Hubert Thompson, vendor, Henderson County Curb Market

Farmers have been called the backbone of American agriculture; one might even say the backbone of America. Tragically, as populations continue to boom, traditional agronomy gives way to government-sponsored farming, mergers, acquisitions and similar bottom-line-driven deportment.

I was blessed to have known all four of my grandparents and three great-grandparents, some of them immigrants, all of them farmers. Back then, I sensed only the pleasing aspects of farming, not realizing the grind, the long hours, the odds of crop failure and livestock disease. Bossies' limpid brown eyes, colossal sows nursing pink youngsters, shaggy-haired horses and waving fields of golden oats, wheat and corn charmed this towheaded youngster in Wisconsin. I overlooked my grandparents' callused and chafed skin and shrugged off the protracted sigh of a grandfather as he sank into his rocker at sundown.

My salt-of-the-earth ancestors were reverent, honest, kind people. I recall grandmothers warm with perspiration and fragrant of lavender toilet water and home-baked bread. A grandfather taught me to draw and played dominos with me when he could have been napping. A great-grandpa fiddled and great-grandma played her pump organ while my sister and I do-si-doed in their front parlor. And my dad's folks—retired from farming—took me fishing when it was my turn behind a brigade of siblings and cousins.

With the passing of my forebears and others of their vintage, so seemed the erosion of virtues like generosity, humility and deals made with handshakes. On the other hand, is it that I had spent too many years away from the farm? The latter must be so, for I find today old-fashioned values and God-fearing people right here in Hendersonville—gathered in abundance at the Henderson County Curb Market.

A Bit of Curb Market History

A co-op of one hundred Henderson County families known as the Curb Market dates to June 1924, when seven vendor-couples sold goods from tables under the shelter of wagon umbrellas. The location was a city-owned lot on Main Street between Fourth and Fifth Avenues. This brainchild of Frank L. FitzSimons Sr. was shepherded by Noah Hollowell, a civic and religious leader and owner and publisher of the *Hendersonville News*.

By 1926, the market's success prompted a move to a building on King Street, near Hendersonville's present-day chamber of commerce. The operation again moved, in the late 1930s, to a lot next to a wood yard on South Church Street and First Avenue; in 1941 to a wooden structure on the same corner; and in 1953 to its current brick building, which replaced the wooden edifice. Today, 137 selling spaces occupy the market where a few vendors are third- and fourth-generation descendants of the early 1900s merchants. Curb Market history includes a gallows on the Church Street property—a convenient location, considering its proximity to the old courthouse.

Frank L. FitzSimons Sr. wrote of a gallows incident in *From the Banks of the Oklawaha*: "The three men [Columbus and Govan Adair and Martin Baynard] were taken back to the old county jail behind the courthouse to be kept while the gallows was being built on Church Street where the Curb Market now stands. From their cell windows, the three men could see the construction taking place."

Bylaws of the nonprofit Curb Market state that vendors must be Henderson County residents and all merchandise must have been exclusively produced in the county.

All fairly priced, Curb Market merchandise ranges from crisp produce to flowers and plants, dairy products and eggs, baked goods, pickles and relishes, honey, jams and jellies.

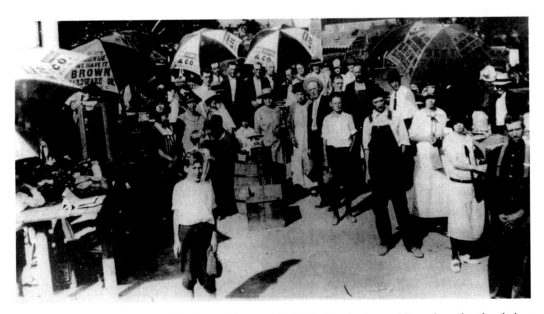

In its early days (circa 1924), Henderson County Curb Market vendors sold goods under the shelter of wagon umbrellas on a Main Street lot between Fourth and Fifth Avenues. *Courtesy of Pat Walker, board member, Henderson County Curb Market.*

Handcrafted gifts and curios include birdhouses, wreaths, quilts and afghans, aprons, rag rugs, table linens, dolls, folk toys and walking sticks.

The Mettle of Farmers

When I moved to Hendersonville from California in late January 2004, the pangs of homesickness quickly took flight as I made new friends at the Curb Market. I felt as though I had time-warped back to 1950s Wisconsin, perceiving the persona and values of my ancestors in many of the vendors.

Entering the market from the parking lot on the northeast corner and proceeding left, Tava Carter and her mother, Louise Guice Orr, greet with welcoming smiles. These ladies sell such delectables as pound cakes, lemon-poppy-seed muffins, cookies and sheet cakes. Next in the aisle, on the left, is the consummate gentlemen Hubert Thompson, who—in his own words—has "never met a stranger" and refers to himself as "the Jed Clampett of Hendersonville." Mr. Thompson's jellies range from elderberry and wild plum to scuppernong, wild huckleberry and rhubarb. Thompson's more unusual comfits include garlic, nuclear and moonshine. Thompson snickers as he admits, "We don't use moonshine, 'cause it's illegal. We use a little wine."

Next in line, Marion Duspiva sells fanciful crocheted and knitted wares, including doll clothes, coasters, door hangers and more. Dewitt and Louise Hill's stall cozies up to Mrs. Duspiva's. On each visit to the market, I make a point of browsing Mrs. Hill's plants, many of which have found their way to my woodland garden. A descendant of Hiram King and one of thirteen children, Mrs. Hill has enjoyed working with native plants since she was a child. In springtime, she sells lady's-slippers, trillium, fairy-wands and nearly every other variety of Appalachian plants. In summer and fall, customers place special orders for ferns, galax or lupine. Louise nobly shares advice on care and propagation, whether or not one makes a purchase. Besides plants, the Hills purvey dish gardens and terrariums, cut flowers, eggs and—among other vegetables and fruit—the tastiest of pole beans, tomatoes, berries and tiny potatoes. But Louise contends, "I find wildflowers most fascinating. Unlike crops, they're just there!"

Near the Church Street entrance, one discovers a cluster of Home Comfort– and Roman Eagle–brand cookstoves. These ancient appliances come back into service during the semiannual Old Timey Day celebrations for the preparation of ham, sausage, biscuits and gravy. Stick around after this hearty breakfast for a barbecue luncheon, live music, a petting zoo for the kids and entertainment for the entire family—a great way to celebrate the county's mountain heritage.

Hang a right just around the corner to find a central aisle filled with unprecedented gourds. From American Indian designs to chickens and quirky faces, Sara Edney has a knack for knocking out the fanciest of gourd art. In autumn, Sara's husband Wade—a third-generation apple grower—sells fragrant and picture-perfect orbs from his orchard, and in earlier seasons cherries, strawberries, peaches and sweet corn. Like many Curb Market vendors, the Edneys know their customers by name, and cater to their requests. Sara says, "With farmers, it's always 'maybe next year will be better.' We grow a variety of seasonal vegetables and fruit to ensure that we will have products to sell when something else doesn't pan out."

Now pass another entranceway on the left and meet Cindy Hudgins, who fashions wreaths from bittersweet and sells unique hummingbird feeders made from Coca-Cola and other beverage bottles. Next to Hudgins's booth, Charles King purveys crisp lettuce and other fresh produce from his farm.

Quilt lovers find at the Curb Market the top of the craft, not to mention fancy table runners and seat covers. On your right, don't miss hand-carved wooden toys, games and furniture. Just ahead, on the left, meet the gracious Lavon Gilbert, whose history in Henderson County dates back to pre–Civil War times. Gilbert's grandmother, Verda Hyder, was one of the market's first vendors. Gilbert sadly remarks, "As I look to the future, I see much of these homegrown, handcrafted goods lost to modernization…"

Gilbert dries and sells flowers and plants, including silver dollars, pussy willow, bittersweet, salvia and Mexican sage. She also purveys homemade jellies and jams, homegrown blueberries and figs and her son-in-law Joel McCraw's robust annuals and perennials.

On your left, meet artist Carolyn DeMorest Serrano and peruse her skillful pen-and-ink drawings of historical buildings in Henderson County. Serrano sells signed and numbered prints as well as notecards featuring her images. Then, in the left-hand corner, find Nancy Ball's booth featuring her seasonal array of flowers from zinnias and dahlias to sunflowers and bluebells. Mrs. Ball's husband fashions realistic deer and bunny sculptures from hornets' nests.

Continue your browse to find more woodcarvings, native and hybrid plants, confiture and honey and works of handcrafted fabrics. Any questions? Just ask the charming Elaine Staton at the information desk in the center of the market.

Curb Appeal

Mostly seasoned citizens, the Curb Market's vendors are always hospitable, never pushy. This civility extends to an unwritten "non-compete" clause, for, on occasion, one dealer has sent me to another, and all the vendors pitch in and help one another. Furthermore, when I buy more than an armload—from whomever—Mr. Thompson carries the overflow to my car.

Stepping into the parking lot, I am an even more contented man, as my visit to the Curb Market has conjured up days of visiting relatives. And unlike much of today's advertising, the market's slogan, "old-fashioned hospitality," rings sincere. As Hubert Thompson says, no one's a stranger at the Curb Market.

Wade and Sara Edney.

Apple Pickin' Time

When by mid-August many of his Gingergolds have been picked, Edneyville apple grower Wade Edney's harvesting has just begun. Besides Gingergold, Edney grows Red and Golden Delicious, Gala, Granny Smith, Jonagold, Mutzu and Pink Lady, among other varieties. While most are ready from late August through mid-October, the demure Pink Ladies won't be ready to harvest until the second week in November.

Apples. We take them for granted with the ready-to-eat, healthful, perfectly packaged taste treats available year-round. But speak with an orchardist to appreciate the complexities of apple growing.

Four Generations of Growing Apples

"Apple growing has changed so much since I've been at it," says Wade Edney. "We used to be able to make a good living, but the price of apples hasn't increased along with the cost of production."

In the old days, according to Edney, apples were gathered in one-bushel boxes. Today, although apples are still gathered by hand, pickers use twenty-bushel bins for collection.

Edney's ancestor, Samuel Edney, was the first Methodist circuit-riding minister in Western North Carolina. The community of Edneyville was named for brothers Asa and Samuel Edney. Wade Edney, a third-generation orchardist, has grown apples all his life on farmland owned previously by his father Fred (son of William Craighton Edney)—acreage Edney subsequently expanded. The Edneys' Piney Mountain Orchards make up sixty acres of this land.

Henderson County is the largest apple-producing county in the state.

The Edneys grow mostly apples and supplement their income with crops of cherries, strawberries, peaches, tomatoes, gourds and Precious Gem bicolor—the tastiest sweet corn around. In winter months, while Wade prunes the orchards and attends to other chores, his wife, Sara Wyatt Edney, transforms gourds into amazing works of art and sells them year-round at the Henderson County Curb Market.

Allison White, the Edneys' daughter, lives with her husband and new baby girl in Jacksonville Beach, Florida. Their son, Jason, helps on the farm, but his position as a technician with the North Carolina Mountain Horticultural Research Station occupies a good deal of his time. Jason's research group compiles data on apple and peach growing in Western North Carolina.

Labors of Love

Although the facets of apple growing are many—without a seasonal break—Wade Edney says the hardest work comes with springtime.

"That's when we sterilize the orchards, which cleans up the bark and rids the trees of insect eggs. Every seven days, we spray silver tips [swollen buds] with oil. And we apply PGR [plant growth regulator]. By April 15, the trees are in full bloom. We work with an apiarist, who provides honeybees to work the blossoms."

Apples are self-incompatible and must be cross-pollinated—with, for instance, crabapple pollen. Pollination takes hours to days, and daytime temperatures must be at least in the upper sixties, Edney explains. "Then comes the thinning, when we remove the smaller fruit."

The center blossom, known as the king bloom, produces a hardy, better-shaped fruit. The four outer apples are removed when they reach six millimeters in diameter—thus energizing the king.

All through late spring and summer, apple growers battle insects and disease. The Edneys do not believe in wholesale spraying. Instead, they target spray for oriental fruit moth larvae and other insects, fungus, rust and fire blight (a bacterial disease). "We use a cover spray for preventative maintenance through picking time," Edney says.

Edney employs a group of pickers for harvesting, grading, washing and removal of imperfect fruit. In wintertime, Edney and his crew prune the orchard to remove excess wood. "There is a lot of hand labor involved," he says, adding, "and we've discussed the easy parts. I haven't mentioned drought, frost, deluges, labor shortages…"

As Robert Frost recounts in his poem "After Apple Picking," "Of apple picking, I am overtired; Of the great harvest, I myself desired."

The Edneys sell apples to Apple Wedge Packers & Cider of Henderson County and Knouse Foods of Pennsylvania, their mainspring clients. Additional outlets include Hendersonville's Apple Festival and the Curb Market, Asheville Farmers Market and a roadside stand.

Gardens of Eden

The apple, genus *Malus domestica* in the family Rosaceae, is believed to have originated in the region between the Caspian and Black Seas. The fruit was eaten by prehistoric people and was a favorite of the ancient Greeks and Romans. European settlers brought apple seeds to America.

China leads the world in apple production, followed by Argentina, the United States and Turkey. In the United States, Washington heads the list, followed by New York, Michigan, California, Pennsylvania, Virginia and North Carolina. All told, worldwide production of apples exceeds forty-five million metric tons, with an approximate annual value of $10 billion.

North Carolina hosts more than three hundred commercial apple operations and ten thousand bearing acres of apple orchards. In a given year, 8 million bushels of apples are produced in North Carolina in five regions: Haywood, Henderson, Mount Mitchell, the Northwest and the South Mountain area. Henderson County farmers produced 85 percent of the state's apple crop in 2006, with 3,326,425 bushels, and a total gross income of $22,819,276, according to Marvin Owings Jr., an agent with the North Carolina Cooperative Extension Service in Henderson County.

How Do You Like Them Apples?

Besides its status as Mother Nature's original health food, the apple is America's favorite fruit. The refreshing snack quenches the thirst and its acidity makes it a natural breath freshener. Nutritionists and dieticians rate apples highly for nutritional value and promoting fitness. A medium-sized apple provides five grams of fiber and a variety of vitamins and minerals including potassium, vitamin C and boron. Better still, the apple does not contain fat, cholesterol or sodium. And the fruit stores for months while retaining much of its nutritive value.

The content of apples may reduce the risk of colon, prostate and lung cancers. Eating apples may also help prevent heart disease, manage weight loss and control cholesterol. Recent research revealed that chemicals in apples protect the brain from risk factors that trigger such neuro-degenerative diseases as Alzheimer's and Parkinson's. And some scientists agree that apples' critical phyto-nutrients and phenolic compounds provide naturally occurring antioxidants.

Sixty-one percent of the United States' apple crop is eaten raw, while 39 percent is processed—juice and cider accounting for 18 percent, and 12 percent canned, 3 percent dried, 2 percent frozen. The balance is used for baby food, apple butter or jelly and vinegar.

Variety

There are more than 7,500 known cultivars of apples. Every seed has the potential to produce a new cultivar. That's why commercial growers use grafting or budding to produce trees that will bear the desired fruit.

Although many old-time apples have stepped aside in favor of modern varieties sporting perfection in shape, texture and flavor, "antique" apples may be found at roadside stands. These include Arkansas Black, Grimes, King Luscious, Limber Twig, Virginia Beauty and Wolf River.

Next time you chomp into an apple, consider the labors of love that went into producing America's favorite fruit.

Accent on Southern Living

Louise Bailey shared with me the Southern interpretation of the regionalism "I wouldn't care to," which means, "I want to." As a newcomer from California, I had much to learn.

This south-pawed, right-brained city boy has never found language to be an obstacle, and finds it reasonably easy to comprehend accents. Invariably fascinated with language and accents, I have always taken pleasure in traveling, particularly in Mediterranean countries where people are for the most part as kind and leisurely paced as they are here in America's South. I now live in the midst of folks with intonations and locutions that charm me to no end.

Witness "stakin' maders." When I first heard this expression in Henderson County, I thought of steak and tomatoes until a local farmer set me straight. On the topic of food, I was told that I have "poke salit" growing on my bank. Having heard the term only in a song written by Elvis Presley, I had no idea what it was.

"Gettin' above his raisin'" is not only easy to interpret, but most aptly put. I was thrown for a loop, however, when I heard "I've enjoyed myself as much as I can stand" when a dinner guest announced to me that she must leave.

Quizzing Mrs. Bailey and Miss Caroline

I asked Louise Bailey about the provenance of our local semantics and more specifically the influence of the accent. Scots-Irish, English and Welsh settlers, according to Louise, contributed heavily to the way we speak in the mountains.

For many years, Appalachia (which includes West Virginia, eastern Tennessee, the western Carolinas and northern Georgia) remained isolated. The population of this region clung to its old ways but also developed and retained its own distinct culture and language—Scotticisms and variations on Old English. Consequently, the vernacular is not considered "Southern," but instead, "Appalachian Mountain."

While African Americans influenced the dialects of Southern regions of the United States, Louise informed me that this was not the case here in the mountains. Blacks influenced local idioms of the deeper South, and the Gullah (descendants of Angolan slaves) certainly swayed colloquialisms along the Carolina coastlines, particularly South Carolina. To quote from *De Good Nyews Bout Jedus Christ wa Luke Write: The Gospel According to Luke in Gullah*: "De angel tell Zechariah e gwine habe son." ("The angel said unto him, Fear not, Zacharias: for thy prayer is heard; and thy wife Elisabeth shall bear thee a son.")

During frequent visits to Saluda—one of my favorite mountain villages—I enjoy speaking with shopkeeper Caroline Tindal of Caroline's Gifts & Keepables, Too. When first we met, I affected a Southern accent and questioned Miss Caroline if she knew from where I came. "Not from these parts," she said with a skeptical grin. I confessed to being a former Wisconsinite and Californian and shared with Caroline my admiration of the Southern accent. She chuckled and asked me to pronounce b-o-a-t. As usual, I articulated the word with one syllable. Caroline, a former South Carolinian, corrected me. "Put an umlaut over that 'a' and say it like this," she said, and then pronounced the word in what sounded like two syllables.

I queried Louise Bailey about the origin of clipping the "g" in the participial suffix "-ing." In her refined accent—calling to mind honey flowing languidly over the edge of a warm cat-head biscuit—she humbly replied, "Just carelessness on our part, I believe."

Manners and Mannerisms

Having been raised by Benedictine nuns and strict parents, I learned a thing or two about manners and protocol, which come in handy here in the South where politeness goes a long way in attracting friends and amiable advice. Though I might be too old to pick up an accent, I try, nonetheless, to understand and respect the local colloquialisms.

In California, where one is judged by the car he drives, the enclave in which he lives and the social ladder he climbs, I find it refreshing that, in Western North Carolina, I am "just as common as the rest of us."

A Partial Appalachian Vocabulary and Pronunciation Gazetteer

arn:	iron	old:	oiled	
backy or backer:	tobacco	passel of:	a lot of [trouble]	
bar:	bear	poke salad (or salit):	pokeweed (*Phytolacca americana*)	
boät:	boat			
britches:	trousers	poo-doo:	outhouse	
Bubba:	friend, buddy	puddin':	pudding	
cat-head biscuit:	a biscuit the size and shape of a cat's head	purdy:	pretty	
		q'uar:	queer, peculiar	
choicy:	choosy	right:	very, extremely	
closter:	closer	seed:	seen	
clum:	climbed	spruce-pine:	hemlock	
creasy greens:	cress	taters:	potatoes	
cyarn:	carrion	wood hen:	pileated woodpecker	
fuh:	for (Gullah)	yam:	sweet potato (Gullah)	
haffter:	have to	yarb:	herb	
heared:	heard	yelk:	yolk (Old English)	
hep:	help			
hit:	it			
holler:	hollow, valley			
licker:	liquor			
mought:	might			
much:	mulch			
nah:	now (Gullah)			
old-timey:	old-fashioned			
ole:	oil			

These Hills Are Full of Expressions

a heap of, or a mess of:	a lot of
a-humpin' it:	in a hurry
all full up:	filled, booked
bird nestes, fence postes:	bird nests, fence posts
gettin' above her raisin':	pretending to be something she is not
I aim to:	I intend to
I enjoyed myself as much as I can stand:	I had a ball
I'll be there directly:	I'll be right there
I mought jest as lief do it:	I might just as well do it
I reckon I'll do:	I am doing well
I wouldn't care to:	I want to
Law mercy me, or Lawzy me:	Lord have mercy upon me
plumb dumb:	quite dumb
plumb give out:	I am in bad shape
right piert:	I am okay
shakin' the rug:	dancing
stakin' maders:	staking tomato vines
swull mah hade:	inflated my ego
toler'ble:	I am so-so
What's got you all tore up?:	What upsets you?
Who dat is?:	Who is that? (Gullah)
You need to get you one of them:	You should get one of those
Pleonasms (redundancy):	done-done it, granny-woman, ham-meat, tooth-dentist, women-folks

In Celebration of Black Bears

Nowadays, we rarely see the American black bear in and around Hendersonville, but we do find the native bruin rendered in wood—chainsaw-sculpted for use in garden décor. Examples decorate the patio of the Hendersonville Visitor Information Center on South Main Street. Best of all, spring through fall, a sloth of bears amuses visitors from their sidewalk perches in downtown Hendersonville.

Bearfootin'

For five years since 2003, between late April and the third week in October, historic downtown Hendersonville's Main Street has been a venue for a new batch of bears—fiberglass bears, that is. Some of the more than twenty fancifully painted and decorated bruins pose upright; others stand on all fours, or pose seated and holding a cub—an exhibit known as "Bearfootin' in Hendersonville."

Jane Asher poses with her 2005 Bearfootin' exhibit, "Literary Bear & Booky Bear."

Early Stages

The journey of a Bearfootin' public art exhibit began in Caro, Michigan, where Precision Concepts, a custom-built motorcycle company, also manufactures fiberglass animal forms. While shopping for vendors, Downtown Hendersonville, Inc., (DHI) found local pricing was twice that of Precision Concepts' fee of $700 per form.

Once shipped to Hendersonville, a bare-bones bear spent weeks in a local artist's gallery, undergoing the metamorphosis from amorphous white cast to whimsical creation. Since the premiere of Hendersonville's Bearfootin' event in 2003, strollers down Main Street have discovered all, from a golfer bear to racecar driver and ballerina to Celtic bruin.

The Evolution of a Bearfootin' Exhibit

Local merchant Jane Asher, a former Registered Nurse with Greenville's St. Francis Hospital, has owned and operated Jane Asher's Antiques and Fine Traditions on Hendersonville's Main Street and Fourth Avenue since 1997. In addition to period antique furnishings and accessories, Asher's shop features a five-hundred-square-foot library/reading room stocked with thousands of antiquarian and gently used books. Since childhood, Asher has enjoyed—and now collects—children's books, including *Little Madeline*, a 1950s series by Ludwig Bemelmans.

Asher sponsored "Woodsy Bear—Keeper of the Forest" for the 2006 Bearfootin' in Hendersonville exhibit. The upright specimen wore tan bib overalls overlaid with a botanical leitmotif.

In 2005, Asher sponsored "Literary Bear & Booky Bear"—a grandfather reading to his grand-cub. Having long enjoyed a love affair with books, Asher said her goal through the exhibit was to promote reading and learning among children.

Asher's antique shop sponsored "Bearied Treasures" in 2004. The bipedal bear was outfitted in blue bib overalls and wielded a shovel—painted by artist Patty Henry. Henry also created Asher's 2005 and 2006 exhibits. Asher selected Henry from a DHI list of volunteer artists. "We have been friends ever since," Asher says.

Henry, formerly of Cincinnati, has painted with watercolors for more than sixteen years. Painting Hendersonville bears was "entirely a hobby," she says. She spent more than one hundred hours on Asher's 2005 "Literary Bears."

Final Touches

With screws, bolts or glue, the artist attached accessories to an exhibit to discourage vandalism. Once painted, the bear moved on to another vendor to receive its clear coat treatment as a measure of weatherproofing. The finished bear was installed on one of Main Street's sidewalks as a family-friendly exhibit throughout spring, summer and early autumn, culminating with an auction. Bids started at $250 and bears fetched from $1,200 to more than $5,000 each. From the net proceeds, 75 percent benefited the winning bidder's favorite charity and 25 percent was distributed to DHI to cover event promotion.

The End of a Journey

Asher was the winning bidder on five bears in 2004. She donated "Butterfly Bear" to Four Seasons Hospice. Immaculata School received "Brave Bear" from Asher and Hendersonville Elementary School was the lucky recipient of "Bearonardo da Vinci." Another of Asher's winning bids was for her store-sponsored "Bearied Treasures." This mascot now comfortably resides in front of her antique store.

"I also had 'Amour En Masse,'" Asher says. "He hung out in my shop's reading room, until we found a home for him at Terra Nova Café."

Several of the fiberglass bears are still to be found in and around downtown Hendersonville.

Black Bear Coffee Company

Stifling a yawn, I drive up Kanuga Road while murmuring a prayer for a short queue at downtown Hendersonville's premier coffeehouse and a parking space within reasonable range. Approaching the door of Black Bear Coffee Company, I inhale deeply and my heart skips a beat.

"A tall, long-shot, double latté, skinny, with no foam, please," I used to tell the cashier. "Have them put the cup under the spigots, to capture all of the *crema*. And fill the cup only halfway with milk."

Finding no Starbucks when I moved to Hendersonville, I fretted until discovering Black Bear Coffee. Give me a good mom-and-pop shop over a franchise any day, particularly if the shop purveys excellence.

Excellence is key at Black Bear Coffee. With personality to spare, owner Beau Rodriguez is deft at surrounding himself with amiable staff and furnishing a comfortable environment for patrons. Regional artworks dot the walls of the decorously lit space, burlap coffee sacks overlay the ceiling and bookcases and fireplaces accent the grand room where regulars spend quality time away from home.

Seating choices are many. Besides café tables and chairs, one may sink into a comfy sofa to enjoy a custom-made beverage and any of the coffeehouse's free or for-sale publications. Or pull up a chair on the patio and listen in on the musings of local literati. On occasion, a musician entertains impromptu with guitar, banjo or voice.

With their three children, Rodriguez and his wife, Stephanie T. Eihl, relocated in 2003 from Chicago and purchased Black Bear Coffee Company from Donald Busher.

"We had two babies that year," Rodriguez says. "Our fourth child, Josephine, and this coffeehouse."

Beau Rodriguez and Stephanie Eihl, owners of Black Bear Coffee Company.

When asked if he worked in the food-and-beverage business in Chicago, Rodriguez answers, "I was a stay-at-home dad," waving his hand across two walls of his coffeehouse and adding, "Stephanie was in the faux-texture paint trade. Now, for the most part, she's a stay-at-home mom."

In 2006, Stephanie juggled her motherly duties with the creation of a Bearfootin' exhibit entitled "Bearista in Black Bearet," a masterpiece in coffee-sack apron with an avocado-pit necklace and a coat of coffee grounds. Eihl and Rodriguez were the winning bidders on their bear at the 2006 auction, and the coffee-themed bruin now resides in front of their emporium.

Coffee Chat

Black Bear draws clientele of sundry shapes, sizes and ages, with incalculable opinions. While waiting in line or hanging out at a table, one overhears all, from local gossip to political and philosophical debates. On any given day, patrons of the Black Bear may include artists, poets, songwriters, musicians and champion chess players.

In early 2007, Rodriguez and Eihl expanded with adjoining space, opening a venue with a stage for special events, poetry readings, book signings and musical performances.

I likely would never leave the garden but for my caffeine compulsion, gladly breaking from horticultural devoirs each mid-morning. As a regular at the Black Bear, I need no longer give my fussy order to the cashier or to any of the *baristi*. When I reach the register, the cashier has rung up my order. Moreover, my drink is ready, flawlessly prepared.

Hendersonville's Annual Tulip Extravaganza

Abreast of downtown Hendersonville's Main Street, thousands of tulips herald the vernal season. Representing dozens of cultivars, graceful blossoms flutter with the breeze in hues from creamy white and butter yellow to smoldering crimson and nearly black.

Between mid- and late April, strollers and unhurried motorists discover sidewalk gardens of tulips, from classics to hybrids in solid colors and striped varieties, some with fringed petals, others sporting lily-like blooms and still more known as Peony and Parrot. Sponsored by the City of Hendersonville and promoted as "Tulip Extravaganza" by the Downtown Hendersonville Merchants Association, this stunner is the handiwork of local landscapers Scott Johnson and Bruce Lowe. Each September since 2003, Johnson and Lowe have planted 8,500 tulip bulbs in the brick planters that punctuate Main Street's sidewalks.

Each springtime, Hendersonville's Main Street sports at least 8,500 tulips.

Johnson and Lowe replace downtown Hendersonville's tulip bulbs each autumn. "If you leave the bulbs in the soil, you can't depend on perfect blooms every year," Johnson says. With the help of two assistants, the process of planting takes two days. In late winter, the tips of tulip leaves may be seen poking up through the snow. Come mid-April, downtown shimmers with a magnificence rivaled only by the Netherlands. The resplendent display reaches its peak in late April and continues to amaze into May. When the blooms are spent, Johnson and Lowe rip out the bulbs, making room for summer annuals.

A distributor in the Atlanta area supplies Johnson and Lowe with bulbs—including Pink Emperor and red and gold Apeldoorns—imported from the Netherlands. But the flowers so strongly linked with the Dutch found their way to the Netherlands from regions more extrinsic.

The wildflower *Tulipa schrenkii* is said to have hailed from Persia and was cultivated in Turkey. In the late sixteenth century, Ogier Ghiselain de Busbecq, the Austrian ambassador to the Ottoman Empire, appropriated specimens of the wild tulip and gave them to the botanist Carolus Clusius. Seeking religious sanctuary, Clusius fled to Holland and perfected strains of tulips at the University of Leiden. Crossbreeding led to an industry and eventually a phenomenon known as "Tulipmania," when bulbs were traded on the stock exchanges of many Dutch cities and could fetch as much as $440 each.

Since tulips are known to grow naturally and prolifically in mountainous regions, the plant fares exceedingly well in Hendersonville. Little wonder that our Main Street bursts with the popular blooms each April.

The next time you stroll or drive down Hendersonville's tulip-bedecked Main Street, consider the era when our 8,500 tulips would have been worth nearly $4 million.

Leaf Peepin'

The autumnal equinox transpires the fourth week of September, signaling the finale of summer and the advent of Western North Carolina's most spectacular vistas.

Scenic Drives

Abundant summer rains help trees retain a good stock of leaves. Later in the season, dry, sunny days followed by cold nights and a frost or two induce the most brilliant of colors—notably after an October cold snap.

Depleted protoplasmic fluid causes the vascular bundles of leaves to break down. A corky membrane grows between the branch and leaf stem (from which a new bud will grow), interfering with the flow of nutrients. In due course, the green color fades and shifts color and the slightest rustle may loosen the leaves from their branches. Meanwhile, fetch the rake from its storage—or, better yet, grab your camera and hit the road.

Sourwoods and dogwoods impart an early blush. Maples, chestnut, sumac and oak follow with a spectrum from yellow to purple. Peak viewing times are October 1–15 for higher elevations, and October 15–31 for lower elevations.

If the high cost of gasoline deters leaf peepers from venturing to the Great Smoky Mountain passes and Cades Cove, they may instead explore the glories of autumn closer to home. Suggestions follow.

The Blue Ridge Parkway is ranked as "America's Most Scenic Drive," renowned for intoxicating panoramas—particularly when deciduous trees don their fall finest. If one is patient enough to creep behind fellow gazers (some on cycles or in slow-moving RVs), take

Autumn leaves afloat.

heed, too, that some trails and recreation centers may be under repair following occasional landslides and flooding.

Henderson County's picturesque drives include Little River Road between the Greenville Highway (U.S. 225) and Kanuga Road/Crab Creek Road. Continue along Crab Creek Road toward U.S. 64 for notable scenery, including farms. And check out Kanuga Lake, Willow, Mill Gap, Fruitland/Old Clear Creek and North Rugby Roads.

The U.S. 176 South route from Flat Rock through Polk County offers not only splashes of fall color, but also glimpses offset by creeks, glades and dripping rock walls.

Buncombe County serves up a riot of fall color and bucolic landscapes along Leicester Road (North Carolina 63).

Buncombe and Yancey Counties' North Fork Road (North Carolina 197) between Barnardsville and Burnsville usually glows with autumnal hues by mid-October.

Madison County rolls rich with forested and agricultural landscapes. The occasional barn and tobacco fields lend further interest to the scenes.

Tips for the Shutterbug

In addition to broad-brush landscape views, focus on a branch of sun-drenched scarlet or ochre foliage or an interesting pattern of colored leaves on a pathway or stream. Size up your subject, looking for distracting elements. Remove unsightly debris and reframe your shot to avoid utility poles and wires, vehicles and signs. A mixture of morning light and fog proposes glorious backlighting for autumnal foliage. Don't forget about the intrigue effected by shadows and modeling. Shoot during early morning hours or after 2:00 p.m.

If you own a single-lens reflex (SLR) camera, make use of warming, polarizing, neutral-density, star and gradient filters to enhance your shots. When shooting with possible print enlargement in mind, use finer grain films such as ISO 50/60, 100 or 200. If you shoot at speeds slower than 1/60 of a second, mount your camera on a sturdy tripod.

Most importantly, stray from the beaten path. The hues of autumn are particularly stunning when contrasted by conifers, water features, a split-rail fence, a weathered wagon wheel or a rusting tractor. Seek foregrounds waving with pampas grass or dotted with goldenrod, lavender asters or fuchsia phlox. Shadows lend drama to a scene and rays of sunlight streaming through a forested setting cast a sense of mood and serenity into a photo composition—so break the triangle and capture the essence of autumn.

Noteworthy

Boston has its Pops, New York its Philharmonic and Los Angeles its Symphony—even rusty Motown boasts one of the United States' top orchestras. Still and all, does the musical devotee find solace in small towns? In Western North Carolina, the answer is a resounding yes, with our natural and cultural appeal having long enticed artisans, scribes and virtuosos.

Irland Brown, pictured here during one of Hendersonville's many Main Street events, also plays his bass fiddle with a group of pickers at Helms' Barbershop on Thursdays.

With an Ear to the Mountains

The discerning listener senses in these mountains nature's refrain in accord with echoes of the ancient Cherokee flute, the hammered dulcimer and Celtic fiddle. For aficionados and even those casually interested, Brevard Music Center, Flat Rock music festivals and the Hendersonville Symphony Orchestra cater the classics through pop standards. Nearby, live sounds throb through Asheville's UNCA Lipinsky Auditorium, Civic Center, Diane Wortham Theatre and sundry cabarets, including the Grey Eagle and Orange Peel Social Aid & Pleasure Club.

Highland games in neighboring villages yield the bagpipers' skirl and the beat of the bodhran. Among its scores, Flat Rock Playhouse stages musicals starring golden-throated thespians. And, February through September, Saluda hosts weekly Front Porch Musical Concerts.

Open-mic nights at the Back Room in Flat Rock feature such local artists as crossover country singer Ryan Whitted and the amazing Jesse Norton, who plays all from jug and washboard to banjo, guitar and saw.

Thursday through Saturday evenings, savory jazz issues from downtown Hendersonville's Double Olive Lounge and, weather permitting, on Monday nights, Main Street pulsates with line dancing to country tunes.

Sweet euphony swells from a youth symphony, a chamber ensemble, a one-hundred-member chorale, the Community Band and the Blue Ridge Ringers. And when you least expect it, the Muse heartens an ingenue to pluck a guitar or banjo at a sidewalk café—or, surprisingly, at a barbershop.

From the tempo of the original inhabitants and Scots-Irish immigrants to bluegrass pickers, a top-notch symphony and gospel choirs shaking Bible Belt spires, these ridges resound with noteworthy timbre.

That Ol'-time Religion

Myriad slender spires pierce the Carolinas' cobalt blue skies. Mostly, the steeples crown Baptist churches, while Normanesque towers or vaulted domes demarcate other houses of worship. Regardless of their conformation or denomination, in this region of the country copious churches betoken devout Christianity—to an extent that, in the early

1920s, newspaperman Henry Louis Mencken coined the term "Bible Belt" to describe the phenomenon.

Bible Belt?

Wikipedia (a multilingual, Web-based free content encyclopedia) describes the Bible Belt as

an area in which socially conservative Christian Evangelical Protestantism is a pervasive or dominant part of the culture. In particular, in the United States, it is the region where the Southern Baptist Convention denomination is strongest. It includes the entire South and nearby areas…The name is derived from the heavy emphasis on literal interpretations of the Bible in Evangelical denominations.

The belt has a buckle, which includes the regions of Charlotte, North Carolina (home of Billy Graham and his Center), and Greenville, South Carolina (home of Bob Jones University). Some folks in Henderson County fondly include their own region as part of the "Buckle of the Bible Belt."

Not surprisingly, North Carolina's population is 88 percent Christian, with an overwhelming 77 percent of that group worshiping in Protestant churches, 40 percent of which are Baptist. Methodists make up 10 percent and Presbyterians, 3 percent. General Protestants compose 24 percent of the population and Catholics, 10 percent. Judaism, Islam, Hinduism and Buddhism embody 1 percent of North Carolina's worshiping public. Non-worshipers make up an estimated 11 percent of the state's population.

St. Jude's Chapel of Hope.

A Western North Carolina Sampler of Churches

From the simple "shoe-box" design of small rural churches to elaborate structures of classic inspiration, Western North Carolina supports a host of worshipful places. A sampling of the more interesting examples follows.

St. Jude's Chapel of Hope

Perhaps the most unique of churches within easy reach of Hendersonville is St. Jude's Chapel of Hope. Built in June 1991 by Beverly Barutio of Madison County, the dollhouse-sized chapel's pews seat just eight people. With no regular services, the shrine is always open, tendering a quiet environment for contemplation or prayer. Mrs. Barutio commissioned construction of the chapel in thankfulness to the saint whom she credits for her miraculous cure from cancer.

The chapel stands near a babbling brook alongside State Road 209—the "Appalachian Medley" Scenic Byway—off North Carolina 63 in Madison County.

The Cathedral of All Souls

At first glance, one does not perceive the cruciform nature of Asheville's All Souls, the Cathedral of the Episcopal Diocese of Western North Carolina. Rather, the edifice appears—except for the two Celtic crosses atop the central tower—quite unlike a church.

Established in 1896 as a parish church, All Souls was built by George W. Vanderbilt to be the central focus of his Biltmore Village. Richard Morris Hunt, the architect for Biltmore House, also designed the church, which became a cathedral in 1995.

The design of the large red brick structure is from the Norman period of the transition from Romanesque to Gothic and is said to be inspired by abbey churches in northern England, though the apse is characteristic of churches in southern France.

David Maitland Armstrong and his daughter, Helen—contemporaries of Louis Comfort Tiffany—designed the stained-glass windows. Many of the kneeling cushions in All Souls are finished in needlepoint covers typical of those found in England.

The Cathedral of All Souls is located at Biltmore Village, 3 Angle Street in Asheville.

St. Lawrence Basilica

Cathedral-like in its breadth and glory, Asheville's St. Lawrence Basilica hunkers on a knoll in the midst of Art Deco–styled high-rises. This red brick church was designed in the Spanish Renaissance style by Spanish-born Rafael Guastavino and completed in 1909. Twin bell towers and a dome reputed to be the largest freestanding elliptical dome in North America count among the many unique aspects of St. Lawrence, a solid brick superstructure with no beams of wood or steel in the entire structure.

A frieze of ten semicircular windows, several massive stained-glass apertures and Spanish-style woodcarving impart an ancient look to this early-twentieth-century Catholic church located at 97 Haywood Street in Asheville.

Calvary Episcopal Church

A short drive north from Hendersonville to Fletcher rewards the seeker of spiritual places, historic structures and notable cemeteries with a church design based on drawings by Sir

Christopher Wren. The church was organized in 1857 at The Meadows, home of Mr. and Mrs. Daniel Blake. Anglican residents of Fletcher had traversed the old "Turnpike" to Flat Rock to attend services at St. John in the Wilderness. Because St. John was kept open only in summers and the distance was thirty miles over a treacherous roadway sometimes choked with mud—a round-trip journey that took the better part of a day—Fletcher residents raised money to found their own church.

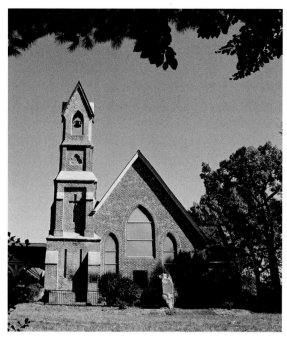

Calvary Episcopal Church.

Fundraising was successful and the brick Calvary Episcopal Church with its sixteenth-century-style tower was consecrated in August 1859. During the Civil War, Confederate troops used the church as barracks. Mostly ruined by fire in 1935, the church was rebuilt based on a design by Scottish architect S. Grant Alexander. Parts of the original shell, together with the bell tower, were saved.

Against the setting of this church's Gothic lines in the shadows of ancient trees, a churchyard of silent congregants beckons the romantic and history-minded. On the monuments, the inquisitive visitor finds the names of prominent local families, including Fletcher, Blake, Weston, Owens and Ledbetter. Moreover, Civil War soldiers, a bishop, an opera singer, famous Southern humorist Edgar Wilson "Bill" Nye and the punk rocker Root Boy Slim occupy plots in the Calvary churchyard.

Don't be fooled by the monuments dedicated to Zebulon Baird Vance and Jefferson Davis. Vance is buried in the Riverside Cemetery at Asheville, and Davis in the Hollywood Cemetery at Richmond, Virginia. The visitor also finds monuments to—and not the graves of—O. Henry, Francis Scott Key and Robert E. Lee.

Calvary hosts a few ghosts, including a young woman in white who dashes through the cemetery after dusk. And, according to local lore, a headless horseman appears each year near midsummer.

Calvary Episcopal Church is located at 2840 Hendersonville Road in Fletcher.

First Baptist Church of Hendersonville

Together with Hendersonville's old courthouse and city hall, First Baptist Church is one of downtown's most conspicuous and elegant architectural landmarks. Founded in 1844, the original house of worship was built circa 1850 on Caswell Street, one half-block east of South Main Street. In 1932, a new church at Fourth Avenue West and Washington

Street replaced the original structure. The present sanctuary with its soaring tower was completed in 1958.

Even non-congregants are familiar with the lavish interior of this colossal church, for it has hosted the Hendersonville Symphony Orchestra's "A Carolina Christmas" program each December and for many years produced a full-dress version of Handel's *Messiah*.

First Baptist Church of Hendersonville is located at 312 Fifth Avenue and Washington Street in downtown Hendersonville.

Mud Creek Baptist Church

A small group of Christians built a log cabin on the bank of Old State Road (on land now occupied by a cemetery cattycorner from the modern church) and founded the Mud Creek Meeting House in 1803. Flat Rock resident and major landowner Abraham Kuykendall deeded a portion of his property for the church near his tavern, gristmill and still house. In 1850, a larger log cabin was constructed to replace the smaller edifice. Deemed unsafe, the church was razed in 1895. The congregation worshiped outside and joined with other congregations, awaiting the completion of a new church in 1900.

In 1952, four lots at the corner of Erkwood Drive and Rutledge Drive were added. More adjoining land was appended and a larger church was completed in 1964. The present 1,500-seat sanctuary was constructed from 1992 to 1995.

In the neighboring burial ground rest pioneers of the community, including Abraham Kuykendall and other Revolutionary War soldiers, Civil War soldiers and James Dyer Justice, the early nineteenth-century surveyor who laid out the streets of Hendersonville.

Mud Creek Baptist Church is located at 403 Rutledge Drive at the corner of Erkwood Drive in Hendersonville.

Hendersonville's Church Street and Beyond

When Judge Mitchell King gave land in 1841 to found the town of Hendersonville, he designated one half-acre at Church Street and Fourth Avenue for a Methodist church. The Methodists never built there. Instead, they sold the property and purchased the present site because they wanted their church built on one of the highest hills in town.

The original 1850s church, known as the Hendersonville Methodist Episcopal Church, featured a pitch-roofed steeple with one bell. In 1861, the name was changed to Hendersonville Methodist Episcopal Church South. Membership increased and a larger building was constructed in 1896. The 1925 yellow brick sanctuary of today (First United Methodist Church) stands over some of the original graves; the others were moved to Oakdale Cemetery. The original bell rests in front of the present neoclassic-style church with its imposing columns and Roman-style pediment located at 204 Sixth Avenue West and Church Street.

St. James Episcopal Church was founded in 1843 as a mission of Flat Rock's St. John in the Wilderness Church. The first church of St. James was consecrated in 1863 with eight communicants. The original church was made of brick. A subsequent chancel—which stood unfinished for many years—incorporated hewn granite blocks from the dismantled Judson College. Federal troops stole the church's first bell during General George

1. One of the many farms gracing the rural outskirts of Hendersonville.

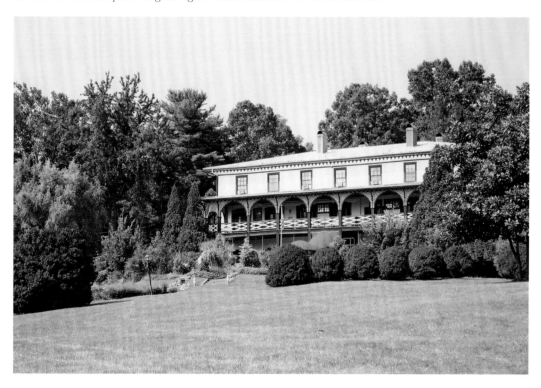

2. Flat Rock's Woodfield Inn (circa 1853), also known as the Farmer Hotel.

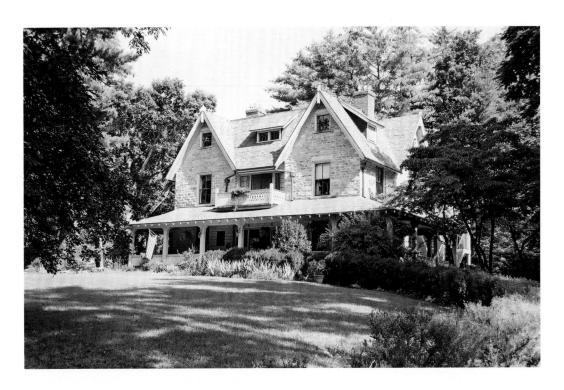

3. Killarney, built for South Carolinian William Bryson, circa 1858.

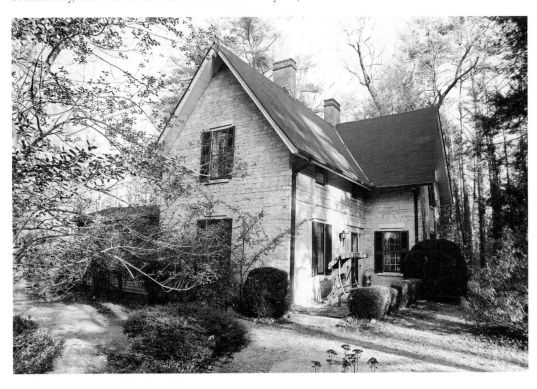

4. The Old Parsonage, built circa 1853 as a rectory for the Episcopal Church of St. John in the Wilderness.

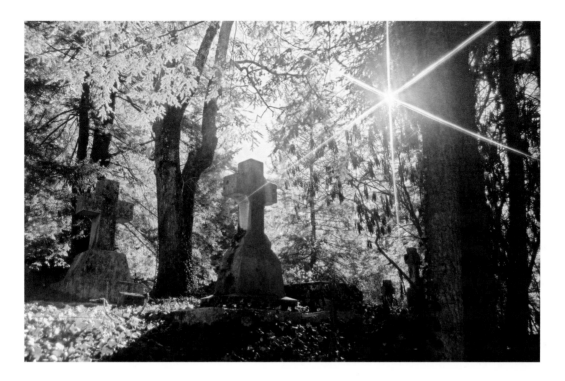

5. The churchyard of St. John in the Wilderness is the final resting place of several Southern notables.

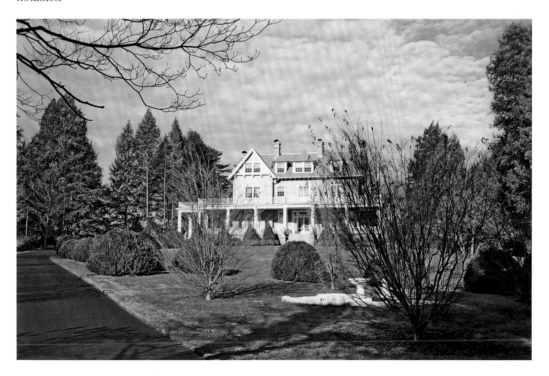

6. Beaumont (circa 1839), built for Andrew Johnstone of Georgetown, South Carolina. Bushwhackers executed Johnstone in the dining hall of this home.

7. A glimpse of Connemara across the lake.

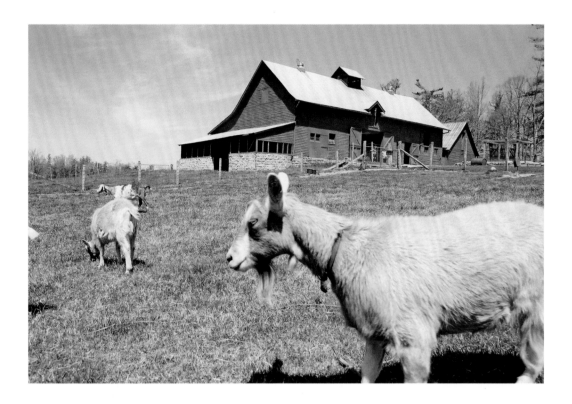

8. The goat barn is a popular attraction at Connemara.

9. Saluda Cottages (circa 1836), built by Count Marie Joseph Gabriel St. Xavier de Choiseul, and extensively altered in 1887 by successive owner Rudolph Seigling.

10. Jump Off Rock on Echo Mountain in Laurel Park provides sweeping views of the Blue Ridge and Pisgah Mountain Ranges.

11. Placid Osceola Lake tucks into a corner of rural Hendersonville.

12. Hendersonville's Willow Creek Mill is purportedly haunted.

13. Hendersonville's city hall, designed by Erle G. Stillwell and completed in 1928.

14. Historic downtown Hendersonville's Main Street retains its turn-of-the-twentieth-century feel.

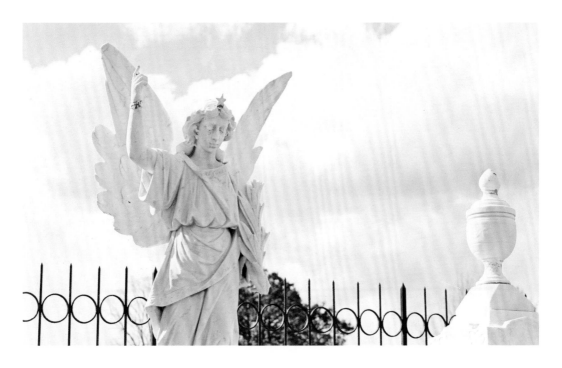

15. *Wolfe's Angel* hovers above the Johnson family plot at Hendersonville's Oakdale Cemetery.

16. Hendersonville's St. James Episcopal Church (circa 1920), designed by Erle G. Stillwell and constructed with hand-hewn granite blocks from the dismantled Judson College.

17. First United Methodist Church (1925) imparts classic grace to downtown Hendersonville.

18. A bluegrass band entertains festival goers at the Henderson County Curb Market.

19. Whitewater Falls occurs even more spectacular in autumn.

20. A wintry view of Bridal Veil Falls.

21. The reconstructed birthplace of North Carolina Governor Zebulon Baird Vance, Weaverville.

22. A drive through Madison County proffers bucolic views at nearly every bend.

23. A honeybee pollinates apple blossoms in an Edneyville orchard.

24. A Pink Emperor in all its glory during downtown Hendersonville's annual Tulip Extravaganza.

25. Dogwood Cherokee Chief (*Cornus florida*), an early spring bloomer in the mountains.

26. Each springtime, mountain laurel (*Kalmia latifolia*) graces the Blue Ridge Mountains with nosegays of blossoms.

27. Purple rhododendron (*Rhododendron catawbiense*) lends elegance to the thickets of Appalachia.

28. Although Transylvania County's Brevard is known for its white squirrel population, the exceptional critters are also found in Henderson County.

29. The Blue Ridge Parkway serves up autumn at its fiery best.

Stoneman's raid on Hendersonville during the Civil War. In 1894, the church gained its independence from St. John in the Wilderness.

Designed by Erle G. Stillwell, the present St. James, including its neo-Gothic cloister, was completed and dedicated in 1978. The tower sports eight bells, used for change ringing, cast at the Whitechapel Foundry in London. St. James is located at 766 North Main Street.

The majestically staged tower of the First Presbyterian Church is usually the first edifice one notices upon approaching downtown Hendersonville from U.S. 64. The red brick church's façade features a Roman-style pediment and soaring columns.

With eleven charter members, First Presbyterian Church was founded in 1852. In its early years a member of Mecklenburg Presbytery, the first building was erected in 1859 with successive churches built in 1905 and 1948. In 1896, the church became a member of the newly organized Asheville Presbytery. As with Hendersonville's First United Methodist Church, graves were moved from the Presbyterian property to accommodate expansion of structural facilities. The church, renovated in 2004, is located at 699 North Grove Street and Seventh Avenue.

In 1979, the congregation of Hendersonville's old Grace Lutheran Church (circa 1924) on the corner of Seventh Avenue West and Church Street moved to a new church on U.S. 64 West and Blythe Street, where one may view the original stained-glass windows. Members of the Reformation Presbyterian Church restored the early-twentieth-century structure for their own use.

St. John in the Wilderness

One of the most photographed churches in the Southeast is Flat Rock's Episcopal Church of St. John in the Wilderness. Entered in the National Register of Historic Sites, the church has stood on a hillock in Flat Rock since 1836. Charles and Susan Baring, the Charlestonians who built the church, are entombed under the south side of the nave. Other notable names from Southern history grace the tombstones in the terraced cemetery. Names include Kings, Memmingers, de Choiseuls, Rutledges, Drakes, Middletons and James Brown—a trumpeter with the Royal Scots Greys who fought Napoleon at the Battle of Waterloo. Brown was later a member of the Barings' household staff.

Slaves and freedmen rest under one of the churchyard terraces. The plots, marked with simple stone crosses, bear no inscriptions.

The cemetery walkways are punctuated with native ferns and wildflowers under a canopy of pine and hemlock, where mosses and lichens find a blissful haven in the crevices of stone walls and between the timeworn pavers. A stroll through the churchyard of St. John in the Wilderness is not only a lesson in history, but also one in celebration of nature's ways.

St. John in the Wilderness is located at 1895 Greenville Highway (U.S. 225) at the corner of Rutledge Drive.

DAY TRIPPIN'

*L*ose yourself in another century as you stroll along the brick-paved sidewalks of a meticulously preserved downtown. Treat your ears to a folk music spree or the skirl of Scottish pipers. Kick up your heels at a street dance or hoedown. Visit a farmers market or browse through the treasures of an arts and mountain crafts festival. Witness a battle reenactment or marvel at a spectacle of falling water in any number of mountain preserves. All of this and more await the day-tripper in Western North Carolina.

Within easy reach of Hendersonville and Flat Rock beckon a legion of intriguing villages. Each of them peerless, they yield their own brand of fun, from Waynesville's Annual Ramp Festival (paying homage to a garlicky weed and its many culinary applications) to Saluda's Coon Dog Day celebrations and Brevard's White Squirrel Festival.

Whether you live here full or part time or are just passing through, the Hendersonville–Flat Rock area furnishes an ideal base from which to explore the Western Carolinas. Following are ten suggestions for easy day trips designed to provide an overview of historic towns and structures and engaging personalities and events.

Black Mountain

The Cherokee word for heaven is *gkwT* (pronounced ga-lu´-la-ti). Although Indians named Black Mountain "Grey Eagle" (*a/hl upusT*, pronounced a-wa-hi-li e-u-ne-ga-e-u-s-ti), the enfolding dale surely evoked notions of heaven to regional natives such as the Cherokee and Catawba who populated the Swannanoa Valley for more than five thousand years.

Enter non-native settlers in 1784 and the railroad in 1879, and the Cherokee flute resonated no longer between the walls of the valley. Black Mountain had become a major pathway for westbound immigrants and commercial trade.

Today, botanists, hikers and travelers seek out the village and environs for its rich heritage of music, arts and crafts and natural splendors. Voted "Best Small Town in Western North Carolina" by an Asheville *Citizen-Times* readers' poll, Black Mountain also is considered an antique- and new-furniture hub for the region.

Buncombe County's Black Mountain is so called by virtue of the town's locality in the shadows of Mount Mitchell, at the southern foot of the Appalachian Black Mountain range. The "black" mountains—depending on the light—may occur to an artist misty violet, indigo or teal-blue. But who's to argue the finer points of a 115-year-old handle?

Black Mountain's Cherry Street retains its early twentieth-century feel.

Incorporated in 1893, Black Mountain became known as "The Front Porch of Western North Carolina." Wanting to know why, I dropped into the town's visitors' center.

"We're cradled in the broadest spread of the Appalachian range, about one hundred miles wide," answered visitors' center volunteer Herbert Gregory, "and called the 'front porch' because we are the first settlement off the interstate from Old Fort."

"Anything to see in Old Fort?" I asked.

An unidentified volunteer spoke up. "They had an Indian museum, but the Indian died."

I wondered if they had only one Indian...

"And an old depot," the woman continued. The little town in McDowell County is known as "The Gateway to the Smokies."

When I mentioned Montreat College and its Manor House (the latter listed with the National Register of Historic Places), executive director Bob McMurray spoke.

"We have the world's largest concentration of conference centers," he said. "Montreat is one of seven. And two colleges, both Presbyterian. There were three, including the now-defunct Black Mountain College, where Dutch artist Willem DeKooning studied."

Gregory chimed in, "And there's Black Mountain Golf Club, with the largest municipal hole of golf in the country, home to the 747-yard par-6 tee box."

I thanked the volunteers and moved on to the historic ten-block downtown.

The Swannanoa Valley Museum occupies the historic red brick Black Mountain fire house designed by Richard Sharp Smith and completed in 1921. Collections include exhibits of Native Americans and early settlers, the coming of the railroad, religious conference centers, textiles and famous local people. The museum is open April through October (closed Mondays) and by appointment throughout the winter.

Though State Street is considered Black Mountain's main street, I found the brick sidewalks and storefronts along Cherry Street most intriguing. There I discovered art and crafts galleries, a rare bookstore, gift shops, a soda fountain, a deli, a top-notch restaurant, antique shops and an old-timey saloon all housed in vintage buildings.

Intersecting Cherry Street is Sutton Avenue, where one finds more shops and the handsomely preserved train depot, now a repository of crafts for sale. From the depot, head east toward Broadway to visit diminutive Centennial Park with its fine bronze sculpture of the Indians' grey eagle, then have lunch at one of Black Mountain's many eateries. Choose from German, Mexican or Cajun cuisine to seafood, continental fare or burgers in any number of family-run restaurants.

Illustrious residents of Black Mountain include NBA star Brad Dougherty, singer-songwriter Roberta Flack, evangelist Billy Graham and NFL quarterback Brad Johnson. Considering the town's thriving art and music scene, the roll of the famous is bound to grow.

Brevard

Orange jewelweed sparkled, lavender gentian shone and mauve-hued joe-pye weeds swayed overhead with the breeze. Although waning, summer graced the margins of Crab Creek Road with a flowery pageant as I headed southwest from Hendersonville toward Brevard, the seat of Transylvania County.

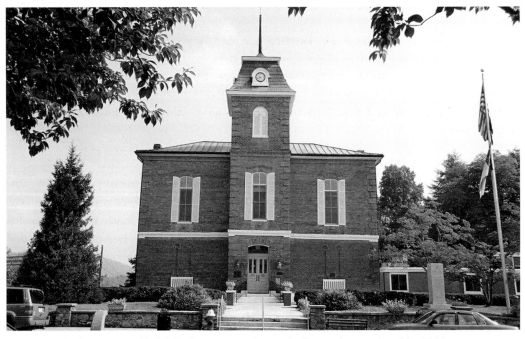

Transylvania County's red brick Italianate courthouse in Brevard, completed in 1881.

What's In a Name?

The first time I crossed over the Transylvania County line, a chill tingled my spine. Noting the ominous epithet on a green-and-white sign, my imagination sprinted from Vlad the Impaler and Bram Stoker's *Dracula* to vampire bats. Or had Romanians settled the region? Then my grammar school Latin kicked in and I remembered *trans* means "through" and *sylvan* translates as "woods."

Much of the forested county of Transylvania once was home—until 1798—to the Cherokee. Thereafter, the region soon sprawled with farmland worked by Scots-Irish immigrants in the early nineteenth century. By 1860, the region's population had grown from just a few settlers, prompting Representative Joseph P. Jordan to introduce a bill to the North Carolina House of Commons to establish a new county from parts of Henderson and Jackson Counties. Jordan, of Blantyre, chose the name Transylvania for the new county.

A City Is Born

During the first official meeting of the Transylvania court on May 28, 1861, Alexander England, Leander Gash and Braxton Lankford jointly donated fifty acres for a new town site. Christened "Brevard," the fledgling city began with two stores, a new wood-frame courthouse and county jail, two churches and a dozen residences.

The name Brevard hails from the surname Beauvert—meaning "beautiful green growth"—of Huguenot provenance. Beauverts emigrated from France to Northern Ireland, then to America before 1711, settling in Maryland and other eastern states. The family modified its name to Brevard.

Although early settlers in the area included John Brevard, it was not John but Dr. Ephraim Brevard (1744–1781)—a non-resident—for whom the city of Brevard, North Carolina, was named. His family relocated to North Carolina when Ephraim was four years old. He studied medicine at Princeton.

A Revolutionary War hero, Dr. Brevard is remembered also as a member of the First Provincial Congress of North Carolina and for having drafted the Mecklenburg Resolves (known also as the Mecklenburg Declaration of Independence) at Charlotte, North Carolina, in 1775. A monument to Ephraim Brevard in front of Brevard's city hall reads, "[He] fought bravely and died a martyr to that liberty, which none loved better and few understood so well."

Early Industry

Sawmills, cotton and paper mills, logging and tanning counted among Transylvania County's early industries. With the coming of the railroad in 1894, Brevard experienced a wave of tourism. To lodge visitors attracted to the region's mild climate, hiking trails and breathtaking vistas, hotels sprang up and homeowners opened their residences to boarders. Early guests included Henry Ford, Thomas Edison and the tire king Harvey Firestone.

An Enchanting Mountain Town

Encompassed by the Pisgah National Forest and hundreds of waterfalls in what began as a settlement of fewer than two hundred inhabitants, Brevard has grown to a population of seven thousand. Intersected by Main and Broad Streets, downtown Brevard was laid

out on the crest of a ridge known locally as Jailhouse Hill. On the northeast corner of the intersection stands Transylvania County's Italianate courthouse, completed in 1881. A jail was added to the rear of the red brick structure in 1921. With the courthouse on one's right, a gaze down West Main Street proffers views of the Blue Ridge Mountains.

Flanking Main and Broad Streets, brick storefronts—many of them dating from the late 1800s to early 1900s—propose a scene from the past. Strolling the revitalized, sixteen-block business district, shoppers and diners discover one-of-a-kind boutiques and eateries.

Distinctive Shops

Brevard—where parking is free on tree-lined streets—boasts the incredible O.P. Taylor's Toy Store, called "Santa's place to shop in the South" by *Southern Living* magazine. Across the street, the White Squirrel Shoppe purveys accessories and collectibles. Collectors also discover a number of treasure shops, and do-it-yourself epicures will surely admire Brevard's offerings.

The Dining Scene

Need a break? Drop into any of Brevard's coffee shops, or enjoy a burger and malt at the 1950s-era lunch counter at Rocky's Soda Shop & Grill. Then grab a luscious pastry at Bracken Mountain Bakery.

For seafood lovers and connoisseurs of continental fare, Brevard indulges with a variety of eateries.

Cultural Oasis

The arts are a vital part of Brevard, evidenced by the Transylvania Community Arts Center and no fewer than eight galleries, including the celebrated Red Wolf Gallery. The Arts Center sponsors monthly Fourth-Friday Gallery Walks.

All about town, the stroller finds on the public greens animal sculptures fashioned by local artists from steel, copper, stone, marble and limestone. Subjects include a bobcat, monarch butterflies, an elk, a red wolf, ravens and a panther. Known as the Sculpture Trail, the permanent exhibit signifies the community's appreciation of the natural world and how nature inspires art.

Transylvania County Handcrafters' Guild presents four annual craft shows at Brevard College. Brevard's Little Theatre has fostered a community theatre group since its founding by Beulah Mae Zachary, the executive producer of *Kukla, Fran and Ollie*, a 1950s television program for children. The Heart of Brevard sponsors annual festivals and concerts at the courthouse gazebo.

The Tinsley Museum and Research Center showcases special exhibits and the private collections of celebrated Brevard native author, artist, photographer, teacher and musician Jim Bob Tinsley. Another celebrity, the comedienne and recording artist Jackie "Moms" Mabley (1894–1975), was also born in Brevard.

The county seat of Transylvania County is probably best known for the Brevard Music Center (BMC), with summer performances ranging from orchestra to opera and chamber music to pops. Founded in 1936, the world-renowned BMC maintains a program for talented young people—one of the country's finest summer institutes for aspiring musicians.

Brevard College, a four-year liberal arts institution with nationally recognized programs in music and environmental studies, is home to the Paul Porter Center for Performing Arts. The Porter Center has established a reputation for its acoustically perfect Scott Concert Hall and its high-quality "Artist Series."

White Squirrels

Second only to BMC, Brevard is famous for its white squirrels. As they have dark eyes, these woodland rodents are not an albino variety. In 1986, the Brevard City Council unanimously approved an ordinance protecting all squirrels in the area. Brevard hosts its annual White Squirrel Festival each May, and there is even a research institute at Brevard College dedicated to the study of white squirrels.

Of Further Interest

Beyond peerless boutiques and a cross-section of eateries on Brevard's Main and Broad Streets lie diversions for nearly every taste and interest.

Using Brevard as a base, the naturalist may enjoy the "Land of Waterfalls" surrounding the county seat. Among more than 250 cascades is Looking Glass Falls—one of Transylvania County's most spectacular and accessible—less than eight miles from downtown Brevard. Others, including Twin, Laughing, Moore Cove, Bridal Veil and Connestee Falls, are found within a distance of eight to twenty miles from downtown.

Just a few blocks from downtown looms Silvermont, the 1917 Colonial Revival mansion of industrialist Joseph Silversteen. Designed by New York architect C. Bertram French and couched within seven wooded acres, the thirty-three-room home has served as a recreation center since the manse was willed to the people of Transylvania County. On Thursdays from 7:00 to 10:00 p.m., Silvermont hosts Mountain Music, a free event featuring area musicians.

Western North Carolina's oldest extant frame home stands just a few miles from downtown Brevard. Known as the Allison-Deaver House, the structure dates back to 1815. Owner William Deaver's brother-in-law, Colonel D. (Davy) Crockett, reputedly visited the homestead. Deaver was one of the men assigned to the task of planning Transylvania County's red brick courthouse. The home is a heritage education center and is listed with the National Register of Historic Places. Docent-led tours are available for visitors mid-May through October on Fridays, Saturdays and Sundays.

Additional historic buildings include St. Philip's Episcopal Church, 317 East Main Street; the Inn at Brevard/William E. Breese Jr. House, 410 East Main Street; and the Probart Street Homes, a concentrated group of significant residences built from 1900 to 1925.

Cashiers and Whitewater Falls

Pack a picnic, grab your camera and retreat to waterfall country near Cashiers, at the southern crest of the Blue Ridge Mountains, northeast of Highlands and just a few miles south and west of the Eastern Continental Divide. Water from this elevation of 3,500 feet flows in two directions: southeast to the Atlantic and southwest to the Gulf of Mexico. And the falls are outstanding.

In the county of Jackson, the resort town of Cashiers (pronounced Cash´-ers) perches on a mountain plateau that drops abruptly on both sides to national forestland. Golfers, hikers, birders and other nature enthusiasts seek this quiet corner of the Blue Ridge.

Historians disagree about the naming of the valley and town of Cashiers. A few suggest a horse called Cash, owned by Senator John C. Calhoun, may have influenced the designation. Some cite the racehorse Cash, whose substantial earnings enabled the equine's winter pasturage in what would become known as Cashiers Valley. A sprinkling of others insist the town was named for Cassius, a prizewinning bull owned by General Wade Hampton, who vacationed in the region. Most, however, agree the village was named for the first white settler—a hermit who lived in the Whiteside Cove area.

Cashiers may be best known for its golfing and country clubs, rock climbing, boating and sport fishing. Visitors or those passing through to neighboring Highlands oftentimes overlook Cashiers's non-sporting amenities.

Cashiers is a shopping oasis, if you know where to look. The town is situated at the crossroads of U.S. 64 and I-107, with no "main street." The Cashiers Chamber of Commerce—located in a log cabin on U.S. 64, just west of the crossroads—provides a fine brochure, "Cashiers Walking Trail Map." Unpaved, the trail is blazed with identification markers. Along the way, look for Cashiers Antique Mall; Chestnut Square with its apparel boutiques, Horacio's Restaurant & Franco's Café, galleries and a salon; and Village Walk Fine Shops. Your stroll will take you over footbridges and alongside a pond shaded by hemlocks.

Interludes

So, you've shopped 'til you dropped? Have lunch or stay for dinner at any of Cashiers's many restaurants. A favorite among locals and visitors is Cornucopia, a gourmet deli with a vast gazebo-style dining room in an 1892 structure made of American chestnut and English poplar. This was a general store until 1901. Later, the building housed a school, post office and tack shop, and was a private dwelling for local residents Uncle Bubba Bryson, Wimp Davis and others. The building first became a restaurant in 1971. In 1979, Scott Peterkin purchased the business and renamed it Cornucopia. Peterkin's family keeps the tradition alive by serving delicatessen classics.

Diversions

Neighboring attractions include Whiteside Mountain, claiming the highest sheer rock face in the

Grimshawe's post office, circa 1878, near Cashiers.

Appalachian chain. Also in the vicinity, one finds Grimshawe's post office—known as the smallest in the United States, at six feet by five-and-a-half feet. (Grimshawe's post office, however, may actually be the third smallest. Ochopee, Florida, claims the smallest postal station, and Salvo in the Outer Banks, North Carolina, the second-smallest.) The circa 1878 structure can be found off Whiteside Cove Road (off North Carolina 107), about one mile from Whiteside Cove Church. Along the way, check out Cashiers Sliding Rock on the right, just after the little bridge that crosses the Chattooga River. A path will lead you to the falls.

Perhaps you prefer the notion of a picnic, but neglected to pack one? You may shop for provisions at Cashiers's Farmers Market, then head for the hills.

A Spectacle of White Water

In 1911, Congress established Nantahala Forest, a nearly 1.4-million-acre preserve. The pristine setting includes picnic tables, refuse receptacles and miles of clearly marked trails. Within easy range of the parking lot is Whitewater Falls, designated a North Carolina Heritage area.

To reach the falls from the parking area at the trailhead, hike an easy quarter-mile along an asphalt-paved track shaded on either side by hemlock and spruce. Oak, maple, sourwood and holly adorn these thickets; beneath the verdant canopy, catch glimpses of sun-dappled rosebay rhododendron, mountain laurel and flame azalea. In early springtime, the keen observer spots rare Oconee bells (*Shortia galacifolia* Torrey & Gray) gracing the understories of the forest. A distant roar moves you along, and about halfway to your goal—on the right, through the trees—catch sight of a cascade known as Laurel Falls.

Before you know it, you have arrived at a split-rail barricade, over which your eyes feast on the tallest waterfall east of the Rockies. To view Whitewater Falls from this perspective is satisfying, but the scene from below is breathtaking. At 411 feet, Whitewater Falls is 244 feet higher than Niagara Falls, and approximately equal to the drop of Africa's Victoria Falls.

If you feel up to it, descend 135 wooden steps. Along the way, you may take a breather on any of the landings or on the bench located

Whitewater is the highest falls east of the Rockies.

midway. As you descend the stairway, the distant hissing segues to a roaring crescendo. Linger on the viewing platform and relish the grandeur: a foamy white deluge tumbling headlong over fractured rock cliffs and boulders, then plummeting to a gorge formed by the Whitewater River—a spectacle framed by stands of evergreens. Autumn punctuates this scene with orange and gold. Even winter visitors rave about the falls' majesty.

Beyond the platform, the trail continues, but beware: this path is treacherous, especially for the inexperienced hiker. Be prudent, too, of straying beyond the pathways. Western North Carolina waterfalls claim more lives than any other falls in the state. Permanent mounting posts were installed at Whitewater for attaching cables, which are used to retrieve bodies. At least a few careless spectators fall to their deaths each year at Whitewater.

The rivers Whitewater, Thompson, Horsepasture, Toxaway and Chattooga (of *Deliverance* fame) and Silver Run Creek feed the falls in this area. In 1986, 4.5 miles of the Whitewater River gorge were designated part of the National Wild and Scenic River System. When a private corporation planned to build a hydroelectric dam on the river, local conservationists stepped in. This group, known as FROTH (Friends of the Horsepasture), launched a campaign that saved the falls.

The Trek

Allow at least 1.25 hours. In this region, U.S. 64 is curvaceous with plenty of hairpin turns and slow-moving trucks.

A Waterfall Sampler

It should come as no surprise that Macon, Jackson and Transylvania Counties host dozens of waterfalls. The region does, after all, receive an average of ninety inches of annual precipitation.

Bearcamp Falls	60 feet/T*
Bridal Veil Falls	60 feet/M/HC
Dismal Falls	200 feet/T*
Drift Falls	80 feet/T
Dry Falls	80 feet/M
Falls on Greenland Creek (Holly Falls)	70 feet in two sections/J
Flat Creek Falls	100-foot sheer drop/J*
High Falls	70 feet/T*
John's Jump	25 feet/T
Laurel Falls (Corbin Creek Falls)	400-foot series of cascades/T*
Lower Bearwallow Falls	30 feet/T*
Mount Toxaway Falls	hundreds of feet of cascades/J
Rainbow Falls (High Falls)	150 feet/T
Schoolhouse Falls	20 feet/J
Slippery Witch Falls	100 feet (private property)/T
Stairway Falls	seven steps averaging 10 feet/T*

Still House Falls	30 feet/T*
Thompson Falls	600 feet in series of drops and adjoining cascades/T*
Toxaway Falls	125 feet/T/HC
Turtleback Falls	20 feet/T
White Owl Falls	20 feet/T
Whitewater Falls	411 feet/T/J
Windy Falls	over 700 feet in a series of cascades and slides/T*
Wintergreen Falls	180 feet/T/HC

Legend:
J: Jackson County
M: Macon County
T: Transylvania County
HC: Handicapped accessible
*Difficult accessibility

Highlands

Off-season Highlands bids—without the rabble—the same deluxe amenities available to tens of thousands of seasonal adventurers and second-home residents. And in wintertime, parking is a breeze, the weather mild and the trails serene.

The 1879 Highlands Inn.

Haute Hiatus

If not for the ninety-minute journey from Hendersonville to Highlands, I would dine habitually at Madison's Restaurant & Wine Garden. From its top-flight menu to professional service and exquisite ambience, this restaurant exemplifies the art of fine dining.

Madison's is part of the Old Edwards Inn, an 1878 structure listed with the National Register of Historic Places, ranking among Historic Hotels of America. The brick-and-stone-veneered inn is the evolution of Central House, a two-and-a-half-story frame structure with clapboard siding, a gabled roof and a two-tier front porch. In the late nineteenth century, specialties of Central House included the cook Dolly McCall's turkey soup, big biscuits and snow pudding.

Today, the sumptuously restored and upgraded nineteen-guestroom, seven-suite resort inn features Madison's, Hummingbird Lounge for high tea and cocktails, the Rib Shack, fine shops and a full-service spa.

The Vision of an Apple Farmer

Founded in 1875, Highlands in the North Carolina county of Macon was known by the Cherokee as *Onteeorah* ("Hills of the Sky"). The village perches on a hilltop in the southern Blue Ridge Mountains encompassed by the Nantahala National Forest, a region coursing with rills and cascades and sporting more than 180 species of birds. Perhaps the avian residents are the reason a nineteenth-century promotional brochure claimed, "No grasshoppers, chinch bugs, canker worms, or musquitoes [*sic*] to destroy crops or personal comfort."

Some historians believe Spanish explorer Hernando de Soto passed through the territory with two hundred troops in 1590. The first colonists arrived in 1666, but it was South Carolinian Silas McDowell who put Highlands on the map. McDowell, a genius in the cultivation of apples, lived most of his life in Macon County and promoted an area near his home as "Sugartown Highlands"—not solely as an agricultural haven, but particularly as a health and summer resort without equal in the South.

Developers Samuel T. Kelsey and Clinton C. Hutchinson of Kansas took an interest in McDowell's vision and promoted what they named Kelsey's Plateau as a summer resort. The paradisiacal settlement—the second-highest incorporated town east of the Rockies—provided common ground for both Northern and Southern pioneers a mere decade after the Civil War. By 1883 nearly three hundred immigrants from the Eastern states were referring to Kelsey's Plateau as home. The city incorporated under the name of Highlands in 1879. By 1931, the town's population had increased to five hundred, with nearly three thousand summer guests and twenty-five businesses.

Today, Highlands—home to fewer than 1,100 permanent residents and at the height of the tourist season swelling to between 15,000 and 20,000—remains a cultural center for artists, musicians, actors, authors, photographers, scholars and scientists who thrive in its natural setting.

Notable Callers

Highlands' natural wonders and luxurious amenities have drawn corporate magnates and luminaries from stage, screen and the realm of literature and politics. Statesman and chemist C.G. ("Gus") Memminger of Asheville summered with his family for fourteen

years in Highlands. Memminger was the nephew of Christopher Gustavus Memminger of Charleston and Flat Rock fame. The younger Memminger developed the Florida phosphate industry and convinced the Seaboard Air Line Railroad to extend its lines into Florida, leading to the development of Tampa as a major port.

Renowned journalist Elizabeth Meriwether Gilmer (aka Dorothy Dix) vacationed in the township. Years later, so did Burt Reynolds, Lonnie Anderson and Alan Alda. The neighboring Buck Creek area provided the location for the 1987 Hallmark Hall of Fame television special *Foxfire* starring Jessica Tandy, Hume Cronyn and John Denver. James Michener and Malcolm Forbes inscribed their books at Cyrano's on Main Street. Painters Norman Rockwell and George B. Matthews and photographer George Masa (Masahara Izuka) found inspiration in Highlands. George H.W. Bush visited, and so did Lady Bird Johnson, Gerald Ford and Newt and Marianne Gingrich.

Sky-high, First-class, Neat as a Pin

Highlands features parking in the center of its broad Main Street. Alongside, quaint buildings house art galleries, boutiques, antique stores, a furrier, jewelers and a kitchenware shop. There is not a franchise in sight on this pristine boulevard flanked by old-time street lamps, flower boxes and specimen trees. John Parris of the *Asheville Citizen* once wrote of this street, "where flowers, instead of neon, provide the color."

Historic buildings include the 1879 Highlands Inn (previously the Smith Hotel), churches, homes and—tucked into the wilderness—log cabins. One finds the Highlands Community Theatre on Oak Street, one block from Main. After touring and shopping, the visitor may opt for an interlude at Buck's Coffee Café or a browse through the tomes at Cyrano's Bookshop.

Primeval Rainforest

If a marathon shopping excursion hasn't melted the calories, head up Main Street, which becomes Horse Cove Road, and park across from the Highlands Nature Center. On foot, proceed to the right adjacent the sign that reads RAVENEL PARK/SUNSET ROCKS, proceed along the trail and climb to nearly five thousand feet. The park is named for Captain S. Prioleau and Margaretta A. Ravenel of Charleston, former summer residents of Highlands. The Ravenel children donated the parkland to the town in memory of their parents.

Minutes into the hike, find yourself in the midst of Eden: a temperate rainforest of boulders glistening black with dew, lush mosses refining the trailside and supple Oconee bells and trailing arbutus defying the winter season. Wide-open-leafed mountain laurel and rhododendron flourish beneath their cloche of pines and hemlock, tulip trees, locust, birch, maples and oaks. A surfeit of chestnut trees once counted among the standing timber. Sixty years ago, blight wiped them out.

Averaging eighty-seven inches of annual precipitation, the Highlands area supports legion genera of mosses, lycopods and Lilliputian forests of lichens. Highlands, after all, ranks as the lichen capital of the world. Locals also claim the same concerning salamander populations.

After twenty blissful minutes, you reach a fork in the trail. To the right is Sunset Rocks—a sheer precipice from which one may gaze at Highlands from 4,900 feet. Step up to the

scarp and linger, sipping the rarified air, marveling at the illimitable breadth of forested mountains, above it all in the Hills of the Sky.

The Trek

There is no easy way to reach Highlands. From Hendersonville, the drive skirts Laurel Park, Horse Shoe and Etowah, cuts through the heart of Brevard and then winds through Lake Toxaway, Sapphire and Cashiers. Nevertheless, the scenery looks mighty fine along the way.

Dillsboro

A blare resonates between the valley walls. The train chugs forward through the wilderness, clacking southeast toward Dillsboro, North Carolina, the eastern terminus of the Great Smoky Mountains. Then, with Bryson City miles behind, the railcars pass through the 121-year-old Cowee Tunnel.

Over the course of eighteen months, five hundred North Carolina state convicts drilled and gouged the tunnel through nearly solid rock to straighten a bend in the Tuckasegee River. When their boat capsized, nineteen shackled laborers plunged to their deaths. The year was 1883. Legend maintains that as you pass through the cool, dark tunnel, you can still hear the clangor of shackles.

The Great Smoky Mountains Railroad runs between Dillsboro and Bryson City.

Next Stop: Dillsboro

In the latter half of the nineteenth century, the environs of Dillsboro were known for log cabins and family feuds. Industry included logging, milling and, with the coming of the railroad, tourism. Like so many towns in the mountains of Western North Carolina, Dillsboro also gave rise to tuberculosis sanitariums.

Between the foothills of the Blue Ridge and Great Smoky Mountains, Dillsboro nestles above the Tuckasegee River and Scott's Creek. The first summer guests came by rail to New Webster (now Dillsboro) in 1886. In 1889, when the village was incorporated, Colonel Alexander Boyd Andrews of Raleigh chose its new name for William Allen Dills, the Jackson County town's first homeowner.

Dills, a surveyor, was elected to the general assembly in Raleigh. His daughter, Gertrude Dills McKee, later served on the assembly as North Carolina's first female senator.

Dills and his wife, Alice Enloe Dills, lived in a home of log construction until their permanent home—on a knoll overlooking Scott's Creek and the Tuckasegee River—was completed in 1876. The nascent town was lighted with Cape Cod lamps and the depot was a decommissioned boxcar on a side track of the WNC Railroad (now Southern). Iron horses transported freight, drummers (traveling salesmen) and summer guests. Given Dillsboro's growing popularity, a proper depot was constructed in the late 1800s and the town grew up around the railroad.

The Dills's clapboard home, still standing—appended and known as the Riverwood Shops since 1957—was a center of activity in early Dillsboro, hosting guests such as North Carolina Governor Zebulon Baird Vance. The home served also as the town's first post office, with Mrs. Dills as the postmistress. Mr. Dills acted as railroad ticket agent until a depot was erected.

A Summer Resort

Dillsboro's first summer callers were the Misses Nellie and Hattie Norfleet of Edenton, North Carolina, and the first women cigarette smokers the locals had ever seen.

Minnie Dills Gray wrote in *A History of Dillsboro, North Carolina*:

> *When passenger trains arrived at the railway station, it was like bedlam. Mt. Beulah's porter would charge up and down beside the coaches calling, "All off fo' de Mount Beulah Hotel where ever-things to yo' likin'." The Potts porter on the opposite side of the train would be yelling his lungs out, "All off fo' de Potts Hotel." At the same time the old apple vendors, Jason Barker and his rival Sol Dorsey were trying to make themselves heard, saying, "Hur's yor good eatin' apples—plenty uv 'em for ever-body." This was during the time before the automobile, when people traveled by train. Summer visitors came and spent the summer, with many remaining until the mountains put on their magnificent garb, seemingly, just for them.*

Mount Beulah Hotel, built in 1884 (later known as Jarrett Springs Hotel), continues to function as a popular inn and restaurant called Jarrett House. Victorian guests enjoyed bathing in a sulfur spring at the rear of the hotel and were frequently entertained by a Cherokee brass band.

Dillsboro's historic structures include Bradley's General Store, Enloe Market Place, Squire Watkins Inn (an 1880s Queen Anne Victorian) and Jarrett Memorial Baptist

Dillsboro's Jarrett House (left) was called the Mount Beulah Hotel when it was built in 1884.

Church. Historic homes and inns flank Haywood Road (State Road 19/23), Front and Webster Streets, many of them in service today as shops, restaurants or lodging. The depot no longer stands alongside the historic tracks.

With a population hovering around two hundred, and only two blocks long, Dillsboro is a slice of old-time, small-town America. A walkable town, Dillsboro serves up a mix of gift, antique and craft shops, art galleries, restaurants and inns. Many of the clapboard-faced edifices are painted white—a splendid townscape against a backdrop of mountains and sky. Moreover, Dillsboro must be a place to kick back, judging by the manifold hammocks, porch swings and rocking chairs.

The town's renown as an arts-and-crafts center dates to the mid-twentieth century when Dillsboro resident Lucy Morgan (1889–1981) originated the Penland School of Crafts. Morgan's brother, Ralph, a doctor, established the Pewter Shop in Dillsboro. Dr. Morgan and his wife taught local craftspeople to hammer pewter—the provenance of Dillsboro's Riverwood Pewter Shop.

Dillsboro's artisans, innkeepers and restaurateurs are laid-back and friendly. Added to this, the town's scenery, activities and glorious landscapes define a restorative weekend getaway or a dilly of a day trip.

The Trek

Before you reach Dillsboro, be sure to stop for a look at the Jackson County courthouse perched on a hill in neighboring Sylva.

Waynesville

Nine townships, fifteen counties and three boroughs bear his name. So does Wayne State University in Detroit—including the university's annual concert, a nearby pub and a fifteen-star flag flying over the campus, designating United States control of Detroit under his leadership in 1796. The man was General "Mad" Anthony Wayne (1745–1796), one of the most colorful commanders in chief of the United States Army. General Wayne earned the sobriquet through his daring in the battle of Stony Point. The United States has Wayne to thank for its expansion beyond the original states along the Atlantic Coast. To recognize the exploits of this Revolutionary War hero, Colonel Robert Love—founder of Waynesville, North Carolina—suggested the name, which was adopted in 1810.

Waynesville's claim to Civil War fame came on May 9, 1865, during a skirmish between Thomas Legion's Cherokee troops and the Union cavalry, when a Federal soldier was killed. This was the last shot of the Civil War in North Carolina, and marked the surrender of General James Martin.

Long before the arrival of white settlers in 1785, the Cherokee inhabited this region of the Pigeon River basin. Previously part of Burke County, it became known as Haywood County in 1808, with Waynesville its county seat since 1809. Edward Hyatt was among the early pioneers, having brought his family from England and established a long line of Hyatts.

Haywood County's most famous resident was Felix Walker (1753–1828), a North Carolina Republican representative elected to the Fifteenth Congress and reelected to the Sixteenth and Seventeenth Congresses, 1817–23. Walker fought in the Indian Wars, as a high private in the Revolutionary War. He also accompanied Daniel Boone on an

The stately Haywood County courthouse at Waynesville dates from 1934.

expedition to Kentucky. Between wars and politics, Walker was a pioneer, farmer, trader, lawyer, frontiersman and land speculator in several North Carolina counties. Felix Walker died and was buried in Clint, Mississippi.

In 1900, two North Carolina congressional candidates hailed from Waynesville: W.T. Crawford (D) and James Moody (R). R.D. Gilmer, the winning candidate for attorney general, lived within a block of Crawford and Moody. Moody won the congressional seat, died before his term was up and was succeeded by Crawford.

Since its founding, Waynesville has been known as a resort destination. With the coming of the railroad, the town gained popularity for its health retreats. Industry included logging, furniture factories, A.C. Lawrence Tannery and Champion Paper at neighboring Canton. In the 1940s, more than half of Waynesville's residents made their living by farming.

Old-fashioned Hospitality

Waynesville, the oldest town in Haywood County, looks forward to its bicentennial in 2009. Meanwhile, visitors enjoy old-fashioned hospitality while savoring the town's amenities from cabins, country inns and vacation rentals to Vance Street Park and Recreation Center, mountain-ringed golf resorts and a thriving downtown. Art galleries, restaurants, specialty shops, an old-timey theater and Mast General Store flank the brick sidewalks of Main Street. Two blocks below, "Frog Level" has been revitalized with additional ateliers, and is listed with the National Register of Historic Districts for the history of its railroad depot and warehousing.

In the shadows of the Great Smoky Mountains, Waynesville plays host to a flourishing music, art and handicraft scene. Local artisans purvey paintings, pottery, metalwork, musical instruments, weavings and glassware.

Benches flank Main Street, abetting the weary shopper, as do pleasant coffeehouses, teahouses and bakeries. Three blocks from South Main Street on Pigeon Street, historic Shelton House embodies the Museum of North Carolina Handicrafts. On Wednesdays and Saturdays, a parking lot across from the courthouse hosts farmers markets from 8:00 a.m. until noon, and each early May, Waynesville hosts its Ramp Festival, featuring food and live music.

Built from the same stone used for the Washington Monument in D.C., Haywood County's historic courthouse in Waynesville is open weekdays to the public. Inside, one finds majestic stone staircases, arched windows and intricately carved woodwork. The courthouse is one of the few in the nation with the Ten Commandments displayed above the judge's bench.

Excursions from Waynesville include hiking and breathtaking views on Cold Mountain, the gardens encompassing Lake Junaluska and the attractions of Canton and Clyde, ranging from trout fishing and horseback riding to gem mines and the historic Papertown Museum.

Added to all of this, Waynesville throbs with festivals, holiday celebrations and a vibrant nightlife, and was voted one of the top one hundred places to retire.

Weaverville and the Zebulon B. Vance Birthplace

Nestled above Reems Creek about ten minutes north of Asheville, Weaverville reminds the visitor of gentler times. Home to fewer than 2,600 residents, the fetching town proposes a time capsule with plenty to do and see.

A Weaverville Primer

Only the Cherokee dwelled in the Reems Creek Valley—which they called Dry Ridge (*uKYd E>f*, pronounced u-ka-yo-di tsa-le-gi)—until the 1700s, when white pioneers discovered the region's healthful, arable nature and named it "Pine Cabin." Among the first early immigrants was John Weaver (1763–1830).

Seeking freedom of religion and speech, Weaver and his three brothers fled Germany and sailed to America via Holland. The brothers volunteered their services during the Revolution and John served five years with the Pennsylvania Rangers. While scouting through the wilds in 1785, John staked land claims from the Ohio River to northern parts of North Carolina, and purchased several hundred acres at fifty shillings each.

At twenty-one, Weaver courted and married thirteen-year-old Elizabeth Biffle (circa 1771–1843) at Elizabethton, Tennessee. With their baby son—the first of eleven children—the Weavers settled in an area that later became known as Reems Creek Valley. Their cabin was the second permanent white settlement southwest of the Blue Ridge, and the first in the northern sector of present Buncombe County. The town of Weaverville was named for them.

The city of Weaverville was founded and incorporated in 1850. Weaver College (formerly Weaverville College) was founded by the Methodist Church in 1856, and operated for sixty years. In the late 1800s, Weaverville was home to grand hotels such as the Dula Springs and Blackberry Lodge. O. Henry, like others, took respites in Weaverville for its clean air and breathtaking scenery.

Entrepreneur Rex Howland opened a trolley line in 1909, which, for a fee of thirty-five cents, carried hotel guests and day visitors the six miles from Asheville's Pack Square to downtown Weaverville. The one-way journey took forty-five minutes. A decade later, the trolley line ceased due to bankruptcy, but Weaverville's distinction as a resort destination was established. The creation of Lake Juanita (now called Lake Louise) in 1910 further enhanced the town's touristic appeal.

The grand hotels are gone now, and Weaverville's elegant country houses accommodate overnighters. And there are always plenty of attractions, activities and enticements for the day-tripper—not to mention hospitality.

A Hub of the Arts, Dining, Spa Services and More

Weaverville thrives as a bedroom community of Asheville, with an enchanting downtown flanked with specialty shops and excellent eateries. An antique street clock, seasonal plantings and a medley of brick, plaster and clapboard storefronts grace the mere six blocks of Weaverville's Main Street. A spectrum of awnings and Old World signage show not a trace of franchise or big-box emporium, but rather a microcosm of art studios and galleries,

restaurants, wellness centers and spas. Other temptations include a bakery, a sporting goods store, florists, a repository featuring vintage architectural fixtures and charming bed-and-breakfasts. Parking is rarely a problem. And on Thursdays during warmer months Weaverville hosts a tailgate market with produce, flowers and homemade canned goods sold by area farmers.

They say in Weaverville that the police jiggle doorknobs every evening to make sure shopkeepers remembered to lock up. Postal carriers deliver letters even when they lack addresses, and one finds but a single traffic light on Main Street.

Zebulon B. Vance Birthplace

In 1957, the State of North Carolina purchased a tangible piece of history, rescuing the old Vance farm from chainsaws, earthmovers and tract developments. Conservators resurrected the structures, and on May 13, 1961—the 131st anniversary of Zebulon Baird Vance's birth—the State rededicated the site to the citizens of North Carolina.

Between 1785 and 1790, pioneer David Vance and his family settled at Reems Creek Valley in the shadows of the Blue Ridge. Vance acquired his farm property in 1795. Research sheds no light on whether the buildings were included in the purchase or whether Vance constructed them.

Vance served in the Continental army and at Kings Mountain during the American Revolution and as representative in the North Carolina General Assembly. He was a teacher, lawyer and surveyor; was appointed clerk for the court of Buncombe County; and was elected colonel of the militia.

Each of Vance's sons led lives marked by service to the people of North Carolina in local, state and national capacities. The most famous of his sons was Zebulon Baird Vance (1830–1894). Zeb, known as the "War Governor of the South," was an ardent supporter of the Confederate cause and served as colonel in command of the Twenty-sixth North Carolina Regiment.

Zeb Vance, one of the dominant personalities of the South for nearly half a century, held public office for thirty years. A lawyer and powerful debater, Vance was elected to his first public office at the age of twenty-four. He served in the North Carolina House of Commons and the United States House of Representatives, and was elected governor three times. Vance was the only governor in any state—North or South—to uphold vigorously the writ of *habeas corpus*. He motivated North Carolinians to make the greatest contribution in men and spirit to the Southern cause.

State Historic Site

The Vance family's two-story, five-room home stands reconstructed of hewn yellow pine logs chinked with clay. Sunlight trickles through mullioned panes and gaps in the roof, illuminating aged brick, braided rugs and blue-and-white quilts. The enormous double fireplace and chimneys are original, as are some of the furnishings. Vivid reminders of life as it was in the eighteenth and nineteenth centuries are evident throughout, from hearthside cooking and baking implements to bed warmers and chamber pots. Period furnishings include poster beds (one original to the house) with true-to-the-period rope netting as mattress supports.

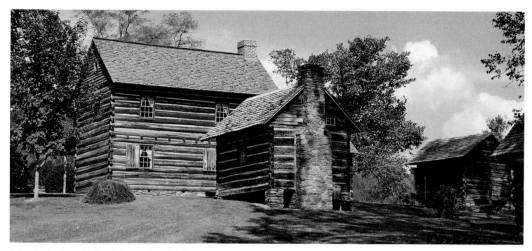

The Zebulon Baird Vance Birthplace near Weaverville.

Clustered about the grounds are six log outbuildings: the corncrib, spring house (still producing one gallon per hour), smokehouse, loom house, slave cabin and tool shed. The land spreads verdant in the shade of mighty black walnut, oak and maple trees.

Docent Victor Burgess, historic site assistant, leads small to large groups through the property. Burgess's passion for history is evident in his detailed descriptions of colonial architecture, weaponry and heroes. He keeps visitors on their toes with trick questions, and if he should stumble upon a puzzling inquiry, he defers to Site Manager David Tate at the visitors' center. On those rare occasions when Tate hasn't an answer, he knows where to find it in one of his books.

The center exhibits portraits of Zeb Vance, his writing desk, books, weapons and other memorabilia. To learn further about the life of one of the South's greatest heroes, guests may take in a twenty-minute video presentation.

Burnsville

Woodlands unfold to pasturelands alongside North Carolina 19, gracing the route between U.S. 26 and the Yancey County seat of Burnsville. Couched amid nineteen prominent peaks—including Mount Mitchell (at 6,684 feet, the highest mountain east of the Mississippi)—this circuit was originally blazed by the Cherokee. More than eight hundred years ago, Indians tended cornfields on the banks of the nearby Cane and South Toe Rivers and hunted elk amid the virgin forests towering above their shores.

The county of Yancey, known as the Gateway to Mount Mitchell, sports the highest average elevation of any county in North Carolina. The town of Burnsville—Yancey's largest—lies at 2,815 feet, one of the county's lowest points. Countywide industries include agriculture (Christmas trees, ornamental shrubs, tobacco and beef cattle), textile mills, a bedspring manufacturer and an asphalt plant.

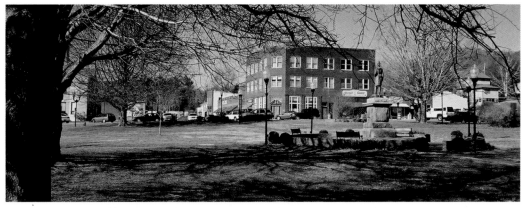

Downtown Burnsville girdles an enormous grassy square.

Elvis Slept Here

Like an oasis in the midst of farmland and backwoods, Burnsville looks almost too cute to be true. The heart of this town, girdled by four main streets, encompasses an enormous grassy square, in the center of which a copper Otway Burns holds court from a pedestal inscribed with the words "He guarded well our seas. Let our mountains honor him."

In his 1888 book *On Horseback*, Charles Dudley Warner described Burnsville as "more like a New England village than any hitherto seen." Changes have occurred since Dudley Warner's time, but for the most part Burnsville is an attractive, old-timey town.

The "shabby courthouse" mentioned by Warner has been restored, updated and is used now as the town hall and police department. A new, classically styled, red brick courthouse stands across the square. The "inviting tavern with a long veranda" was the NuWray Inn (1833), which stands today and has hosted such guests as Mark Twain, Elvis Presley and Christopher Reeve. The historic inn maintains a family-style dining room called Fireside Restaurant.

In downtown Burnsville, one finds no franchises and no cookie-cutter sameness, only vintage architecture and unique shops. Wedged between a warren of brick-faced buildings, the Yancey Theater manifests a prominent Art Deco marquee. Like mini malls, some of the structures commingle, including the Design Gallery, which opens to Gourmet Gallery and Yummi Yarns; and Monkey Business (toys) to Something Special Gift Shop. Heart & Soul Books is up a flight from Appalachian Java and the visitors' center occupies a restored service station on West Main Street.

Perched on a hill above the visitors' center stands the Rush Wray Museum of Yancey County History. The museum occupies the circa 1850 McElroy House, which headquartered the Western Brigade of North Carolina Home Guard during the Civil War.

When moonshine ran like water in Yancey County, Burnsville was known for incidents of heavy drinking, fighting and murder. Today the county is dry and the village of Burnsville is leisurely and picturesque. In their town of fewer than 1,700 residents, Burnsvillians say they've never met a stranger.

Yancey and Burns

Established in 1833 from portions of Buncombe and Burke Counties, Yancey County was named for Bartlett Yancey Jr. (1785–1828), a distinguished statesman. Yancey served with Henry Clay in the U.S. Thirteenth and Fourteenth Congresses, 1813–17, and was speaker of the North Carolina Senate, 1817–27.

Burnsville was named for Captain Otway Burns (1775–1850), a War of 1812 naval hero and commander of the merchant ship *Snap Dragon*. Burns served in the North Carolina Legislature and—at the cost of his political career—cast the tie-breaking vote permitting new Western North Carolina counties to be formed, including the establishment of Yancey County. Burns and Yancey were friends, and it was Burns who convinced Yancey that local citizens should have a courthouse more conveniently located than in distant Morganton. Burns recommended to Yancey the site that would be established as Burnsville in 1834. John "Yellow Jacket" Bailey gave the land for the town and named the county seat for his friend Burns.

A Panoply of Artists

Today, Burnsville boasts more crafters and artisans per capita than anywhere else in the United States. Basket makers fashion their wares (including those known as glass-and-berry baskets) from the bark of tulip trees. Local talent also includes glassblowers, metalsmiths, painters, photographers, potters, quilters, sculptors, weavers and woodworkers.

Unique among the artisans are sisters Dana McDowell and Karen Wyatt. The two grew up in Burnsville and then worked for years in Asheville. In 2000, they opened DK Puttyroot and the Orchid Tearoom in Burnsville. McDowell and Wyatt produce handmade papers, pulling each sheet the old-fashioned way. From these exquisite papers crafted from parochial fibers—such as tobacco, corn, kudzu and grapevine—the sisters fashion journals, sculpture, boxes and other décor items, and they size sheets for use as stationery and original notecard designs. DK Puttyroot carries accessories for the artist, journalist and scrapbooker such as fine art papers, calligraphy sets, exotic feather quills, inkwells, pen sets, choice writing inks and hand-blown Venetian glass writing instruments.

An unexpected fête awaits the shopper in the upper level of DK Puttyroot: the Orchid Tearoom, a self-service tea bar purveying a vast array of premium, rare and exotic leaves and custom-baked pastries. Patrons may relax in any of the sunny nooks, which are themed from Japanese (equipped for authentic tea ceremonies) to African and traditional Southern porch décor. Private rooms are available for parties or meetings.

Burnsville Town Center

No matter the season in Burnsville, there are always activities concerning the arts, crafts, storytelling and music that embody the spirit of Appalachia. Come springtime, arts and crafts are featured with a festival on the square. During summer, there's bluegrass pickin' at the town center, where there is also a farmers market, quilting workshops and exhibits reflective of Appalachian culture and heritage. A Fourth of July bash, hoedowns, clogging, the Fall Festival and Christmas festivities count among the many occasions celebrated in Burnsville.

Ideal Encampment

If you have more than one day available to spend in Burnsville, enjoy an overnight stay. Yancey County indulges the explorer with all from hiking trails and biking, fishing, kayaking, golfing and skiing to dude ranches for serious horseback riding. Mountain peaks, streams, waterfalls, campgrounds and a plenitude of log cabins, crafters' cottages and galleries dot the back road scenery along North Carolina 80 through the Toe River Valley. Then, following a full day of exploration and physical activity, kick back in one of Burnsville's cozy inns as you contemplate the next day's diversions.

Saluda and Pearson's Falls Glen

The city in Polk County known since 1881 as Saluda derives its name from the Cherokee word *su-lu u-we-yv* ("Corn River"). Called Pace's Gap by early settlers and white herdsmen in the early 1800s, Saluda was then simply a crossroads of Winding Stair and Howard Gap Roads where drovers herded livestock for trade from western towns. Spreading over seven hills, one thousand feet above Tryon, Saluda once prospered as a railroad town drawing vacationers and the infirm from far and wide. Today, Saluda—together with Tryon, Columbus and Landrum (South Carolina)—counts among the loop of historic villages known fondly as "the String of Pearls."

A Wealth of Railroad History

Though trains no longer clamber up a precipitous grade and through Saluda, many of the town's citizens lobby for a tourist run through downtown. Here, early railroad culture is evident, beginning with the relocated—though historically accurate—Craftsman, or "stick-style," depot at the northwest end of town.

Early railroad history is unmistakable in Saluda.

Shortly after the Civil War, Captain Charles William Pearson surveyed this region for the Norfolk Southern Railroad route between Salisbury and Asheville, and Asheville to Murphy. As groundwater precluded a rail system through Howard Gap, Pearson selected the grade up Saluda Mountain. At great expense—including that of human lives—ties were laid and rails were spiked along what became known as the steepest mainline standard-gauge grade in the United States. The railway was completed in 1878 and on July 4, 1879, the first train chugged up the three-mile grade from Melrose to

Pace's Gap. Ultimately, eight passenger trains passed through daily. Six of those were the *Carolina Special* routed between Charleston and Cincinnati with whistle stops at Columbia, Spartanburg, Tryon, Saluda, Hendersonville and Asheville. Writers F. Scott and Zelda Fitzgerald and Dorothy Dix were counted among the celebrity passengers.

A northbound locomotive required a pusher engine—what locals called the Helper—to propel the last car of a passenger train as it lurched up the grade to Saluda from Melrose Junction. Nevertheless, trains experienced wrecks, runaways and the peril of traversing fifty hairpin turns—among them Slaughterhouse Curve.

Alongside the now-quiet tracks, the visitor enjoys fine shops and galleries in the old depot and its neighboring Summer House, which purveys home and garden accents, antiques and gifts. The expanse between the two buildings and a vintage caboose provides acoustical excellence and is known as Saluda's "open-air listening room." Here local musicians perform in concert from late February through September.

Cultural Treasure

Though I-26 will get you to Saluda expeditiously, opt for the scenic route. Along U.S. 176—with Hendersonville about ten miles behind you—Saluda submits an excellent vantage point from the High Bridge over the tracks. From this approach, one can appreciate the queue of brick and plaster storefronts.

Recently awarded a position on the National Historic Register, Saluda is a time capsule of nineteenth- and early twentieth-century architecture. The 5.2-acre historic commercial district includes the Saluda depot, the library (donated by Nolan D. Pace Sr.), Saluda City Hall/Police Department (once the Carolina State Bank), M.A. Pace Store, Thompson's Store, the pebbledashed Robertson Store, the Nelson Building (formerly the Princess Theatre) and the 1910 post office (currently occupied by the Saluda Mountain Telephone Company).

A walk down Saluda's Main Street is a stroll through the past, with antique and modern temptations. From the sidewalk, produce and hardware goods beckon the shopper as they did in days of old. Artworks, gifts and antiques tantalize from the windows. Fragrant aromas waft from restaurants, and in warmer weather a potter throws clay on her wheel, curbside, on a tree-shaded sidewalk. Drop into any of the galleries, shops or restaurants as a treat for the senses and experience the friendly atmosphere of this former railroad town. Better still, visit in early July during Coon Dog Day—a fun-filled event featuring a parade.

Beyond downtown, tour the cross streets to discover Victorian homes, some of them bed-and-breakfast inns. Find and admire the Gothic Carpenter–style Presbyterian church, the Episcopal Church of the Transfiguration and the John Howard Johnson house and farm.

Saluda once sported thirty-seven inns and hotels, having become a popular resort as seasonal callers flocked to this town for its clean mountain air and a hopeful cure for tuberculosis. In addition to the now defunct TB sanitariums, Saluda boasted a baby hospital, opened in 1914 by Dr. David Lesesne Smith of Spartanburg, South Carolina.

Today, Saluda is home to 565 residents, among them artists, craftspeople and musicians. The population mushrooms to more than 3,000 during the summer months.

Time for a Break?

Take a respite from touring in any of Saluda's excellent eateries. Assuredly, you will not find franchises here. And if hospitality is an art in Western North Carolina, then Saludans have perfected this notion to the state of masterpiece—whether restaurant personnel, merchants or the gatekeeper at Pearson's Falls Glen.

Crowning Jewel

More intimate than Pisgah or DuPont Forests, the 259-acre site known as Pearson's Falls Glen volunteers a wonderland for nature enthusiasts, hikers and picnickers alike.

Park in the shade of a noble forest and prepare for an unprecedented quarter-mile hike. Passing between moss-enrobed boulders and stones, note delicate flora shaded by hemlock and rhododendron. In springtime, look closely to find Huger's red trillium (*Trillium hugeri*) and walking ferns (*Asplenium rhizophyllum*)—only two of the more than two hundred genera that grace this gorge. Dripping ledges and grottoes harbor in their crevices spleenworts, liverworts and ferns; filtering light renders these delicacies a sweeping spectrum of green.

Along the way, to your right, white water splashes and swirls through Colt Creek; then suddenly before you appears the source: Pearson's Falls, one of the most elegant displays of falling water in Western North Carolina.

In the mid-1850s, engineer Charles Pearson happened upon this glen and falls and later purchased hundreds of the surrounding acres. The Tryon Garden Club has owned and maintained the glen since 1928. The botanical tract, drawing botanists and bird fanciers worldwide, is also a Natural Heritage Site, wildlife preserve and outdoor laboratory for botany departments of nearby colleges and universities.

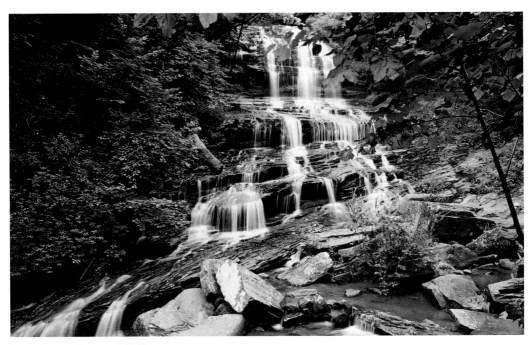

The elegant Pearson's Falls.

Though Saluda is big as a minute, the village and its environs offer much for the day-tripper.

Landrum

If not for accounts from dedicated Boswells, much of our history would be lost to time. Hendersonville's Louise Bailey, Dr. George A. Jones, Jody Barber, Kermit Edney and Frank FitzSimons Sr. researched and recorded events from Henderson County's rich and storied past. The city of Landrum, South Carolina, vaunts such a chronicler in James Walton Lawrence Sr. (1911–2005), the newspaperman and author known as "Old Man Lawrence."

Mr. Lawrence, founder of Landrum's *News Leader* in 1955, knew Landrum and its environs as Hogback Country, so named because the mountain bordering the Piedmont to the north brought to the early settlers' minds a sow nursing her piglets. In a number of books, Lawrence traced the history of his hometown to the mid-1700s.

Settling In

The flatlands of the Piedmont enjoy an idyllic thermal-belt clime protected by Hogback Mountain, spring fed by an important water source named by the Cherokee *Pacoletto*, from which the Pacolet River derives its name. The region was home to the Cherokee long before homesteaders from Pennsylvania, Virginia and Maryland settled in their midst. In this isolated region, white traders built a post in 1760 and shortly afterward fortified the log structure—a defensive measure against natives' guerilla attacks. This was but one of four forts located at critical points in the area.

The first known settler in the region was Lum Pace, whose descendants can still be found in neighboring Polk, Spartanburg, Greenville and Henderson Counties. British fur trade in the region spurred an influx of English and Scots-Irish immigrants seeking religious freedom, many of whom farmed the rich land. Another early pioneer was Theron Earle, who owned vast land holdings in this sparsely populated region known briefly as Earlsville.

At the close of the Revolution, the fortified blockhouse was again modified, this time into a way station and tavern. Sawmills and corn mills added to the local commerce, and settlers' log cabins gave way to frame houses. From the arable banks of the North Pacolet and its tributaries, corn grew in abundance and was available for the drovers' herds of hogs. Farmers traded through Spartanburg and, because of the remoteness of this region known as Dark Corner,* revenuers—Old Man Lawrence explained—often overlooked the most marketable product: "corn in liquid form." Corn was distilled and purchased in abundance not only by locals, but by North Carolinians. In the mid-1800s, Fairview Baptist Church was erected on the site of the old blockhouse.

*Now a part of the Greenville Watershed, Dark Corner is formed by portions of Henderson, Polk, Spartanburg and Greenville Counties.

The Age of Steam

Shortly after the Civil War, civil engineer Charles W. Pearson was commissioned to survey a route for the Spartanburg & Asheville Railway (later Southern) to connect Spartanburg to Tryon, Saluda, Flat Rock, Hendersonville and Asheville. One of the first S&A officers was C.G. Memminger.

Baptist minister Reverend John Gill Landrum (1810–1882) and his brother-in-law owned a large tract of land southeast of Bird Mountain—land that now makes up downtown Landrum. The old Rutherford Road connecting Greenville with Rutherfordton ran through his property. A keen and farsighted man, Landrum proposed to the railroad company that if they were to establish a station at the point where the new railroad would cross the Rutherford–Greenville Road, he would give four acres for the purpose. Memminger accepted the offer and turned the first spade-full of earth at Landrum's Station, as the settlement was known in the 1870s.

In 1877, a little wood-burning balloon-stack locomotive puffed up to Landrum's Station on June 13, pulling two flat cars and a single passenger coach. From lots staked off and sold to speculators for $20 to $100 each, a village formed around the station. A post office opened in 1880 and the village was incorporated as a municipality on December 24, 1883, under the name of Landrum. (The letters of incorporation burned in storage, and Landrum was incorporated again as a township in 1897 and still again in 1912.) Inns and hotels sprang up to accommodate travelers, and soon timber, cotton, grapes and peaches counted among Landrum's commercial enterprises.

More Progress

The late nineteenth century brought to Landrum four hosiery mills, including the Blue Ridge Hosiery Mill, and a cotton gin, the Damask Mill, mercantiles and liquor stores. In the early 1920s, a flourmill (Blue Ridge Roller Mills) was built. Later acquired by Spartan Grain & Mill Co. of Spartanburg, the latter operated into the 1960s.

Making an additional impact on Landrum's economy were Bommer Industries (a spring-hinge manufacturing plant relocated from Brooklyn in 1953), Specialty Electronics, Upstate Machine & Tool Co., Folding Box Co., a casket-manufacturing operation and enterprises that produced slingshots and whirligigs. Some of the downtown buildings were constructed of handmade brick from the O.P. Earle Kiln at Tanyard Creek.

By the 1970s, Landrum's downtown had fallen into decline. A federally sponsored urban renewal project in the 1980s brought back the village's old-time milieu.

Landrum Today

Smaller than Hendersonville, larger than Saluda, Landrum (population 2,500) is situated in Spartanburg County just south of the North Carolina/South Carolina border along South Carolina 14 and west of I-26. Like its neighbors to the north, Landrum has retained and strengthened its traditional downtown center through careful and deliberate city planning.

Gone are most of the feed and farm suppliers and general stores that once flanked the crossroads of Trade and Rutherford Streets, but Thomson Hardware cedes an old-time feeling alongside a stair-step sidewalk. Gone too are the outfitters for English-style fox hunters who once frequented the area between Landrum and Tryon. Nevertheless,

Over the years, Landrum's 1924 post office building has housed a number of businesses.

Landrum's three-block downtown appears as though from the past, albeit the post office, mercantiles and liquor stores now house antique shops, art galleries and restaurants along Rutherford Street, the town's main street. Part of it burned, but a portion of the historic depot stands in a new location, having been moved and restored as a civic center.

Beyond flower-and-bench-bedecked Rutherford Street lie peaceful parks and cemeteries. The environs are punctuated with steeples of Presbyterian, Methodist and Baptist churches. The pace is gentle and residents make time to know one another and extend congeniality to visitors.

Sensing its charms of yore, the visitor to Landrum might wonder about its beginnings. Old Man Lawrence preserved all of that with meticulous documentation. One would only hope that others, prompted by historians' records, would carry the baton into the future, for to know where we are going we must know from where we came.

Epilogue: Touring Western North Carolina

A number of historic bed-and-breakfast inns and conventional hotels and motels together with a variety of restaurants and numerous services make the Hendersonville–Flat Rock area an ideal encampment from which to explore the Western Carolinas.

No matter the season, events and art shows, musical venues and festivals abound throughout the region. During each season, the cities and villages take on distinctive characteristics. Pearson's Falls serves up spring at its wildflowery best. Whitewater Falls thunders sensationally during summertime, as do the hundreds of cascades in the vicinity of Brevard. The environs of Black Mountain, Burnsville, Dillsboro and Waynesville don their most vivid attire during autumn. Tourism in Cashiers and Highlands simmers down in wintertime, affording room to stretch out and breathe in the crisp mountain air. As for Saluda, Weaverville and Landrum, each exudes its own brand of charm regardless of the season.

Many of the homes covered in the "History in Stone and Wood" section of this book are privately owned, although many of them are made accessible to the public during annual or biennial home tour events.

Appalachia's forests and parks provide idyllic facilities for naturalists, hikers, picnickers and campers. During each of our four seasons, parkland visitors revel in nature's offerings. Nearby, the adventurous will likely discover a rousing event or festival and opportunities for intimate glimpses into our rich and complex Western Carolina heritage.

The following appendix lists several of the region's events, festivities, historic places and sites.

Appendix: Henderson County Events and Sites

*I*n Western North Carolina, with its wealth of festivals, workshops, reenactments and four seasons of vistas lading the pages of our mountain city and village calendars, there is never a lack of interesting activities to occupy one's time. A case in point: more than forty festive events enrich each winter holiday season in Hendersonville and Flat Rock. And that's just the beginning.

Whether native, newcomer or tourist, art lovers and the history-minded may choose to browse a cache of museums, historic sites or art galleries, take in a concert or attend a Broadway-caliber play. The adventurous find plenty of locales in which to hike a woodland trail to scout for wildflowers and waterfalls. Or tour orchards during apple blossom and harvest time. And if there's any time left over, golfers may perfect their swing at any of many local courses.

To fill your own calendar, options follow.

Everyone loves a parade, and Hendersonville hosts two per year.

Events

Hendersonville Symphony Orchestra—world-class in a small-town atmosphere, six-concert seasons

Brevard Music Center—summer concerts, box office open May through early August

Gallery Walk—historic downtown Hendersonville, first Friday evening of each month

Hendersonville Little Theatre—a variety of productions in a vintage barn, State Street between Kanuga and Willow Roads, Hendersonville, February through November

Henderson County Crafters Association Shows—Blue Ridge Mall, Hendersonville, March, July and October

Easter Egg Hunt—Jackson Park, Hendersonville

Tulip Extravaganza—more than eight thousand tulips abloom on Main Street, Hendersonville, April

Historic Johnson Farm Spring Festival—Hendersonville, April

Sandburg Folk Music Festival—Carl Sandburg Home National Historic Site, highlighting Sandburg's *The American Songbag*, Flat Rock, May

Olde Tyme Music Festival—historic downtown Hendersonville, May

Flat Rock Playhouse—Flat Rock, mid-May through mid-October plus holiday productions

Garden Jubilee—historic downtown Hendersonville, Memorial Day weekend

ECO Garden Tour—Henderson County, early June

Old Timey Day—Henderson County Curb Market, 221 North Church Street, Hendersonville, first Saturday in June, last Saturday in September

Music on Main Street concert series—historic downtown Hendersonville, every Friday, June through August

Main Street Sidewalk Antique Fair—historic downtown Hendersonville, June

Street Dances—historic downtown Hendersonville, every Monday, July through August

Summer Music Series in Flat Rock—back deck of the Little Rainbow Row of Shops, corner of Greenville Highway (U.S. 225) and Blue Ridge Road, Flat Rock, July through August, 8:00 p.m.

Art on Main—historic downtown Hendersonville, first Saturday and Sunday in August

Fabulous Fourth of July Celebration—Jackson Park, Hendersonville

Chalk It Up!—free sidewalk art contest with prizes, Main Street, historic downtown Hendersonville, mid-July

Flat Rock Tour of Homes—biennial tour of four or more historic homes in Flat Rock

North Carolina Apple Festival and Parade—historic downtown Hendersonville, Labor Day weekend

Coston's Apple House—pick your own apples, tours, wagon rides, 742 Apple Valley Road and 3750 Chimney Rock Road, Hendersonville, open daily, August through October

Lyda Farms—farm tours for groups by appointment, apple sampling, farm animals, games and a hayride through the orchard, 3465 Chimney Rock Road, Hendersonville, open daily, August through October

Railroad Days—sponsored by the Apple Valley Model Railroad Club, Historic Hendersonville Depot, HO-scale model dioramas, free admission, Labor Day Weekend

Apple Country Bicycle Tour—Hendersonville, September

Bird Walk—guided by ECO and the Henderson County Bird Club, Jackson Park, Hendersonville, September and October

North Carolina Mountain State Fair—Western North Carolina Agricultural Center, 1301 Fanning Bridge Road (exit 220), Fletcher, September

A Visit with Lincoln—Carl Sandburg Home National Historic Site, Flat Rock, September

Grandparents' Day—Chimney Rock Park, September

Flat Rock Music Festival—songwriting workshops, jams, camping, boating and kids' village at Camp Ton-A-Wandah, Flat Rock, September

Children's Indian Artifacts Day—Mineral & Lapidary Museum of Henderson County Inc., 400 North Main Street, Hendersonville, September

Farm City Day—farm equipment, old-timey demonstrations, live entertainment, children's games, tractor pull and petting zoo, Jackson Park, Hendersonville, first Saturday in October

Motorama—automobile dealers display new models, historic downtown Hendersonville, October

Autumn Colors Autorama—vintage, antique and classic car show, historic downtown Hendersonville, October

Southeastern Animal Fiber Fair—Western North Carolina Agricultural Center, Fletcher, late October

Trick-or-Treat on Main—historic downtown Hendersonville, October

Craft Show—Blue Ridge Mall, Hendersonville, late October

Fall Harvest Days—antique engine and tractor show, Western North Carolina Agricultural Center, Fletcher

SCOTS Foothills Highland Games—Hendersonville, November

Home for the Holidays—Hendersonville, multiple festive events from early November through late December

Downtown Holiday Lighting Celebration—historic downtown Hendersonville, Friday after Thanksgiving

Holiday Tour of Homes—featuring five or six homes all decked out in a variety of holiday decorations, sponsored by Hendersonville Historic Preservation Commission, Hendersonville, December

Christmas at Connemara—Carl Sandburg Home National Historic Site, Flat Rock, December

"A Carolina Christmas" concert—presented by the Hendersonville Symphony Orchestra and guest artists, December

Historic Johnson Farm Christmas Open House—Hendersonville, December

Olde-Fashioned Hendersonville Christmas—holiday refreshments, carolers and more, historic downtown Hendersonville, first Friday evening in December, merchants stay open until 9:00 p.m.

Hendersonville Christmas Parade—Main Street, historic downtown Hendersonville, first Saturday in December

Ongoing Attractions In and Around Town

Arts Council of Henderson County—a nonprofit organization providing classes, lectures, workshops, educational programs and museum-quality exhibitions, 538-A North Main Street in the historic Skyland Hotel, Hendersonville

Bat Cave—longest known fissure cave in North America, located in the scenic Hickory Nut Gorge, guided hikes available during summer months

Bullington Center—nonprofit horticultural education center offering programs, activities and workshops, Upper Red Oak Trail off Zeb Corn Road, open weekdays from 9:00 a.m. to 4:00 p.m.

Chimney Rock Park—hiking trails, spectacular rock formations and Hickory Nut Falls, lodging, shops, U.S. 64/74A, Chimney Rock, North Carolina

Fifth Avenue Mask Museum—a private cache of more than five hundred exotic masks collected from around the world by Ellen Hobbs, 317 Fifth Avenue West, Hendersonville, by appointment

Henderson County Curb Market—local produce, canned goods, plants, fresh and dried flowers and handicrafts, 221 North Church Street, Hendersonville, open 8:00 a.m. to 2:00 p.m. Tuesday, Thursday and Saturday, April through December; Saturdays only January through March

Henderson County Genealogical & Historical Society Inc.—400 North Main Street in the historic State Trust Company Building

Historic Flat Rock Post Office (circa 1847)/The Book Exchange—2680 Greenville Highway (U.S. 225)

Historic Depot (1902) and Apple Valley Model Railroad Club—HO-scale model dioramas, free admission (donations accepted), Seventh Avenue and Maple Street, Hendersonville

Historic Johnson Farm—furnished Italianate farmhouse, barn with loft museum, tours, trails, petting zoo, 3346 Haywood Road (Highway 191 North), Hendersonville

Holmes Educational State Forest—exhibits depicting the ecology of the managed forest with "talking trees," picnic facilities, ranger-conducted classes available, 1299 Crab Creek Road, Hendersonville, open mid-March through mid-November

Jump Off Rock Scenic Overlook and Park—legendary outcropping on Echo Mountain; trails, spectacular sunsets and views of the French Broad River Valley, the Blue Ridge and Pisgah Mountain Ranges, located at the end of Laurel Park Highway, Laurel Park, open daily from sunrise to sunset

Mineral & Lapidary Museum of Henderson County Inc.—gems, minerals, fossils, artifacts, geodes, dinosaur eggs, free admission, 400 North Main Street, Hendersonville

The Old Mill—early nineteenth-century mill, West Blue Ridge Road near the Greenville Highway (U.S. 225), Flat Rock

St. John in the Wilderness—built 1836, the oldest Episcopal church in Western North Carolina, magnificently landscaped historic cemetery, 1895 Greenville Highway (U.S. 225) at the corner of Rutledge Drive, Flat Rock

Skyland Hotel (1920)—with lobby décor preserved, and housing the Arts Council of Henderson County; author F. Scott Fitzgerald was a guest in the 1930s, 538 North Main Street, Hendersonville

Tailgate Farmers Market—parking lot of the Henderson County Commissioner's Building, 100 King Street, Hendersonville, Saturday mornings, April–October

Western North Carolina Air Museum—adjacent to the Hendersonville Airport, 1340 Gilbert Street off Brooklyn Avenue

Hendersonville and Flat Rock Landmarks Listed with the National Register of Historic Places*

*As of 2006

Aloah Hotel (also known as Inn on Church Street, the Hendersonville Inn/Carson Hotel)—Classical Revival, circa 1900, 201 Third Avenue West, Hendersonville

Brookland (privately owned home)—Greek Revival/Colonial Revival/Federal, designed by Charles Edmondston, 1836, off the Greenville Highway (U.S. 225) north of Flat Rock in the neighborhood of Brookland Manor, Hendersonville

Carl Sandburg Home National Historic Site (also known as Connemara/Rock Hill)—Greek Revival home designed by Charles F. Reichardt, circa 1838; historic furnished home, guided tours, goat herd, dairy barn and milking parlor, cheese-making demonstrations, special events, trails and picnic facilities; Little River Road off the Greenville Highway (U.S. 225), Flat Rock

The Cedars—Classical Revival, 1908, former hotel and boardinghouse, the elegant red brick building now houses a catering and banquet facility, 227 Seventh Avenue West, Hendersonville

Chewning House (also known as the Claddagh Inn/Smith-Green House/McCurry Hotel/Charleston Boarding House)—Classical Revival designed by W.A. Smith, circa 1888 (third story added circa 1912), 755 North Main Street, Hendersonville

Clarke-Hobbs-Davidson House (also known as Masonic Temple/Charles A. Hobbs House)—Queen Anne/Colonial Revival, circa 1900, 229 Fifth Avenue West, Hendersonville

Mary Coxe Mills House—pebbledashed Colonial Revival, circa 1900, 1210 Greenville Highway (U.S. 225), Hendersonville

Druid Hills Historic District—Tudor Revival and Bungalow/Craftsman homes, 1900–44, designs by Earle Sumner Draper and John Nolen, roughly bounded by Meadowbrook Terrace, U.S. 25 North, Ashwood Road and Ridgewood Avenue, Hendersonville

Flat Rock Historic District—Gothic Revival, Stick/Eastlake and Second Empire structures, 1825–99, church-related residence, hotel, post office, religious structure, single-dwelling homes, west of East Flat Rock

Grey Hosiery Mill (also known as Water Department, City of Hendersonville)—Classical Revival, 1915 (with additions in 1919 and 1947), 301 Fourth Avenue East, Hendersonville

Henderson County courthouse—Classical Revival designed by Richard Sharp Smith, 1905, recently restored, featuring a history museum, First Avenue and Main Street, Hendersonville

Hyman Heights–Mount Royal Historic District—Colonial Revival and Bungalow/Craftsman homes, circa 1900–74, roughly bounded by Ridgecrest Place, Highland Avenue, Hyman Avenue, Patton Street, North Main Street and Oakland Street, Hendersonville

Kanuga Lake Historic District (also known as Kanuga Conferences)—Bungalow/Craftsman structures designed by Richard Sharp Smith, John Nolen and others, 1900–49, roughly the area surrounding Kanuga Lake, rural Hendersonville

King-Waldrop House (also known as Maple Grove)—Queen Anne/Italianate, circa 1875–99, 103 South Washington Street, Hendersonville

Lenox Park Historic District (also known as Columbia Park)—Bungalow/Craftsman, Queen Anne and other structures built by Acie H. Jones, circa 1900–74, roughly bounded by Allen, Spring and South Whitted Streets and Southern Railroad, Hendersonville

Main Street Historic District—Classical Revival, Chicago-style and other commercial architecture designed by Erle G. Stillwell, Richard Sharp Smith and others, circa 1850–1949, Main Street between Sixth Avenue East and First Avenue East, Hendersonville

Moss-Johnson Farm (also known as the Historic Johnson Farm)—Italianate brick home designed by Riley Barnett, 1880, 3346 Haywood Road, Hendersonville

Reese House (also known as Sinbad Restaurant)—Queen Anne Victorian designed by James Brown, circa 1885, 202 West Washington Street, Hendersonville

Seventh Avenue Depot District—Queen Anne, Bungalow/Craftsman buildings, commercial, transportation, hotel, warehouse, 1875–1949, Seventh Avenue between Grove and Ash Streets, Hendersonville

Erle Stillwell House—designed by Erle G. Stillwell, 1926, 1300 Pinecrest Drive, Hendersonville

Erle Stillwell House II—Tudor Revival, designed by Erle G. Stillwell, 1925, 541 Blythe Street, Hendersonville

The Waverly Inn (also known as Anderson Boarding House)—Queen Anne, circa 1898, featuring a Robert Eastlake staircase, this is purportedly the oldest surviving inn in Hendersonville, 783 North Main Street

West Side Historic District—Colonial Revival and Bungalow/Craftsman dwellings, school and secondary structure, designed by Erle G. Stillwell and Richard Sharp Smith, 1850–1974, roughly bounded by Fifth Avenue West, Washington Street, Third Avenue West and Blythe Street, Hendersonville

Further Points of Interest

Hendersonville

City hall—designed by Erle G. Stillwell and completed in 1928; Charles Keck's life-sized model for the Raleigh Capitol Building's *The Three Presidents* (North Carolina–born: Andrew Jackson, Andrew Johnson and James Polk) stands in the lobby, 145 Fifth Avenue East

First Bank & Trust Building—designed by Erle G. Stillwell in the neoclassic style and built in 1923, 401 North Main Street

The First Citizens Bank Building (modern)—houses a twenty-eight-foot-high standing clock by Canterbury Clocks, which strikes the hours and quarters in the Westminster Chimes; quilts and historic photos are also on display in the lobby, 599 North Main Street

Justus Pharmacy (also known as the Justus Rexall Store)—1882, now Mike's on Main Street; noteworthy is the vintage, repainted Coca-Cola sign on its side, detailed tin ceiling, early-twentieth-century fixtures and soda fountain/counter, 303 North Main Street

Killarney—built by William Bryson of South Carolina, circa 1858; architect Richard Sharp Smith designed the additions and modifications; presently, Killarney House Inn, 322 Killarney Street

Mast General Store/Syndicate Building (also known as the Maxwell Store Building)—completed circa 1910, the structure housed Maxwell Brown's Fancy Groceries, Freeze Drug Store, Potts 5¢ & 10¢ and the Woodsmen of the World (a benevolent secret society); Mast General Store purveys traditional clothing, travel and trail outfittings, rugged and casual footwear in an old-time mercantile setting with oiled floors, pressed-tin ceiling and a grand staircase, 527 and 529 North Main Street

McClintock Chime Clock—installed in 1923 and now maintained by the local chapter of the National Association of Watch and Clock Collectors; located on the corner of the granite State Trust Co./Ewbank and Ewbank Building (circa 1920), 400 North Main Street

People's National Bank Building (formerly the Henderson County Bank and now commercial and residential space)—neoclassic, designed by Richard Sharp Smith and completed in 1910, one of the earliest examples of reinforced concrete construction in the city of Hendersonville, 229 North Main Street

Queen Theatre (currently occupied by The Goldsmith by Rudi)—Classical Revival second-story façade, 434 North Main Street

Ripley Building ("The Rock Store")—a commercial building of granite, antebellum in style, completed in 1847, the oldest surviving building on Hendersonville's Main Street, 101 South Main Street

St. James Episcopal Church—circa 1920, stunningly beautiful stained-glass windows designed by Frederick W. Cole of the London studios of George Payne, 766 North Main Street

Shepherd-Ripley Building—antebellum commercial building featuring original brick façade and wooden bracketed Italianate cornice, circa 1850, 218 North Main Street

Willow Creek Mill—purportedly haunted, Willow Road

Wolfe's Angel—a white marble statue purchased by William Oliver Wolfe, father of author Thomas Wolfe; the angel, reputed to have spurred the title of the younger Wolfe's 1929 *Look Homeward, Angel*, stands guard at the Johnson family plot, Oakdale Cemetery, U.S. 64 West

World's Heaviest Twins' Burial Site—twins Billy and Benny McCrary weighed 743 and 723 pounds and were renowned for wrestling and motorcycling; their tombstone, at thirteen feet wide and three tons, is the largest in the world; Crab Creek Baptist Church Cemetery, 72 Jeter Mountain Road at Crab Creek Road

Beyond Town

Biltmore Estate—home of magnate George W. Vanderbilt and the largest home in America; spectacular gardens, winery, four-star inn, "Christmas at Biltmore" with extravagant holiday décor, off U.S. 25 in Asheville

Blue Ridge Parkway—more than 469 toll-free miles of breathtaking scenery from Virginia through North Carolina, ranked as "America's Most Scenic Drive"; from elevations between 650 and 6,050 feet, spectators enjoy natural wonders including waterfalls, scenic overlooks, hiking trails, historic sites, parks, picnic facilities, campgrounds, lodging, restaurants and the village of Little Switzerland

Appendix

Downtown Asheville—several examples of classic Art Deco architecture, plus shopping, galleries, bookstores, international dining, professional entertainment, the Grove Arcade, Grove Park Inn

Downtown Greenville, South Carolina—shopping, galleries, bookstores, international dining, the Peace Center performance hall

DuPont State Forest—Stone Mountain, Fawn Lake, Corn Mill Shoals and waterfalls, Cedar Mountain

Lake Lure—tours, marina, beach, Cedar Creek Riding Stables

North Carolina Arboretum—434-acre botanical garden with impressive bonsai exhibit, trails; located within the Bent Creek Experimental Forest of the Pisgah National Forest, 100 Frederick Law Olmsted Way, southwest of Asheville near the Blue Ridge Parkway

Pearson's Falls Glen—quarter-mile trail to the spectacular falls located off State Road 176, four miles north of Tryon, North Carolina, or three miles south of Saluda, North Carolina

Pisgah National Forest—located in the heart of North Carolina's Blue Ridge Mountains; includes Cradle of Forestry, Pink Beds, information center, picnic facilities, waterfalls, guided walks, craftsmen, historic cabins, logging, locomotive, helicopter simulator, Forest Discovery Center and hands-on exhibits

Thomas Wolfe Memorial—Queen Anne–style home of the author furnished with family possessions and open for tours, 52 North Market Street, Asheville

Western North Carolina Farmers Market—thirty-six-acre shopping facility with seventy vendor spaces, farm-fresh produce, canned goods, honey, handcrafted items, 540 Brevard Road, Asheville, open daily 8:00 a.m. to 5:00 p.m., November through March

BIBLIOGRAPHY

Adams, Kevin. *North Carolina Waterfalls: Where to Find Them. How to Photograph Them*. Winston-Salem, NC: John F. Blair, 2003.

Bailey, Louise Howe. *Draw up a Chair*. Skyland, NC: The Hickory Printing Group, 1990.

———. *50 Years with the Vagabonds*. Hendersonville, NC: Coo Coo Enterprises, 1996.

———. *From "Rock Hill" to "Connemara": The Story before Carl Sandburg*. Asheville, NC: Eastern National Park & Monument Association, 1980.

———. *Remembering Henderson County: A Legacy of Lore*. Charleston, SC: The History Press, 2005.

———. *Saint John in the Wilderness: The Oldest Episcopal Church in Western North Carolina, 1836*. Asheville, NC: Biltmore Press, 1995.

Bailey, Louise Howe, and Jody Barber. *Hendersonville and Henderson County: A Pictorial History*. Norfolk, VA: The Donning Company Publishers, 1995.

Baldwin, Mart. *A Busy Day in Loafer's Glory: A Ramblers Guide to Mostly Off-the-Path Carolina Places*. Nebo, NC: Appalachian Press, 1996.

———. *Drifting the River: Growing up Wild in the South*. Old Fort, NC: Wolfhound Press, 1999.

Baring, Alexander. *My Recollections: 1848–1931*. Santa Barbara, CA: The Schauer Printing Studio, Inc., 1933.

Bray, Mary, and Genon Hickerson Neblett. *Chosen Exile*. Nashville, TN: Rutledge Hill Press, 1980.

Brouke, Ben. *Southern Appalachian Hill Tauk Dictionary*. Charlotte, NC: APS Inc., 2002.

Byrne, Kathleen. *Paula Sandburg's Chikaming Goatherd*. Conshohocken, PA: Eastern National Park & Monument Association, 1993.

Bibliography

FitzSimons, Frank L., Sr. *From the Banks of the Oklawaha*, vols. 1–3. Hendersonville, NC: Golden Glow Publishing Co., 1998.

Gray, Minnie Dills. *A History of Dillsboro, North Carolina*. Asheville, NC: The Stephens Press, 1989.

Jenkins, The Reverend Mark. *Calvary Episcopal Church: First 100 Years*. Fletcher, NC: Calvary Parish, 1959.

Jones, George Alexander. *The Heritage of Henderson County, North Carolina*, vols. 1 and 2. Spartanburg, SC: The Reprint Company, Publishers, 1988/2003.

King, Mitchell. Facsimile copies of personal diaries loaned by Louise Howe Bailey: Charleston and Flat Rock, 1829–62.

Lawrence, James Walton, Sr. *Hogback Country*. Landrum, SC: The News Leader, 1982.

————. *The Who and Why of Landrum, S.C. 29356*. Landrum, SC: Lawrence, 2000.

LeBoutillier, Deidre. "Woman of Two Worlds: An Adventurer in the Half-World and the World of Fashion, the Old World and the New." NDL.

Lefler, Susan M. *Brevard*. Charleston, SC: Arcadia Publishing, 2004.

Marsh, Kenneth, and Blanche Marsh. *Historic Flat Rock*. Asheville, NC: Biltmore Press, 1961.

McCullough, Gary L. *North Carolina's State Historic Sites*. Winston-Salem, NC: John F. Blair, 2001.

McDaniel, Douglas Stuart. *Asheville*. Charleston, SC: Arcadia Publishing, 2004.

McGowan, Pierre. *The Gullah Mailman*. Raleigh, NC: Pentland Press, Inc., 2000.

Morgan, Larry G. *Mountain Born, Mountain Molded*. Boone, NC: Parkway Publishers, Inc., 2002.

Niven, Penelope. *Carl Sandburg: A Biography*. New York: Charles Scribner's Sons, 1991.

North Carolina Department of Transportation. *NC Scenic Byways*. Raleigh: North Carolina Department of Transportation's Roadside Unit and Public Affairs Division, 2001.

Patton, Sadie Smathers. *A Condensed History of Flat Rock*. Asheville, NC: Church Printing Co., n.d., circa 1950.

————. *The Story of Henderson County*. Asheville, NC: Miller Printing Co., 1947.

Peattie, Donald Culross. *Pearson's Falls Glen: Its Story, its Flora, its Birds*. Tryon, NC: The Tryon Garden Club, 1962.

Ray, Lenoir. *Postmarks: A History of Henderson County, North Carolina, 1787–1968*. Chicago: Adams Press, 1970.

Reuther, Galen. *The Carl Sandburg Home: Connemara*. Charleston, SC: Arcadia Publishing, 2006.

———. *Flat Rock*. Charleston, SC: Arcadia Publishing, 2004.

Reuther, Galen, and Lu Ann Welter. *Hendersonville*. Charleston, SC: Arcadia Publishing, 2005.

Sakowski, Carolyn. *Touring the Western North Carolina Backroads*. Winston-Salem, NC: John F. Blair, 2002.

Shaffner, Randolph P. *Heart of the Blue Ridge: Highlands, North Carolina*. Highlands, NC: Faraway Publishing, 2004.

Summer Institute of Linguistics and Wycliffe Bible Translators. *De Good Nyews Bout Jedus Christ Wa Luke Write. The Gospel According to Luke in Gullah Sea-Island Creole with Marginal Text of the King James Version*. New York: American Bible Society, 1994.

Swannanoa Valley Museum. *Black Mountain and the Swannanoa Valley*. Charleston, SC: Arcadia Publishing, 2004.

Trenholm, Alicia Middleton. *Flat Rock, North Carolina: A Sketch of the Past*. Flat Rock, NC, 1908.

The histories of the Flat Rock homes are the distillations of site visits, tours and conversations and interviews between Terry Ruscin and the homes' current owners. Additionally, Ruscin interviewed Henderson County historian Louise Bailey; Historic Flat Rock, Inc. (HFRI) president Andries Jansma; Elise Pinckney, board member of HFRI, retired editor of *South Carolina Historical Society Magazine* and great-granddaughter of Frederick Rutledge; HFRI volunteer David Dethero; and Newton Duke Angier. Ruscin researched and garnered the lineage of ownership through the Henderson County Register of Deeds Office.

ALSO BY TERRY RUSCIN

Dining & Whining: Commiseration and Celebration for Gastro-Snobs

Los Duendes: A Nostalgic Journey through Spain

Taste for Travel: A Trilogy of Gastronomic Adventures: Great Britain, France, Italy

Mission Memoirs: A Collection of Photographs, Illustrations, and Late Twentieth-century Reflections on California's Past

Terry Ruscin also collaborated with Father Jerome Tupa and Holly Witchey in *An Uncommon Mission*

Index

C

INDEX

Index

Visit us at

www.historypress.net

MUD ROOM

Drift of Roses

Ollie Clouds

Drift of Roses

Entry Curves thru Ollie Clouds.
Clouds @ 4'-0" o.c.

Driveway into clearing @ House

9' Hanley Gravel Driveway

Pepper Canopy

Delivery Box

Rosemary

Delivery Box for packages

Climbing Roses on Fence

Entry under Canopy of Tree

Giannetti '18

Patina Living

BROOKE GIANNETTI & STEVE GIANNETTI

PHOTOGRAPHY BY VICTORIA PEARSON

GIBBS SMITH
TO ENRICH AND INSPIRE HUMANKIND

Contents

The Fire

It was ten in the morning on December 5, 2017. Steve and I were doing our last-minute check around Patina Farm, the family home we designed in Ojai, California. On this morning, Patina Farm was a smoky ghost town surrounded by deep orange flames. A viscious California wildfire was forcing us to evacuate. As we watched the towering flames engulf the mountains around our home, Steve, our daughter, Leila, and I packed up our cars with our dogs, rabbit, sheep and goats and all of their necessities. Our gardener, Ricardo, and his team somehow convinced our four miniature donkeys to get into our neighbor's trailer to be driven to a safe location. We set our chickens free, leaving food and water and praying for their safety until we could return.

After walking through each room of the house, attempting to take a mental inventory of cherished, memory-filled possessions, we headed out to the gardens. As we hurried through the now-mature grounds of Patina Farm, we were reminded of the time we had installed the new plantings that would become our outdoor rooms. Now, five years later, the gardens looked lush and lovely, softened by the pale pink haze of the fire; but they were also quiet and lifeless. Our donkeys, Buttercup, Daisy, Blossom and Huckleberry, were not grazing the lower fields or sleeping under the pepper trees as they normally did. The protected garden and animal barn next to my office—where our miniature pygmy goats, sisters Thelma and Louise and their best friend, Dot, and our sheep, Linen, Paisley and Cashmere, normally lounged and played—were silent and deserted.

As we headed out to our packed cars, Steve asked me if there was anything else that I wanted to take with us. I looked around at the house—a house we had spent years thoughtfully designing—and realized that all I really needed to take, the soul of our house, was already securely resting in our cars.

While driving away, we talked about our first dreams of Patina Farm. Steve recalled his ideas of an Italian garden complete with a terraced fruit orchard, a formal rose garden, and outdoor rooms surrounded by boxwood. I remembered imagining myself standing at our future kitchen sink as I watched donkeys chasing each other across the field. I clearly envisioned farm animals visiting me in the garden next to my office. I saw myself gathering fresh eggs from our coop, giving mealworms to the chickens as a thank-you for our breakfast. At the time, Steve had looked at me like he thought I had gone mad. "What are we going to do with all of those animals?" he asked.

Five years later, on this terrible morning during the fires, we both understood the answer to that question in a deeper way than we could ever have imagined before, and the answer had more to do with what the animals were doing for us and the meaning they had brought to our lives.

As we've shared our journey to Patina Farm—on my blog, *Velvet and Linen*, in our book *Patina Farm* and on Instagram—many of our readers have shared their desire to move toward an organic, nature-centered life. Some of you just want to add more gardens to your property or figure out how to have a few chickens in your side yard, while others dream of creating your version of Patina Farm, with farm animals and a potager to grow your own food.

We are writing this book for all of you, to share why we decided to embrace this lifestyle and what we have learned along the way. We will also introduce you to some of the wonderful people in our life who have helped us navigate the winding road of farm life. One of the important nuggets of wisdom we have learned is that there is not just one way to live. The idea of this book is to explain what works (and hasn't worked) for us and why. By sharing our journey, we hope to demystify the homestead farm lifestyle. If we city folk can do it, so can you!

Where It
All Began

If you had met Steve and me fifteen years ago, you never would have imagined us living on a farm. We both grew up in the city. We raised our children in the city of Santa Monica, where we lived on a small 50 by 150-foot lot. Our life was hectic, filled with family activities and the demands of our design work. We were happy, but we craved some calm to balance the fast pace of our life.

As we described in our previous books, I found a reprieve from our life commitments in the *potager* garden that we built in the front of our Santa Monica home. I discovered the zen of gardening, finding the time I spent weeding, planting, amending, and watering to be meditative. The dirt underneath my nails began to look more beautiful than any manicure. This connection to the earth energized my body and soul, and the ability to grow food for our family to eat fed my innate desire to nurture the ones I loved. The voices in my head became quieter and the frenetic pace of life slowed down.

For many people living in the city, this is where the story would end. But the serenity I experienced in our garden was a game changer for me and soon led to my adding chickens to our urban life. Caring for our new ladies and eating the eggs they gifted us pushed us farther down the path toward rural living, and Steve and I began to think about other ways we could re-center our lives to include more time gardening and caring for animals.

Combining dreams with reality is a challenge, but it's at the heart of what we do for our architecture and design clients. We decided to apply this process to our own life. Steve and I started to brainstorm what our dream life might look like. Our thoughts led to the creation of Patina Farm in Ojai, a small artistic and rural community about an hour and a half north of Los Angeles.

Over the past five years on Patina Farm, we've come to realize that it is the living things that bring deeper meaning to our days. It is the pleasure we feel when we are working in the vegetable garden or sitting under that massive oak tree, listening to the water as it flows through our fountain. It's the contentment I experience when I'm in our garden, lost in the beauty of the blooming roses and the relaxing scent of the lavender. Patina living is embodied in the joy that envelops us when the donkeys greet us by their hay barn in anticipation of dinner, and the pleasure that fills us when one of our goats affectionately nuzzles her head against our legs in appreciation for a neck massage. It is these moments during our day that make our life worthwhile.

The fabric of our daily life is a weaving of animals, gardens, family time and work. We decided the best way for you to fully experience life at Patina Farm is to allow the parts of our life to intertwine throughout the book as well. We hope you enjoy your visit.

Morning Meditation

Have you ever gone to bed in the evening and thought "Where did the day go?" When we lived in the city, most of my days ended this way. I was on the go from the moment I woke up until my head hit the pillow at night. During the day, I found that I was lost in contemplation about either the future or the past. My thoughts would bounce from worrying about design details for a project to concerns about different issues with our children. Don't get me wrong: some worry is good and can ensure that important items don't fall through the cracks. But obsessing about things past and future that were beyond my control was making me anxious and unhappy. I tried all of the usual ways to stay in the moment—a variety of yoga classes, meditation, etc.—but nothing quieted the voices and slowed down time more than the moments I spent gardening or with my animals. So I began to structure my days to include more of these in-the-moment experiences.

I wanted to design a daily morning ritual that would help me focus on the present moment. Instead of quietly meditating, my morning spiritual practice is centered around animal care. Like many other routines, Steve and I tend to our animals in a specific order; we have a flow. I walk out of my office and am greeted by the quacks and squawks of our ducks and little bantam chickens. After I open their coop doors, my ladies fan out with excitement, cheering me on as I fill their water bins and scoop their custom-mixed feed into vintage troughs. Morning treats include hand-torn lettuce for the ducks and crunchy dried mealworms for the rest.

I'm allowed only a minute or two to get lost in the view of my flock happily taking turns eating worms, pecking at their feed, or drinking from their water bins like giddy ladies at an all-you-can-eat buffet before "baas" and "maas" emanating from the barn bring me back to my tasks. Inside the barn, the goats, sheep and our "upstairs," full-size chickens greet me and Steve, who has already fed our four braying donkeys and the handful of "downstairs" chickens that sleep in the lower coop. The heightened energy from our tribe of five mini goats and three Babydoll sheep is infectious, as they start their prebreakfast break dance around us. Steve and I take turns grabbing the hay from the hay closet and fluffing it up in the feeder that sits outside the barn. While our little herd is busy eating, Steve and I refill water tubs and glamorously sweep up the poop that has piled up around the barn overnight. I place bowls of goat minerals, grains, and black oil sunflower seeds on top of the goat sleeping shelves, so the food can be easily eaten by the goats but is out of reach from the sheep, who are unable to digest the copper in the goat feed.

Then comes the best moment of the day: Steve and I stand still as we watch our contented animals and listen to them thank us with sounds of delight.

When people find out how many animals we have, they often ask, "Doesn't it take a lot of time to care for them?" The answer is yes and no. Yes, we do spend a lot of time every day caring for the animals, but because we are living in the moment during those times of day, it actually feels like we've been given *more* time, and the quality of those moments is higher than any other time in the day.

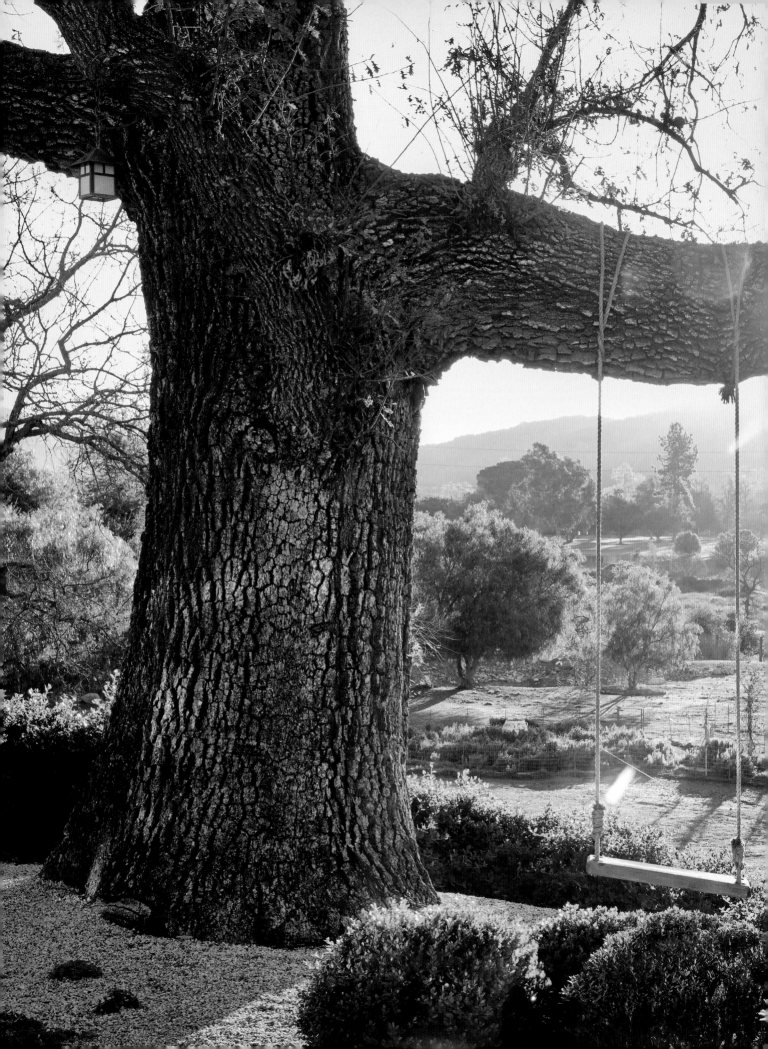

When our ducks reached maturity, we noticed an alarming situation. Our male, Skipper, was viciously attacking MaryAnn. Through research, we discovered that this was a common occurrence during mating season, but it didn't change the fact that if left to his own devices, Skipper might very well kill MaryAnn. We decided to separate them and thought MaryAnn would be happier in the bantam chicken garden. But she spent her days crying out for Skipper. Our solution was to make a screen door between the office garden and the duck area, allowing MaryAnn to see Skipper while staying safe.

Outside My Window

When we first began the design of Patina Farm, we had only the chickens to focus on. We placed their coop next to my office, a focal point beyond my original vegetable garden. It was very important that the design of the chicken coop be not only beautiful but also secure and efficient. Because of the many nighttime predators, we installed strong chicken wire on all sides of the coop and sheets of stainless steel mesh underneath the dirt floor to ensure no animals could dig their way into the space. A wall of cabinetry on one side of the coop provides ample storage for supplies and also includes a sink/cleaning area. A bale of hay fits perfectly in one of the tall closets while still leaving room on the upper shelves for goat treats and extra chicken feed.

Our original bantam chickens (smaller breeds) were thrilled with their new housing, and I adored popping into the coop during the day to check for eggs, scattering our extra table scraps as treats for our hens. Viewing my feathered ladies digging and pecking through my office window gave me delightful breaks, even during the most hectic workdays.

As our menagerie grew, so did their housing needs. We transformed our original coop into the goat and sheep barn by adding platforms and stairs around the interior of the barn to serve as a goat sleeping area at night and a jungle gym by day. The sheep love sleeping in the cubbies underneath the platforms. The tallest platform is too tall for the goats to jump on, so it is a perfect location for the chicken feeder.

We invited the sheep and goats into the garden outside of my office as well. I adored having the animals in clear view during the day, but truth be told, the amount of poop in proximity to the house was not ideal. It wasn't too bad when the weather was dry, but rain made it quite a mess. As much as I loved having my herd so close, I had to accept that there needed to be a little separation. Fortunately, I can still see them from my office because the walls to the barn are made of clear plexiglass and chicken wire.

When the goats and sheep moved into the barn, we constructed a new coop and secure chicken run behind our greenhouse on the lower level of our land. Back then, we didn't let our chickens free range, fearing they might become a meal for a hawk. One day, the door to the run was left open, and we found all of our hens joyfully exploring our entire acreage. Seeing how happy our ladies were with their new-found freedom, we didn't have the heart to restrict them to their run anymore. Now all of our full-size chickens spend their days free ranging, working as our natural pest control. Their instincts send them seeking safety under bushes and trees when they feel threatened, and we haven't lost a bird to a predator yet. As with other problems that have arisen in our life with animals, we know that there may come a day when we will need to take other precautions, but that's just life on the farm!

The garden outside my office has enjoyed many transformations! It is now the home to our seven smaller bantam chickens. MaryAnn, our female duck, lives in this garden as well. For now, everyone seems happy with their roommates, but that can change. When it does, we will go into problem-solving mode again!

Split Rail Fencing
Chicken Wire

"Mt. Ranier" Greenhouse

Corrugated Roof w/2x4 Roof Framing

Parrafin wax ventilator

extra pots

Seedlings

5'6"

Cross-Section

Stainless Steel Mesh

Door Hold open to let chickens out but not let goats in...

Feeding planters

Chicken Aviary

8'0"

8'0"

Cedar 1x8 Siding

2x4 Framing

Roosting Boxes

Cedar Door

8'0"

Roosting Poles

Chicken Coop

Rosemary Hedge

12/12

5'6"

Cut away view above

Elev.

Chicken Garden

amy 18

We store our custom chicken feed and other supplies in covered, galvanized
trash bins. The cans keep our greenhouse looking pretty
while protecting the feed from curious squirrels, rabbits, gophers and mice.

One Big Happy Family

When we started adding different animals to our family, we had concerns about housing. Did we have to keep everyone separated? Would the rambunctious goats harm our chickens? Do sheep and goats get along? We've discovered that there is mutual respect among species. As I will explain later on, every breed of animal has its own personality traits. As with people, there are also different personalities among the same breed. But for the most part, all of our animals live in harmony. Exceptions to this rule have more to do with interpersonal relationships within breeds than relationships between different types of animals.

We are always surprised by the unexpected friendships that occur here at Patina Farm. Last year, we thought we would keep some chickens in a cage in the barn. We thought this would allow the new chickens to safely get to know some of our bigger animals in the upstairs barn before introducing them to our existing chickens that live in the coop on the lower level of our land. After moving the acclimatized new ladies to the lower coop, to our surprise, they had no interest in becoming part of our existing flock. They much preferred the company of the sheep and goats! Paisley, our most demure sheep, and one of these new hens formed a very special bond, and we often find the little black hen hitching a ride on top of Paisley's back. Paisley doesn't seem to mind. In fact, she seems to slow her stride to keep her chicken friend from falling off!

I believe our animals see Steve and me, as well as the other humans they encounter, as just members of another breed, no better or worse. As long as we treat them kindly and appreciate their needs (feeding them on their set schedule, giving them a dry place to get out of the rain, providing them with plenty of room to roam), they show us respect and appreciation as well. This is one of the many lessons our animals have taught us.

Lounging with the Sheep

I call our sheep "the couch potatoes of the ruminants." Unlike our curious and somewhat mischievous goats, our sheep are content with being fuel-efficient lawn mowers in the morning and relaxing in the shade under our pepper trees or in the barn as the temperatures rise in the afternoon. Their sedentary tendency allow them to be easily contained but also makes them prone to gaining weight more easily than our goats.

I find a sheep's personality to be equal parts stoic Buddha and alert soldier. When I stare into their eyes, I see a calm wisdom. But if our sheep feel the slightest bit threatened, they are quick to make a run for it. Because sheep are so often preyed upon, they have a healthy level of instinctual distrust of everyone, including their loving caregivers and their barn roommates. In their eyes, any one of us could be a wolf in sheep's clothing!

There are many different breeds of sheep, each with its own unique characteristics. We chose Babydoll Southdown sheep for several reasons. Babydolls are a miniature breed (about 17 to 24 inches at the shoulder), which pairs nicely with our miniature goats. Since they eat from the same feeder and sleep in the barn together, we didn't want too much of a size difference. Steve and I care for the animals on our own most of the time, and Babydolls' smaller size makes them easier for us to handle. Babydolls are also particularly good weeders. They can be trusted around our fruit trees and most of our other shrubs, unlike our naughty goats! Babydolls are also a hardy breed and are less susceptible to foot rot and intestinal parasites. The final reason we chose Baby doll sheep? Those adorable smiles!

I also love the Babydolls' soft wool. I'm learning how to knit and hope to be able to turn their wool into cozy, chunky blankets and beanies. One challenge, though, is that Babydoll Southdown sheep have thick wool that grows around their eyes. As cute as their fuzzy faces may be, this fur can cause wool blindness and make them more susceptible to problems navigating and detecting predators. Frequent shearing or trimming around the face can help prevent wool blindness. Steve and I do the trimming together; Steve calms the animal and holds its head motionless while I carefully guide my scissors around its eyes. Great care and focus enable us to finish this task without accidents.

Living in the warm Southern California climate, we have our sheep sheared twice a year, for the animals' comfort. The first shearing is done in early April, after the coldest weather is over and before the summer heat sets in. The second shearing is performed in early August, since the hottest months in Ojai are often September and October. In cooler climates, shearing is done only once a year, in the spring.

Our Babydoll sheep have been a wonderful addition to our family. Hand feeding them some of their molasses oat treats in the morning and just watching them graze as a herd on the grass that grows in the winter on our lower land add to the tranquility at Patina Farm.

When the sheep are newly sheared, they look almost identical.
We can't tell them apart. The funny thing is they can't recognize each other either.
They often call out looking for each other even when they are together.
OPPOSITE, CLOCKWISE FROM UPPER LEFT: *Our black sheep, Velvet, passed away last year,*
but we have many fond memories of our short time with her. Although our shearer is a gentle man,
on shearing day, we often find our sheep attempting to hide. Steve and I giving
Linen a little face trim to keep the wool out of her eyes.

Rose Gardens
and Arbor

For the gardens at Patina Farm, we desired to create a balance of formal and informal, structure and chaos, masculine and feminine. Our rose-covered arbor on the lower land is a perfect example of all of the above. The arbor is a series of pale gray steel arches on axis with the vegetable garden. We chose to cover the metal structure with white flori-bunda roses and plant lavender along the base of the vines. This restrained palette allows the arbor to read as one larger structure. When in bloom (which is most of the year), the arbor is a gorgeous focal point of the view from our home.

Our two rose gardens are more chaos than structure. Instead of just one color of bloom, I chose a selection of David Austin roses whose colors range from intense fuchsia to the palest peach. Their scents are equally varied, filling the air with hints of sweet fruitiness and musky rose. Beneath the roses is a carpet woven from a mixture of my favorite ground covers: pink and white Santa Barbara daisy, deep purple geranium and white blooming snow-in-summer. In the spring, pale lavender, peach and white bearded iris make an appearance just before the roses hit their stride.

Our rose gardens are a delightful and meaningful part of my routine. In the morning, I look forward to toting my cutting basket outside. With sharp clippers in hand, I spend several moments breathing in the perfumed air. These deep inhalations calm my body and guide my focus. I gaze out at my garden and admire the natural floral arrangement that already exists when the blossoms have yet to be cut. But I am not alone here: the bees from our hives are always present, gathering the pollen that is hidden inside the velveteen petals.

Our hens also enjoy spending the morning in the rose garden with me, dining on the insect breakfast they uncover in the soil. Frequently, one of our cats turns up as well, as he keeps a lookout for any stray rodents that might decide to wander onto Patina Farm. No sounds pass between us, but there is a sense of camaraderie among us all as we all perform our morning tasks.

OPPOSITE: *After several years, the white floribunda rose vines are making their way across the arbor, creating a romantic walkway toward the lavender circle.*

On many days, our outdoor dining table transforms into a shady cutting table.

Italian Cypress

Lavender Hedge

Boxwood
Balls

Garden Axis

Companion
~ Plants ~

Bearded Iris
Isis croatica

Snow in Summer
Cerastium tomentosum

Germander Hedge
Teucrium lucidrys

Santa Barbara Daisy
Ergeron Karvinskianus

Geranium rozane

Lambs ear
Stachys byzantia

Fuji Espialier apple

Oval
Lawn

Antique
fountain as
focal point
of Rose garden

Antique
oil jar

David Austin
~ Roses ~

① Ambridge Rose

② Shepards Rose

③ Alnwick Rose

④ Jude the obscure Rose

⑤ Crocus Rose

⑥ Wildeve Rose

⑦ Eden Rose - climbing

Rose Garden

any 18

Inspired by the famous "pink moment" sunsets in Ojai, I chose many of the flowering plants for their blush-color blooms. The various shades of pink also complement the cool, neutral colors inside our home.

*Little Louise may be our smallest goat, but she is full of personality. She is the
first one to discover a hole in our fence or an open gate that will allow her to snack on our roses
or lavender.* OPPOSITE: *After cutting in the garden, I place buckets of roses and
flowering branches in the mudroom until I can arrange them into bouquets around our home.*

Our Peeps

I'm a bit addicted to baby birds and enjoy the experience of raising day-old chicks inside our home. The experience of raising our babies fills my need to nurture, and I know our little birds bond to us as much as we bond to them. We now have a place in Steve's office bathroom that is dedicated to the baby chick cage, and it seems to be filled with little peepers at least twice a year. After five years on the farm, Steve doesn't even bat an eye when he sees the red glow of the heat lamp emanating from his bathroom. Unfortunately, it doesn't take long for the little ones to grow their feathers and get ready to be introduced to the rest of our flock.

I have such a weakness for these little critters that I imagine Steve holds his breath every time I visit Wachter's, our local feed and grain store. He never knows what I'll decide to bring home. A couple of years ago, I became smitten with three tiny, pale gray button quail. Not only were these miniature fowl "cute as a button," they were also in the Patina Farm color scheme! Although Steve doesn't instigate any of these new additions, he's always a happy participant and an excellent problem solver, which definitely comes in handy! The day I brought them home, Steve helped me design a custom quail habitat. Inside the enclosed area, we planted strawberries to provide the quail with something to nibble as well as offer them a sense of security from (nonexistent) predators.

After a recent visit to Wachter's, I proudly told Steve how I resisted bringing home a few of the precious two-day-old yellow ducklings that were sleeping in a cozy pile under a heat lamp. To my surprise, he responded, "You should have brought them home." Well, after that reaction, how could I resist? I immediately drove down the street to correct my oversight! The next moment we were the proud parents of four living yellow peeps, just in time for Easter! I now call Steve "my enabler."

During a visit to our local feed store last year, I couldn't resist these four little ducklings.
They were bonded to each other at the store, so I brought them all home.

*Although Ginger looked exactly like the other three Pekin ducklings, when she
grew up she turned out to be an a tall, lanky Indian Runner.*
OPPOSITE: *Even at this early age, all four of the ducks always went everywhere as one unit.*

Our free-ranging chickens produce the most vibrant-colored eggs. They are as delicious as they look!
I don't believe it is a coincidence that our hens lay eggs in a color palette that
is similar to the colors of our home. Were they inspired by my work, or was I inspired by theirs?

Using our beautiful wedding china at breakfast brings meaning and history to our day.

SIMPLE FRITTATA WITH OVEN-ROASTED CHERRY TOMATOES

Serves 4

1 pint cherry tomatoes
3 tablespoons olive oil, divided
3 sprigs fresh thyme, leaves picked, divided
¾ teaspoon salt, divided
¾ teaspoon pepper, divided
1 large onion, peeled and sliced
1 small green bell pepper, thinly sliced
1 small red bell pepper, thinly sliced
8 large eggs, beaten
4 ounces goat cheese, crumbled

Preheat oven to 400° F. On a rimmed baking sheet, toss cherry tomatoes, 1 tablespoon olive oil, 2 sprigs thyme, ¼ teaspoon salt and ¼ teaspoon pepper. Roast for 25 minutes, or until tomatoes are wrinkled and juicy.

Heat a 10-inch ovenproof skillet over medium heat and add remaining 2 tablespoons olive oil. Add onion and peppers and sauté 8–10 minutes, or until softened. Beat together eggs, ½ teaspoon salt and ½ teaspoon pepper and pour into skillet. Turn off heat, sprinkle with goat cheese and transfer to oven for 18–22 minutes, or until set in the middle. Carefully remove from the oven and let cool 4 minutes before loosening around the edges and sliding from the pan onto a cutting board.

To serve, slice frittata into wedges and top with roasted tomatoes and their juices. Garnish with remaining thyme.

The Cloud
Garden

Wysteria

climbing Roses on
Sunset Trellis

-Catmint groundcover
Below Boxwoods

Rocks and gas logs
for an outdoor campfire
Firepit,

Boxwoods placed
2-3' apart will grow into
Clouds 2-4' Tall

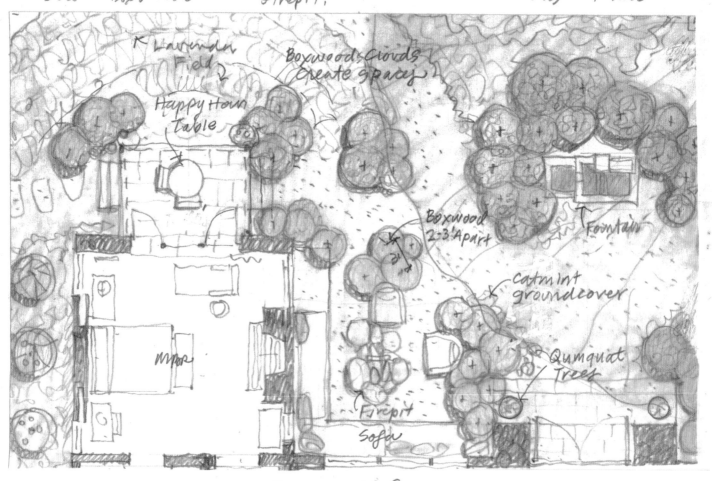

Lavender
Field

Boxwoods Clouds
Create spaces

Happy Hour
Table

Boxwood
2-3' Apart

Fountain

Catmint
groundcover

Qumquat
Trees

Firepit

Sofa

Cloud Garden

Aug '18

We designed the landscape at Patina Farm to enrich the time we spend in our gardens and with the animals throughout each day. Behind our home, we created outside garden rooms surrounded by boxwood topiary "clouds." The restrained color palette of plantings imbues these outdoor spaces with serenity, making them ideal locations to dine and relax with family and friends. These outdoor rooms overlook the lower portion of our land, allowing us to be entertained by our animals as they graze and frolic.

When we have guests or the children come home for a visit, we gather around the farmhouse table (page 49), shaded by the 250-year-old oak tree. The sound of the water gently splashing in the limestone fountain is the musical accompaniment to all of our alfresco meals. This outdoor dining room also gives us an ideal view of the Topa Topa Mountains as they turn bright pink at sunset.

After we've eaten, we invite our pups to relax with us around the firepit as the chickens wander by. Occasionally we allow the goats some special time with us in these spaces behind the house. Once they've "trimmed" the foliage, we walk them back through the gates to their designated grazing areas.

Our outdoor rooms provide us spaces to mark the winding down in the evening or to spend rejuvenating moments in the morning or afternoon. These restful breaks have added enormously to the quality of our life and our mental well-being. I believe they contribute to our productivity and focus when we are at work. There is more of a balance to our life now, and whenever we feel overwhelmed or a little burnt out, we just walk out our back door.

OPPOSITE: *The Boston ivy and wisteria vines add a sense of the seasons. During the spring and summer, our home turns green. As fall approaches, the leaves on the vines turn burnt orange and yellow. In the winter, the leafless vines give an ancient character to our home.*

*We rescued our barn cat, Sundance, and in return he helps keep the
rodent population down at Patina Farm. Although he is feral,
he has become quite friendly and often joins us for drinks on our porch.*

Pink dahlias in a collection of bud vases complement
the worn blue-gray paint on the Swedish cabinet in our bedroom.

An archway in the tall hedges provides a glimpse into the boxwood secret garden by our bathroom.
OPPOSITE: *A potted boxwood and a pitcher of flowers connect our dressing room to the garden outside.*

Lavender
Garden

When designing our gardens, Steve and I envisioned creating a world that was pleasing to all of the senses. With this goal in mind, we selected many plant varieties that contribute not only visual beauty but also fragrance or other qualities to our outdoor spaces.

We are very blessed to live in a Mediterranean climate that is conducive to growing lavender. Lavender is one of my favorite gifts that the garden offers our family. We plant our lavender in fields that get the benefit of gentle breezes. Our bees enjoy pollinating the lavender fields, buzzing from the abundant flowers. A hint of lavender is present in all of the honey they produce. During much of the year, the air at Patina Farm is infused with the herbal scent of the lavender flowers and bushes. As I stroll through the garden, I often slide a handful of the small purple flowers off their stems into my hand and deeply inhale their fragrance. I can feel my body relax with each breath.

Lavender makes its way into our home in a variety of ways. After drying the lavender stems upside down in a dark, cool place, I remove the flowers and fill muslin sachet bags with dried blooms to place in my linen closet and between my folded pajamas. I also set a bowl of freshly dried lavender by our bedside. Its naturally calming perfume relaxes us as we drift off to sleep. Lavender has also found a place in our kitchen. We've discovered that a subtle whisper of lavender flowers is tasty in cookies and spring salads, and it also makes a delicious addition to summer lemonade.

I included a couple of different varieties of lavender in our landscape. They bloom at different times of the year, allowing us to appreciate each type as the garden changes from spring into summer and then transforms into early fall. The varieties we grow also complement the other flowers in our garden. Freshly cut garden roses mix well with the long, slim stems of both our English lavender *(Lavandula angustifolia)* and Spanish, or French, lavender *(Lavandula stoechas)*, whose butterfly-shaped blooms and stalky silver foliage enhance rose bouquets for the house.

Our French lavender blooms in late spring, covering the hills with a purple carpet.

After harvesting the lavender, I tie it with twine and hang it to dry in our cool, dark shed.

A combination of Spanish lavender with its butterfly-shaped blooms
is paired with the soft, fuzzy-leafed lamb's ear.

Leonardo da Vinci

The simple floral arrangement from the garden, combined with a vintage cement snail garden element and a collection of old gilt candlesticks displayed on our antique French limestone is a wonderful mix of rustic and ornate. OPPOSITE: *The flowering stems in our Gracie wallpaper panels and the galvanized bucket of budding branches clipped from our fruit trees add a sense of springtime to our living room.*

Midday Recess
with the Goats

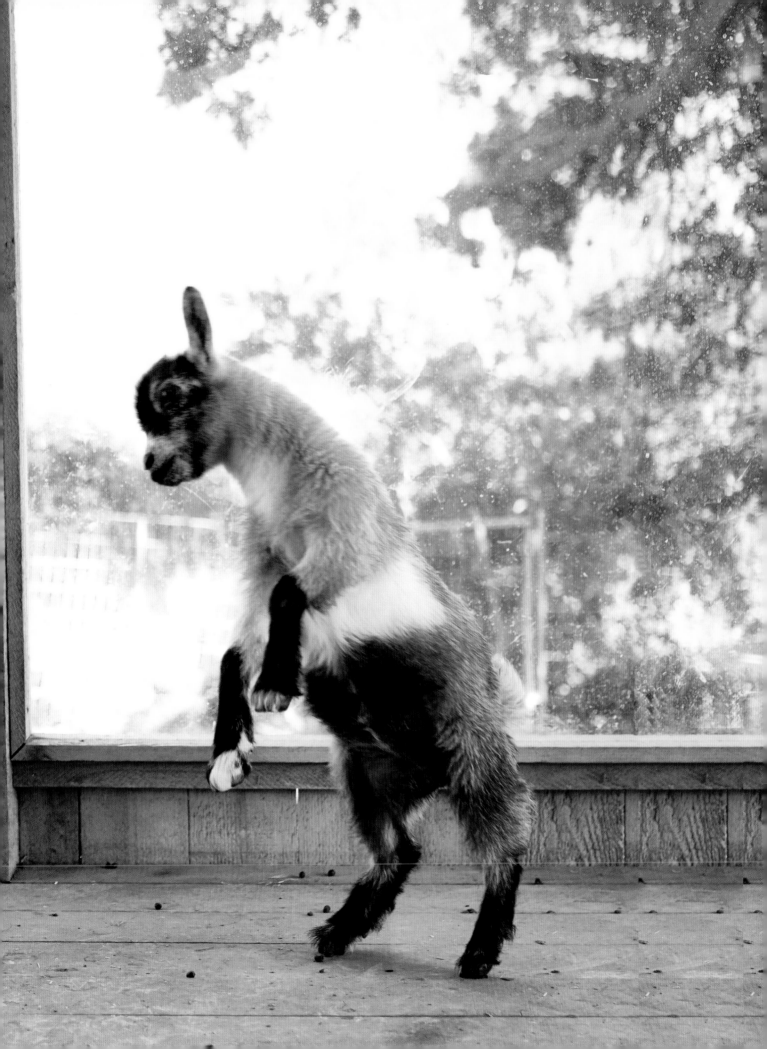

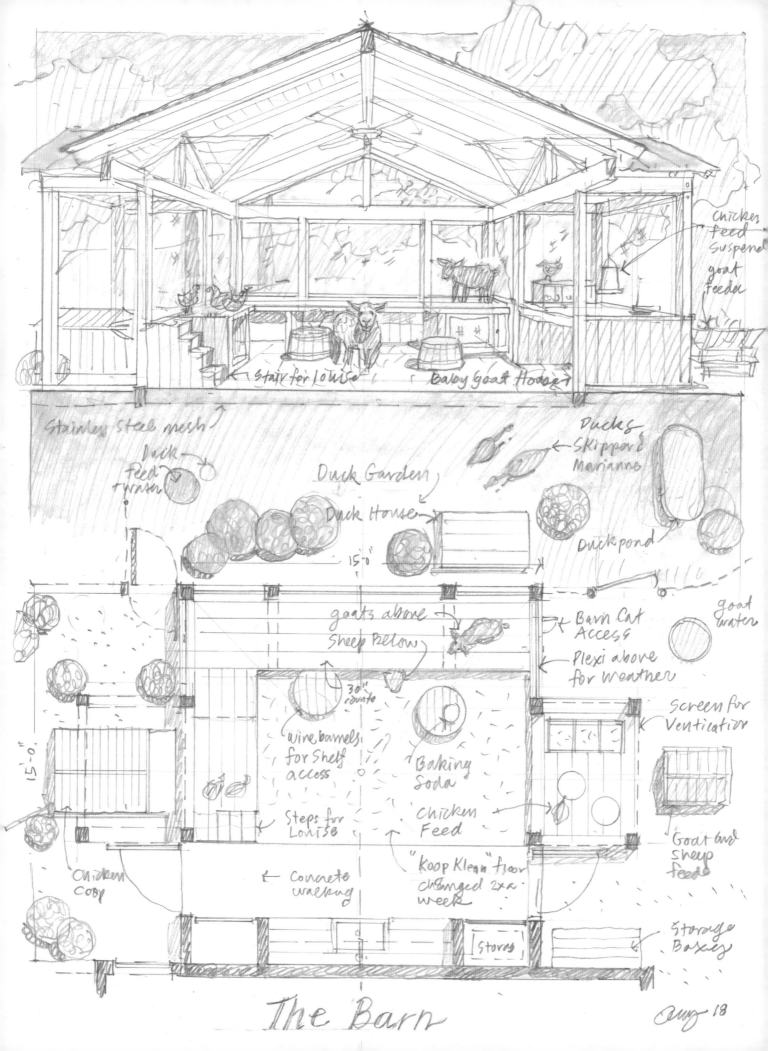

chicken
feed
suspend
goat
feeder

Stair for Louise Baby goat House

Stainless steel mesh
Duck
Feed
+ water

Duck Garden

Duck House

15'-0"

Ducks
Skippor &
Marianne

Duck pond

goats above
Sheep Below

30" counter

wine barrels
for shelf
access

Baking
Soda

Barn Cat
Access

Plexi above
for weather

goat
water

Screen for
Ventilation

15'-0"

Steps for
Louise

Chicken
Feed

Goat and
sheep
feeds

Chicken
Coop

Concrete
walking

"Koop Klean" floor
changed 2xa
week

Storage
Boxes

Stove

The Barn

aug 18

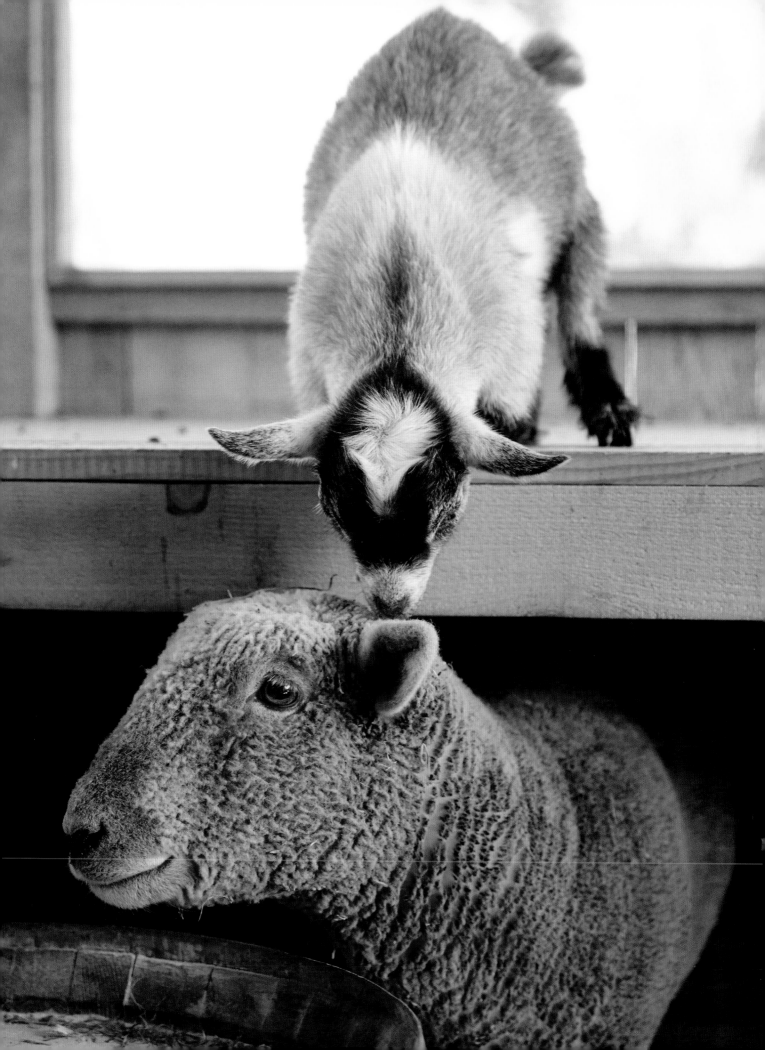

Steve's days start very early. Even before we start our animal routine, he has been drawing at his desk for at least a few predawn hours. By lunchtime, he is ready to take some time off.

Steve has a special connection with the goats and enjoys spending his afternoon "recess" with our little herd. They are always ready for some fun. He likes to take them on walks around the lower area. There is a game of head butting, and like any doting father would, Steve always lets the goats win. After playtime, he'll pull down a couple of branches from our pepper trees to give the goats a snack. No matter how many times I tell him that the goats are getting a little too chubby, he can't help giving them some pepper treats, followed by a few tasty roses from our bushes. Who can really blame him? A half hour of goat time in the middle of the day is all Steve needs to clear his head for an afternoon of design.

All of the species of animals bring their unique personalities to the Patina Farm family. A pygmy goat is like a best friend who is always willing to get into trouble with you. Goats are playful, curious and more than a little mischievous. Leave the hay box open? A goat assumes you want some help to clean it out! Forget to close the gate to the front yard? A goat thinks that's an invitation to prune the rose bushes by the front door. Their relationships with each other also exemplify their playful nature. In the mornings, all five goats enjoy hopping and jumping on the different levels we constructed for them in the barn. The chasing inevitably ends with our full-grown goat, Thelma, engaging little Sam in a game of head butting.

Goats are also interactive with their human family members. In the morning, Thelma, Louise, Dot, Ida and Sam are the first ones to greet us in the barn. Ida and Sam, our two new little ones, will let us rub their necks for as long as we like. Steve's favorite end-of-day activity is cuddling with Ida, rubbing her neck as she closes her eyes and relaxes.

People often ask me if it is true that goats eat everything. Goats are actually picky eaters. Instinctively, they avoid eating spoiled food, and they will not eat anything that falls on the floor. They don't eat most plants that have a heavy scent, such as lemon verbena or onions. However, there are exceptions: they will eat most things that you don't want them to eat. Apparently, roses are delicious. All of our goats are capable of eating a rose bush down to a stick, no matter how thorny it may be. And lavender? It is another goat favorite.

*Steve is never happier than when he is playing with our goats. Because he is the "softy"
in our family, our goats are always excited to see him.* OPPOSITE, CLOCKWISE FROM UPPER LEFT: *Louise
and her very expressive tongue. An open hay box is an invitation to dine.
The light-colored flecks of fur around Dot's eyes look like eyelashes to me and add to her feminine
mystique. Our animals enjoying a snack with one of our smallest visitors.*

The Potager

My wish to have a vegetable garden started when we lived in Santa Monica. This yearning began from my innate desire to feed my family and was sustained by the pleasure and sense of well-being that tending to my garden provided.

My *potager* is now an artistic outlet that has the added benefit of producing food and flowers for our family. Each season, my raised beds are a blank canvas that I can compose into a unique art piece. I watch my creation evolve as the weeks pass: diminutive lettuce seedlings grow into swirling, viridian, van Gogh–esque heads. Sweet pea sprouts transform into mountains of candy-scented posies as their tendrils pull them climbing up the sides of my garden trellises. Gardening is a very forgiving art form that allows me to try something new every few months.

My favorite days include a couple of visits to the veggie garden. In the morning, when the cool mist still blankets the bottom land, I drift down to the garden and scoop out holes in the earth with my hands for new seedlings. Most mornings I forgo the protection of garden gloves, preferring the sensation of the moist, cool soil against my skin. My body craves this connection to the earth. After an hour working in the garden, my mind is clear and cobweb free.

Before our evening animal duties begin, I head down for another fill of *potager* time. As the sun starts to set and the shadows grow longer, I'll pull onions and harvest a few zucchini to include in the next morning's omelette. I'll snip a few tomatoes off one of the many vines that have wrapped themselves around the metal supports and clip a handful of arugula and mint to toss into a midday salad. Heading back up the hill to the kitchen, with my basket full of my evening harvest, I realize how much the garden feeds not just my body but also my soul.

Whether living in the city or the country, the joy of tending vegetables comes with its share of challenges. I've seen that lettuce heads disappear one by one, thanks to the ground squirrels. Adorable, fluffy bunnies don't seem so sweet when you find them chomping on your carrots and cauliflower. There are also insects to address. Later I will share with you some of the ways I deal with all of these natural impediments to growing our own food, but after five years here on Patina Farm, I've found it's best to embrace the "some for you and some for me" attitude. It's also a wonderful lesson in letting go and accepting what you cannot control.

The design for our veggie garden includes spaces where we can spend time doing a variety of activities during the day. In front of the greenhouse, a round table is placed beneath the branches of a sycamore tree to provide a protected dining or reading space. On axis with our garden table is a side gate that opens to a gravel walkway covered by roses and lined with lavender. With its lower, three-foot fence, this shaded walkway is the perfect place to feed the donkeys some newly harvested carrots or snap peas. At the opposite end of this rose arbor is a lavender labyrinth, a beautiful focal point as well as a meditative destination.

There is nothing better than the satisfaction of growing the food your family eats,
even when it doesn't look as perfect as the produce at the market.

wire cloches

Rosemary Hedge

Peppermint
Spearmint

Oregano
Basil
Red pepper

Rose Trellis

Fuji Apples
Wooly thyme
Thymus
serpyllum

Shed
storage

Rosemary
Topiary

Peas
Green beans
Corn

Squash
Beet Onion
Pumpkin

Prostrate
Rosemary

Rosemary
officinalis

Lettuce
Spinach
Tomatoes

Lemon
Verbena

Onion
Broccoli
Carrots

Potatoes
Cucumber

Potager Garden

Giannetti '13

Growing veggies in the country has been a learning experience.
The rabbits, gophers and squirrels think I'm planting food for them! I've found
some ways to deter them so we can now enjoy some of the food we grow.

*I stack baskets of veggies and herbs from the garden next to
our sink to be washed. They add a pop of color to my kitchen during the day.*

GARDEN GREENS WITH PICKLED RED ONION & LEMON VINAIGRETTE

Serves 4–6

1 medium red onion, peeled and thinly sliced

½ cup red wine vinegar

¼ cup water

½ cup olive oil

2 tablespoons lemon juice

2 tablespoons lemon zest

1 tablespoon Dijon mustard

1 clove garlic, grated

¼ teaspoon salt

½ teaspoon pepper

8 cups mixed lettuce, cleaned, dried and torn into pieces

½ cup mixed fresh herbs, such as parsley, basil and mint

1 large avocado, pitted, peeled, and thinly sliced

¼ cup roasted and salted sunflower seeds

In a small bowl, combine onion, vinegar, and water and let sit at room temperature for 30 minutes. Drain well and set aside.

In a jar, combine olive oil, lemon juice, lemon zest, mustard, garlic, salt and pepper and shake well.

In a large salad bowl, toss lettuce and herbs together gently. Add avocado and pickled onions, drizzle with dressing and toss just before serving. Sprinkle with sunflower seeds and additional pepper for garnish.

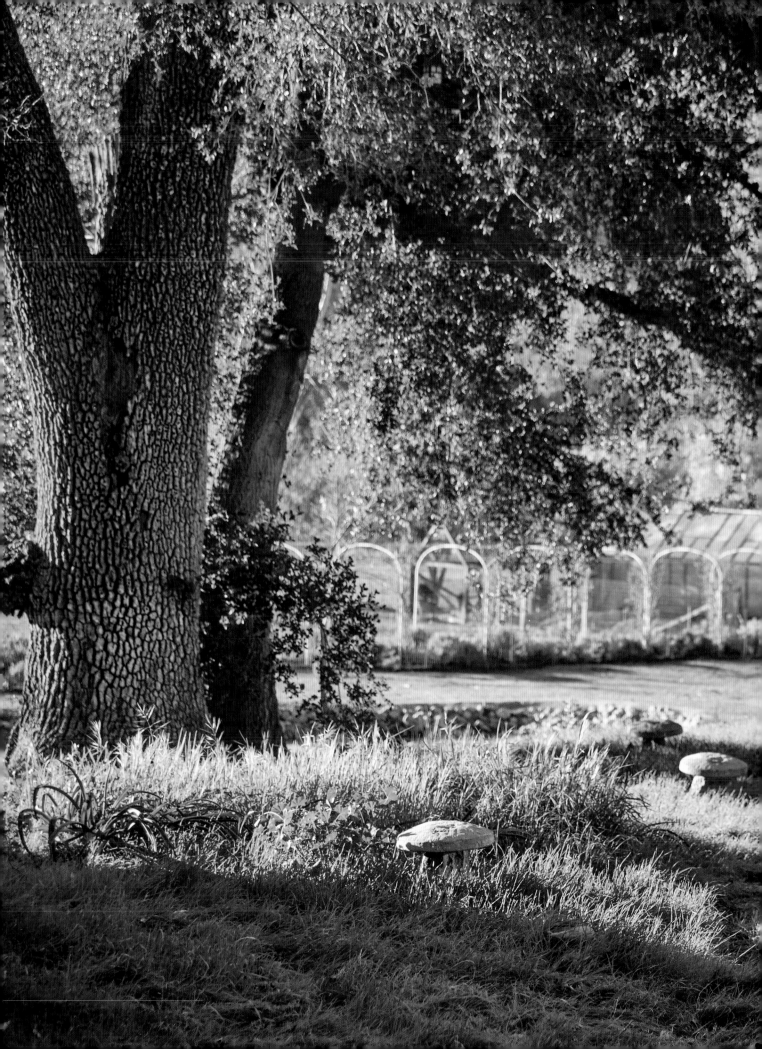

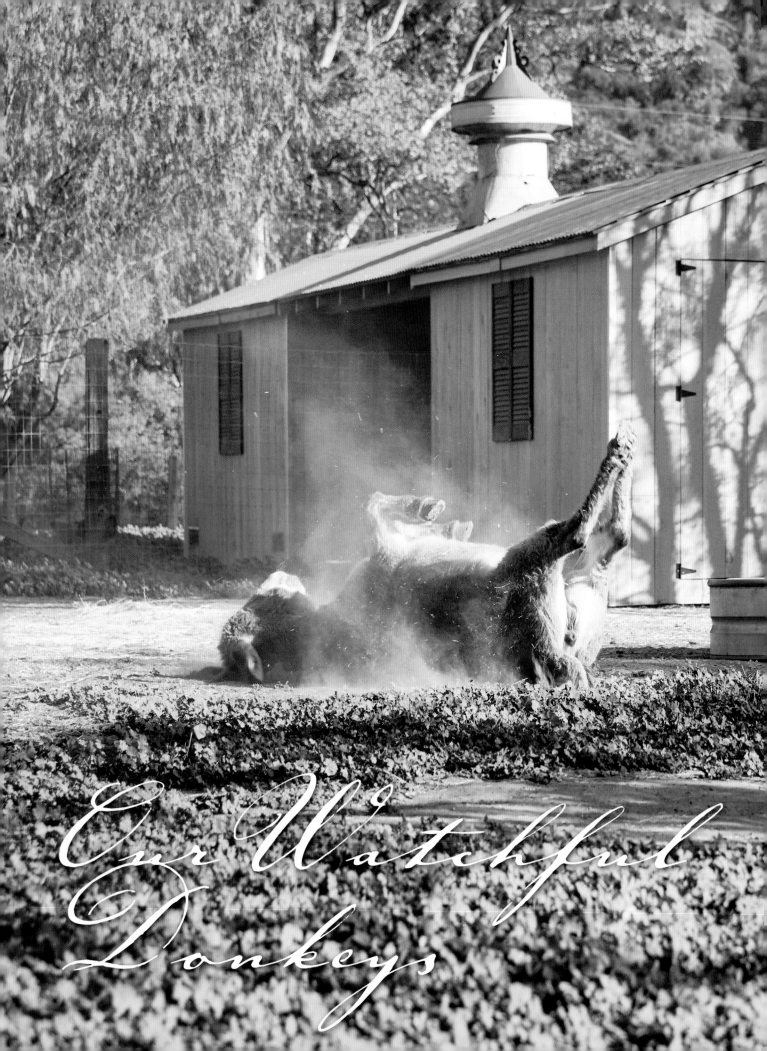

Our Watchful
Donkeys

I now call our chickens the "gateway" farm animals, since they were just the beginning of our diverse menagerie. Our miniature Sicilian donkeys were the next addition. From its inception, my image of Patina Farm always included some sort of grazing animals that would spend their days on the lower portion of our land. Originally I thought we would own miniature horses, but after researching them, I discovered that they can be temperamental and can have many of the delicate health issues that full-size horses can have. It was a chance meeting with a soulful-eyed miniature Sicilian donkey at the Ventura County Fair that introduced me to these affectionate animals.

Although our donkeys are people loving by nature, they are wonderful watch animals. Our land backs up to a dry riverbed that is a playground for coyotes, bobcats and an occasional mountain lion. Our donkeys patrol our back fence and will always let us know if there is an animal that wants to trespass onto our property. They could kill most predators with their strong back legs.

We purchased Daisy and Buttercup from Linda Marchi at Seein' Spots Farm in Santa Ynez. They were already a bonded pair and have a relationship similar to sisters, a loving connection mixed with a little pestering and playful teasing. When our neighbors' goats were attacked by a mountain lion, we decided to add a couple more donks to our herd. We introduced Blossom and her boyfriend, Huckleberry, to our young ladies who immediately welcomed them to Patina Farm. Although they are definitely two bonded pairs, they function as a foursome in games of hide-and-seek and always dine family style. All of our other animals defer to the donkeys and treat them with respect in appreciation for the protection they offer us all from the many predators.

Daisy, Buttercup, Blossom and Huck are an integral part of our family and our days on the farm. Their braying in the morning is our natural alarm clock, reminding us that it's time to start our animal care routine. At dawn and dusk, all four donks line up at their gate to greet Steve as he heads down the stone steps to feed them in their corral. While Steve sprinkles their hay on the soft dirt floor, all of the goats and sheep race down the hill to enjoy a hay snack as well. The donkeys tolerate a little nibbling but shoo away anyone who gets too comfortable. The goats and sheep can tell when the donks have had enough of them and sprint back up to their barn for safety. After the hay has been gobbled up, our equine foursome enjoy aiding Steve in the manure cleanup game, including the joy of turning over the full wheelbarrow.

I always treat the donkeys to some of our vegetables before bringing our harvest up to the house.

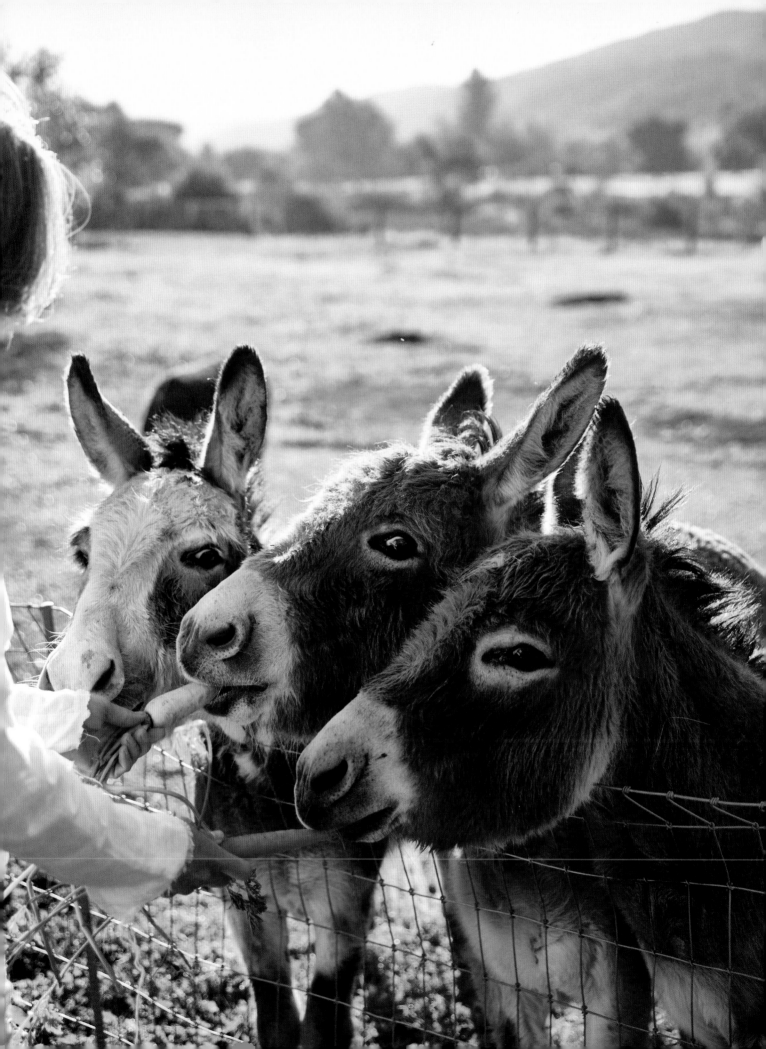

A pair of white iceberg rose vines on a gray arched trellis creates a picturesque entrance to our donkey enclosure. OPPOSITE: *Blossom and Buttercup are a bonded pair and are rarely apart.*

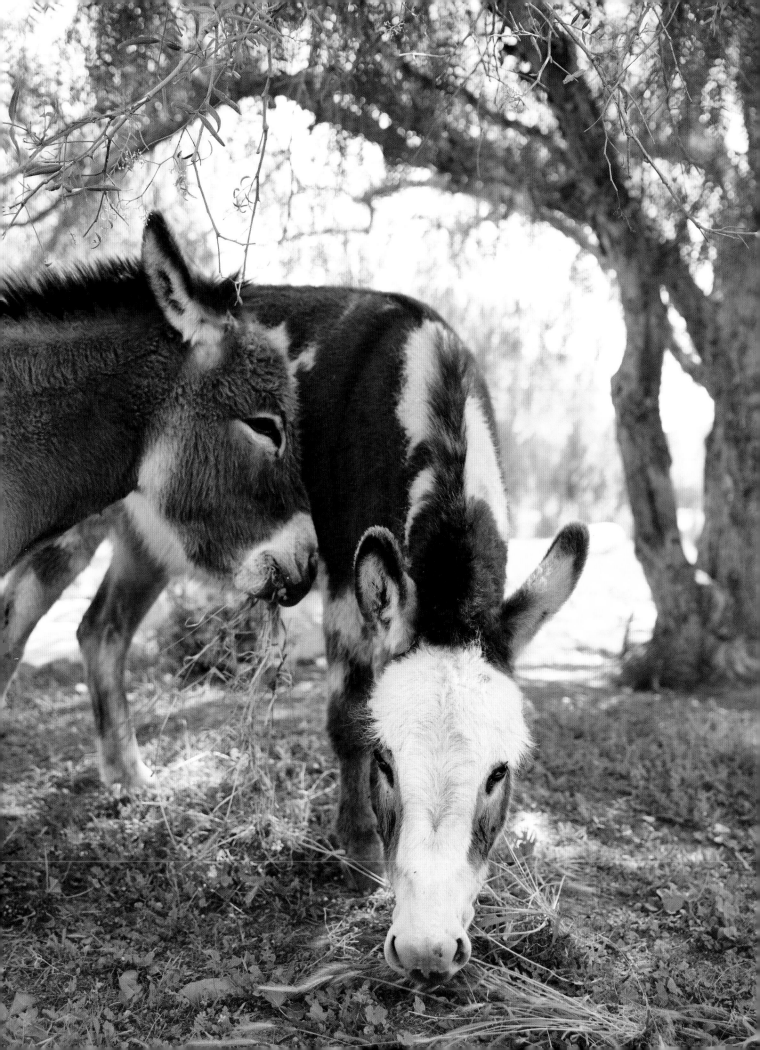

galvanized
water bins

small goat
and sheep gate

goat

Donkeys access
to 2 Acres of
Grazing

"Outdoor Living"
8×12 Garden Shed
@ Home Depot

ATV Storage →

Solar Panels →

Rainy Day feeding

Climbing Roses 2

K— 8'-0" —→

8×12
Hay Storage for
Donkeys and Goats

Shade Trees
Water
Bins in
Shade

Hay
Feeding

Fence around all
Trees Keep
Donkey
away

California Pepper

storage

Hanging
Salt lick

Shed for Rain
8'×8'

Donkey Tack
Room and
access to garden

Donkey Garden

Aug 18

Day's End

The end of the day is one of my favorite times of the day at Patina Farm. As the sun prepares to set and the sky begins to turn the mountains a deep blush pink, we begin to wind down and enjoy the results of our day's labor. The clipped flowers from the garden are now spread around the house in relaxed, nature-inspired floral arrangements, connecting the rooms of the house to the gardens outside. A crystal pitcher—a special gift from my mother—sits on my dressing table, filled with a profusion of magnificent peachy pink roses cut from the Pearly Gates rose vine that grows on the trellis outside our bedroom doors. A vintage ice bucket with the same color roses embellishes the outdoor table on our bedroom porch, waiting to be admired during our open-air cocktail hour. On the dining table, a tall turquoise pitcher is brimming with an explosion of white roses and rich purple lavender. A few deep orange kumquats add a pop of color to our tablescape. In the spring, tall branches covered in delicate pear or apple blossoms adorn the table in our living room, infusing the space with the freshness of that time of year.

The garden is welcomed into my bathroom. I fill the bath with warm water, adding soothing lavender and rose petals. My muscles relax as I breath in the perfumed air and take a moment to appreciate the leftover roses in their vase as well as the verdant garden beyond our all-glass shower. Then I dab my skin with a towel, leaving the lavender oil covering my body.

After my bath, I make my way to the kitchen. On the marble counter, baskets filled with the colorful vegetables and herbs harvested that day serve as inspiration for the dinner I am about to prepare. The scents of rosemary, thyme, sage and mint permeate the room as I rinse the leaves and small, woody branches.

Once the dishes are warming, the juice press and I get to the serious work expressing the tart Meyer lemon juice from the fruit plucked from the tree outside our front door. I fill the martini pitcher with a combination of vivid yellow lemon juice, fresh green cucumber juice, and sweet amber agave. (On Fridays we add a splash of vodka). I place a few fresh mint leaves in my hand and press my palms together, releasing the scented oils from the leaves before garnishing the cocktails. Steve and I head to our bedroom porch, drinks in hand, for the evening's entertainment—goat dances and donkey chasing.

Like our animals, Steve and I are creatures of habit, enjoying our evening routine. It's always the same, with maybe a few minor changes with the addition of a new baby animal to cuddle and kiss. We spend a little less than an hour washing out water and feed bins and giving neck rubs before safely "tucking" everyone into their barn, coop or cage.

Most evenings, Steve and I make an effort to thank each other for what we do. We find that saying it out loud is the best way to stay grateful.

Steve and I never imagined how much we would both enjoy taking care of the animals. After the evening feeding is complete, we walk back to the house with an increased feeling of peace and well-being.

*During blooming season, roses from the garden can always be found in
my bathroom. There is nothing more luxurious than taking a bath in fresh rose petals.*

Señor Hector Fuzzbottom lives in Steve's office and sometimes hops up onto the desk.
I often joke that I believe Hector is doing most of the drawings and Steve just takes all of the credit.

At the end of the day, all of the animals and humans start to relax.
OPPOSITE: *Sophie and Steve share a restful moment on the window seat.*

My love for the combination of rustic and refined is evident everywhere in our home.
A natural floral arrangement in a turquoise Mason jar is paired with our wedding silver.

ROASTED ROOT VEGETABLES
Serves 4

1 pound parsnips, peeled and cut into 1-inch chunks
1 pound rainbow carrots, peeled and cut into 1-inch chunks
1 pound sweet potatoes, cut into 1-inch chunks
3 tablespoons olive oil
2 tablespoons fresh thyme
1 tablespoon fresh rosemary
1 teaspoon salt
1 teaspoon pepper
¼ cup roasted and salted pistachios
¼ cup crumbled goat cheese, optional

Preheat oven to 400° F.

Toss vegetables, olive oil, herbs, salt and pepper on a rimmed baking sheet and roast for 40–45 minutes, or until tender, stirring halfway through. Transfer to a serving platter and garnish with pistachios and goat cheese.

A variety of pink blossoms arranged in a simple Mason jar is a lovely centerpiece on our outdoor dining table. OPPOSITE: *Floral arrangements from our garden often include Patina Farm citrus branches as well.*

We designed our garden to include plants that can be admired
during different times of the year. In fall and winter, our citrus trees are in full bloom,
while most of our vines, including this Boston ivy, go dormant.

PATINA FARM COCKTAIL

In the summertime, we like to take a walk around Patina Farm and gather the ingredients to make this delicious drink. This refreshing cocktail is just as delicious without the alcohol, served over ice.

Makes 4

2–3 cucumbers

1 cup freshly squeezed Meyer lemon juice

2 tablespoons agave syrup

1 cup vodka, optional

Fresh mint leaves, for garnish

To make cucumber juice, peel 2 to 3 cucumbers and run them in a food processor until they are pulp. Pour pulp through cheesecloth to strain. Measure 1 cup juice to proceed.

To make the cocktail, mix 1 cup cucumber juice, the lemon juice, agave syrup, and optional vodka in a tall pitcher. Stir until mixed.

Fill a martini shaker with ice and pour in some of the mixture. Shake. Serve in a chilled martini glass. Garnish with 1 or 2 fresh mint leaves.

When the evenings get chilly, we enjoy ending our
day in our outdoor living room, staying warm by the fire.

What We've
Learned

Looking back,

I'm not sure why Steve and I weren't apprehensive about starting a family of animals or building five acres of gardens. Fortunately, we found some generous, knowledgeable, kind-hearted, non-judgmental people to help us along the way. Following is some of the wisdom they have shared with us and a few things we've learned from the mistakes we've made on our own.

*Join us for more on Instagram @velvetandlinen, @stevegiannetti
and on our website, Giannettihome.com*

Chickens & Ducks

1. The first question to ask: Are you allowed to have chickens in your neighborhood? The good news is that more and more cities are seeing the benefit of allowing a backyard flock.

2. Before purchasing chickens, research different breeds to see which ones best suit your needs. We purchased Silkie bantam chickens first. These beautiful, small chickens were perfect for the side yard of our Santa Monica home, but their eggs are pretty small. Anyone for a twelve-egg omelet?

3. *Mypetchicken.com* is a great resource. They provide an exhaustive breed list that describes each type's characteristics, including temperament, egg color, etc. They also sell chicken coops and baby chicks, including heritage and rare breeds.

4. I love the natural products from *treatsforchickens.com*. Their Nesting Box blend is an all-natural way to keep your flock from getting parasites; plus, the lavender, chamomile and peppermint keep your ladies' nesting boxes smelling divine. My hens love all of their healthy treats, and I get a laugh from the names of the products: our two favorites are "Chicken Crack" and "Cluck Yea."

5. I use food-grade diatomaceous earth preventively. I sprinkle a thin layer on bedding in the coop, nesting boxes and duck house to keep the birds dry. I also add a teaspoon to my ladies' feed to keep internal parasites from occurring.

6. I don't recommend roosters. Not only are they loud at all times of day and night, but they can also be mean. When we had a rooster, he pulled the feathers out of the heads of several of my hens! The same is true with ducks. Trust me, your girls will be happier without a man.

7. If you are gluten free, like our family, you might want to feed your chickens a wheat-free feed. *Newcountryorganics. com* carries a variety of specialty feeds, including a wheat-free, soy-free option. You are what you eat and so are your chicken eggs! I also supplement their diet with coconut flakes and Omega Ultra Egg by Omega Fields to provide my hens with an extra dose of good fats. You won't believe the beautiful color and rich taste of your chicken and duck eggs.

8. If you are going to let your chickens free range, make sure there are plenty of places for them to hide from predators.

9. Ducks need water to eat. Always place their food next to a water bin. Since they love to make mud, their water will need to be cleaned once a day.

10. Always provide grit and a probiotic to prevent sticky butt or pasty butt. I'm sure you can guess what that is.

Goats

1. Goats are pretty easy animals to keep as pets, but they do require some maintenance. Their hooves need to be trimmed a few times a year. This can be done with a simple pair of pruners. Goats also need CDT vaccinations twice a year. We pick up the vaccines at our local veterinarian office and administer the shots ourselves.

2. Our pygmy goats love to climb. We've created a jungle gym comprised of houses with stairs and different levels so they can jump and play.

3. To avoid deathly bloat, always provide a container of baking soda for your goats. Although goats do burp (which is pretty hysterical), they can't always get rid of all of the excess gas that their constant grazing can produce. When a goat has an upset stomach, it instinctively knows to eat the baking soda.

4. Worming is a necessary precaution for goats and all of our animals. I don't love the chemical wormers and have found some great natural alternatives. Molly at Fiasco Farms, *fiascofarms.com,* makes a great herbal wormer. Her website is also a wealth of information on many different goat issues.

5. I also found *biteme@104homestead.com,* which offers a variety of herbal goat treats. I give Louise the Achy Breaky Bites to help with her arthritis. All of the goats get Mineral Mojo Bites as a supplement and Squirmy Wormy Bites to discourage parasites.

6. Castrated male goats are susceptible to urinary calculi, or calcium buildup in their urinary tract. To prevent this deadly disease, we give our little Sammy IP Freely Bites, ammonium chloride in a delicious treat form from *biteme@104homestead.com.*

7. Goats hate being in the rain. Even before the first drop hits the ground, our little herd finds their way back into the barn. For this reason, a rain protective shelter is a must if you are thinking about getting goats.

8. Goats and sheep have no defenses against large predators such as coyotes, bobcats, and even raccoons, so you must provide a predator-safe house for them to sleep in. Our goats and sheep walk themselves into the barn to be locked up for the night as soon as the sun starts to set.

9. Because all goats are preyed upon, they've become very good at hiding illness. It is not uncommon for a goat (or sheep) to mask their illness until they are gravely ill. For this reason, it is important to keep an eye on your goats' health and take notice of any changes in eating or level of activity.

Sheep

1. When selecting a breed of sheep, look into the breeds that do well in your type of weather. A thick woolly sheep breed may not be right for you if you live in a hot area. It's also helpful to talk to another sheep owner or breeder to understand what is required to own sheep responsibly.

2. Before getting sheep, decide what to do about shearing. Is a shearer in your area and will he come to your property for just a few pet sheep? If not, you might need to transport your sheep to join with a larger herd for shearing. Or else you might learn how to shear your own, but sure you have a plan in place. You can tell that it's time to shear your sheep if they are constantly seeking shade, spend a lot of time panting, or their wool is so long that it becomes matted or forms dreadlocks.

3. Sheep should never be bathed. They produce lanolin (a grease/oil secretion specific to sheep) all over their bodies. Not only does lanolin help repel water in rainy conditions, it is also an important part of the sheep's immune system and can help when superficial wounds occur.

4. If you have both sheep and goats and you give your goats minerals or grains made specifically for goats, *do not* give them to your sheep. Most products made for goats include copper, which is toxic to sheep.

5. Sheep in a soft pasture without rocks to wear down their hooves will need their hooves trimmed. This might be done by your shearer or a large-animal veterinarian, or you can buy the tools and learn from another sheep rancher how to do it yourself. Sheep also need the CDT vaccine (as do goats) twice a year and worming once a month.

6. Grazing needs to be monitored. Our Babydoll Southdown sheep have a tendency to overeat. We vary their ration of hay depending on their weight.

7. We keep a layer of Koop Clean and diatomaceous earth on the floor of the sheep and goat shed as bedding for the sheep. It gets changed out twice a week.

8. With all farm animals come flies. We deal with flies in several different ways. *SpaldingLabs.com* sells small insects called fly predators, which we spread around our fields. These small insects eat the fly larvae. As gross as that may sound, hundreds of annoying flies are even more irritating to your herd. Spalding also has a variety of fly traps that can be used in conjunction with the predators.

9. To keep flies off the sheep and other animals, we spray them with all-natural neem oil spray.

This list was made with the help of our amazing shearer, Trevor Hollenback.

Donkeys

1. Donkeys' powerful back legs make them wonderful watch animals. In the time that the donkeys have been part of our family, there hasn't been any predator brave enough to try to skirt past our donkey herd.

2. If you or your neighbors need quiet, then donkeys may not be ideal pets. Although they are silent most of the time, donkeys bray when they want to get your attention. Our donks "hee-haw" in the morning before breakfast and in the evening before dinner. Donkeys will also bray if they sense a predator nearby, which can sometimes occur in the middle of the night.

3. Although donkeys are easier to keep than horses, they still require some care. Our donkeys get their hooves trimmed every eight weeks. These scheduled "mani-peds" keep them from getting diseases or infections.

4. Keeping donkeys from getting fat is a challenge. Given the chance to eat to their hearts' content, donkeys will overeat. In the springtime, when grass is plentiful, we limit the amount of supplemental hay. We also give them Bermuda hay (which we call "diet hay") because it has less protein. This allows us to give them more hay without them putting on weight.

5. Because donkeys can get fat, I recommend giving them space to roam and exercise. I'm sad when I see a donkey living in a small pen.

6. Donkeys need companionship. I recommend getting a pair of donkeys, but I have heard of donkeys bonding with other equine.

7. Donkeys prefer to live and sleep outdoors. It is much healthier for them to be outdoors at all times. We do have a little donkey house for shelter from the rain, but the donkeys only seem to go inside during the most torrential storms.

8. Do not expect to let your donkeys roam in your gardens. They will pull your rose bushes out by the roots and eat your fruit trees down to toothpicks. I learned this the hard way.

9. Donkeys love to nibble on wood, which includes tree trunks as well as wood buildings. All of our trees at the bottom of our land have three-foot fencing around their trunks. We also installed metal edging on the corners of the donkey shed to prevent its becoming a pile of splinters.

10. Before you get donkeys, make sure there is a good equine veterinarian in your area to help you with vaccinations and teeth cleaning.

Potager

Growing food comes with constantly changing challenges. It can often feel like spinning plates on sticks: Once you have one plate spinning, another plate is teetering and about to crash to the floor.

1. It's always helpful to ask local vegetable gardeners what they've learned. I've even asked some of the farmers who sell at our local farmers market if I could visit their farms. In return, I offer to help them weed, water or harvest for a couple of hours. These hands-on tours have been incredibly informative.

2. We attach stainless steel mesh to the bottom of all of our raised beds to deter ground squirrels and gophers.

3. I've found some very useful products for animal control at *gardeners.com*. Their mesh garden cloches give my seedlings a chance to get established. I keep the cloches in place with Gardeners' metal garden stakes. Once my plants are bigger, I find Gardeners' 3-season garden tents, or their crop cages for bigger plants, work really well in keeping the rabbits and squirrels at bay.

4. We don't use any toxic pesticides. Instead, we use all-natural neem oil spray. I apply it to all of my veggies twice a week. It helps fight aphids, spider mites and whiteflies as well as mildew and rust.

5. Diatomaceous earth is a natural powder that is great for sprinkling in the garden. It deters all kinds of crawling pests, including slugs, ants and caterpillars.

6. We buy all of our raised planter beds from *gardenraisedbeds.com*. Their well-made mortise-and-tenon boxes, made of rot-resistant Vermone White Cedar, come in a variety of sizes to fit your garden space and are reasonably priced.

7. All of our raised beds are drip irrigated. It's a time- and water-efficient way to hydrate your veggies.

8. Age-old advice: rotate your crops. Planting each vegetable in a different spot each year will keep your soil from getting depleted. It will also fight nematodes, which attack root vegetable like carrots and tomatoes. Planting nematode-resistant crops, such as corn will also help.

9. Keep a garden journal mapping the locations of your crops each season. A journal is also a great way to write about your successes and challenges.

10. Experiment with your garden! Mix edible flowers in with your vegetables to create your own edible bouquets. If you want to have hedges in your garden, plant edible ones. We use rosemary as hedging and thyme as a ground cover under our apple trees. They look beautiful and taste delicious!

Tools

1. To keep my sheds and garden storage looking clean, I like to store items in similar containers. Too many different types of containers can look chaotic. It's difficult for me to feel organized if the space feels frenetic.

2. Flea markets and antique stores are ideal places to hunt for unique galvanized buckets, watering cans, troughs, and other containers. I use them for storage and as planters and vases. They also look great when displayed together.

3. To store mulch, rose food and other amendments, I use galvanized trash cans with lids, from the local feed store. These cans come in a variety of sizes, making them useful for 50-pound bags of feed or 25-pound bags of soil. Tying classic manila labels to the cans is an easy way to know what's inside.

4. I collect interesting shaped baskets to use in the garden and inside the house. Large baskets are great for wood storage inside and outside. Small baskets are perfect for egg collection as well as vegetable harvesting. Flat baskets are ideal for floral clippings.

5. I always choose natural-colored baskets, which age beautifully, so they can be stored in full view. Extra baskets can be easily stored on hooks or stacked in the greenhouse or pantry or on the walls of the shed.

6. Tools don't have to be ugly. Look for tools made from natural materials that age beautifully over time.

7. I like the durability of stainless steel garden tools and prefer those with wooden handles because the stay cool in the summer and warm in the winter. Sneerboer Dutch tools are my favorites. They are a bit pricey but will last a lifetime. Check out the heart trowel at *sneerboerusa.com*. It's a work of art.

8. The most helpful tools in the garden? Family and friends. Invite them to help out, and turn your gardening chore into a party!

Landscape

1. Before purchasing plants, it's good to think about what your garden will look like during each season. In our front garden, we planted evergreen Little Ollie shrubs around our rose bushes to provide some color when the roses go dormant in winter. We love the yellows and oranges our sycamore trees add to our garden in the fall. We planted several California pepper trees, which provide greenery when the sycamores go dormant.

2. We like to balance order and chaos in the garden. Some of our favorite pairings: clipped boxwood with more natural catmint ground cover; clipped Little Ollies with the rose bushes and lavender.

3. Organic mulch during the year is a great way to control weeds, keep moisture in the beds and enrich the soil.

4. Gravel is a wonderful ground cover and can be used close to trees without damaging their roots. We don't use any barrier fabric underneath. Although this means that we need to pull weeds, we like the relaxed aesthetic the unlined, loose gravel adds to our gardens.

ABOUT ROSES

5. Decide on what characteristics are most important before making your final rose selections for your garden. Many of the David Austin roses have incredible fragrance, but their blooms don't last long when cut. Pearly Gates roses last a long time in floral arrangements but have no scent at all. Eden rose vines are one of our favorite for their long blooming season. Also remember to research which rose varieties do well in your location.

6. We feed and fertilize the roses every four weeks. We use an organic rose food and organic Happy Frog top dressing as a fertilizer.

7. We prune the roses only once a year, in January, when we cut the bushes back to 18 inches. We spray them with organic dormant horticulture spray. At the same time we cultivate the base and give it a very light fertilizing.

8. At pruning time, we also remove all of the leaves on all of the rose bushes and vines. This prevents mildew and also allows new growth to come in stronger for the new season.

9. During the growing season (early spring), we spray the roses with organic neem oil or horticulture oil to prevent white mildew and aphids. Later in the summer, we spray them for rust and black spot.

10. We deadhead (clip off all of the dead roses) throughout the season. We can usually get two or three good flowering stages through the year from spring through fall.

Thanks to Ricardo Gutierrez for sharing his knowledge and taking such great care of our gardens.

Resources

We purchased our sweet pygmy goats from Amber Waves. Owners Debbie and Jim Hosley raise their animals with love and are very supportive during the entire process. They also raise beautiful Bantam chickens. *amberwaves.info.*

The Shed in Healdsburg is a fantastic resource for beautifully made garden tools as well as housewares. Although they have an easy-to-use website, their brick and mortar store is a must-see if you are ever in the area. *healdsburgshed.com.*

The Humane Society of Ventura County is a private nonprofit organization dedicated to promoting the health, safety and welfare of homeless animals in the county. Steve and I are forever grateful to the Humane Society for caring for our donkeys during the Thomas fire. We also adopted two of our adorable barn kittens from this wonderful organization. *hsvc.org.*

Our happy Babydoll Southdown sheep were bred by Moon Hollow Ranch in Sonoma, CA.

Breeder Suzanne Harmon couldn't be more helpful and generous with sharing her knowledge. Moon Hollow Ranch raises heritage-breed animals, including Kunekune pigs and Nigerian Dwarf goats. *moonhollowranch.com.*

We buy all of our rose bushes from the family-owned Rose Story Farm. Danielle is a world-renowned rosarian. A visit to Rose Story is a must for anyone who love roses. *rosestoryfarm.com.*

Our miniature Sicilian donkeys were raised by Linda Marchi at Seein' Spots Farm in Santa Ynez. Linda makes a point of socializing her animals. Our donkeys are some of friendliest burros I've met. If you are ever in Santa Ynez, you'll love visiting Seein' Spots and meeting their menagerie of goats, sheep, pigs, turkeys, ducks, geese, chickens and tortoises. Don't forget to say hello to their zonkey too! *seeinspotsfarm.com.*

Our greenhouse is the Sunshine Mt. Ranier 8 by 16-foot size. We bought it on *hayneedle.com.*

Dedication

*To Charlie, Nick and Leila for joining us on this crazy journey
and always being open to any adventure.
Thank you for making our life richer by sharing your wisdom
and passions with us. You give our dreams meaning
and push us to dream even bigger.*

Acknowledgments

It is with sincere gratitude and appreciation that we thank the following talented people for helping us create this book:

Our dear friend Jill Cohen, who has masterfully and patiently guided us on this journey. We can't imagine doing any of this without you.

Madge Baird, our wonderful editor at Gibbs Smith, for understanding and supporting our love of animals and gardens.

Victoria Pearson, for being the ideal photographer to capture our animals' personalities and the natural beauty of Patina Farm.

Gemma and Andrew Ingalls for sharing their beautiful photos.

Our meticulous gardener, Ricardo Gutierrez; our gentle shearer, Trevor Hollenback; our benevolent veterinarian, Clinton McKnight; and our kind farrier, Ted Everton, for generously sharing their knowledge with us.

Belle Cook and Caitlin Cooper, for caring for our large furry and feathered family with so much love when we are away.

Carrie Purcell and Lawren Howell for adding their touch to *Patina Living*.

Special appreciation to all of our *Velvet and Linen* readers and Instagram followers for joining us on this adventure!

23 22 21 20 5 4

Text © 2019 Brooke Giannetti
Illustrations © 2019 Steve Giannetti
Photographs © 2019 Victoria Pearson, except:
 pages 6, 9, 56, 76, 156, and 157 © 2019 Steve Giannetti;
 pages 41, 102, 104, 116, 132–33, 161 top right and bottom, and 171 top left © 2019 Gemma and Andrew Ingalls.

Published by
Gibbs Smith
P.O. Box 667
Layton, Utah 84041

1.800.835.4993 orders
www.gibbs-smith.com

Developed in collaboration with Jill Cohen Associates, LLC

Printed and bound in China

Gibbs Smith books are printed on either recycled, 100% post-consumer waste, FSC-certified papers or on paper produced from sustainable PEFC-certified forest/controlled wood source. Learn more at www.pefc.org.

ISBN 978-1-4236-5092-8
Library of Congress Control Number: 2018950570

Lavender

2

3

8

16

8

1

4

17

1

6 5 oak Tree

Antique Fountain

Firepit

mirror

1 Boxwood · Buxus Microphylla

2 Lavender · Hidcote

3 Rose Vine · Pearly gate Rosa wekmeyer

4 Catmint · Nepeta groundcover

5 Valley Oak · Quervs Lobata

6 Ceanothus · California Lilac

7 Blue Hydrangea ·

8 Lime Tree

9 California Lilac · Ceanothus

10 Mediterranean Cypress · Cypressus Sempervirens

Antique Fountain

Boxwood Balls

Patina Farms

Back Garden